2007

马来西亚·广西文化舟
—— 漓江画派精品展 作品集

The Malaysia·
Boat of
Guangxi Culture
2007
Collection of Lijiang Painting
School Fine Arts Exhibition

2007 马来西亚·广西文化舟组委会 编

广西美术出版社

Compiled by the Organizing Committee of
The Malaysia·Boat of Guangxi Culture 2007

Guangxi Fine Arts Publishing House

图书在版编目（CIP）数据

2007 马来西亚·广西文化舟：漓江画派精品展作品
集/2007 马来西亚·广西文化舟组委会编.—南宁：广西
美术出版社，2007.5
ISBN 978-7-80746-202-6

Ⅰ.2… Ⅱ.2… Ⅲ.美术—作品综合集—中国—现代
Ⅳ.J121

中国版本图书馆 CIP 数据核字（2007）第 053133 号

2007 马来西亚·广西文化舟
——漓江画派精品展作品集

The Malaysia·Boat of Guangxi Culture 2007
–Collection of Lijiang Painting School Fine Arts Exhibition

编　　者：2007 马来西亚·广西文化舟组委会
执行主编：刘绍昆　雷　波　谢　麟
图书策划：杨　诚
责任编辑：杨　勇　陈　凌
装帧设计：凌　子
责任校对：黄雪婷
英文编辑：韦丽华
审　　读：林柳源
摄　　影：余亚万
出 版 人：伍先华
终　　审：黄宗湖
出版发行：广西美术出版社
地　　址：广西望园路 9 号
邮　　编：530022
制　　版：广西雅昌彩色印刷有限公司
印　　刷：深圳雅昌彩色印刷有限公司
版　　次：2007 年 5 月第 1 版
印　　次：2007 年 5 月第 1 版印刷
开　　本：889mm × 1194mm
印　　张：14.6
书　　号：ISBN 978-7-80746-202-6/J·745
定　　价：280 元

ISBN 978-7-80746-202-6

9 787807 462026 >

2007 马来西亚·广西文化舟 ——漓江画派精品展

吉隆坡

2007.5.13.— 17.

The Malaysia·Boat of Guangxi Culture 2007
–Lijiang Painting School Fine Arts Exhibition
Kuala Lumpur
May 13 — 17. 2007

主 办：

中国·广西壮族自治区人民政府

中国美术家协会

马来西亚文化艺术及文物部

中国驻马来西亚大使馆

Organizers

People's Government of Guangxi Zhuang Autonomous Region · China

China Artists Association

Malaysian Ministry of Culture, Arts & Heritage

Embassy of the People's Republic of China in Malaysia

承 办：

广西壮族自治区文学艺术界联合会

广西美术家协会

漓江画派促进会

马来西亚创价学会综合文化中心

Sponsors

Art & Literature Union of Guangxi Zhuang Autonomous Region

Guangxi Artists Association

Lijiang Painting School Promotion Association

SGM Culture Center of Persatuan Soka Gakkai Malaysia

协办：

马来西亚国际现代书画联盟

马来西亚广西会馆

Co-sponsors

Malaysian Contemporary Chinese Painting & Calligraphy Association

Malaysia Federation of Kwongsai

展出地点：马来西亚创价学会综合文化中心

（马来西亚·吉隆坡武吉敏登路 243 号）

展出时间：2007 年 5 月 13 日— 17 日

Venue:

SGM Culture Center of Persatuan Soka Gakkai Malaysia

(Wisma Kebudayaan Soka Gakkai Malaysia (WKSGM) 243,

Jalan Bukit Bintang 55100 Kuala Lumpur, Malaysia)

Schedule: May 13−17, 2007

Preface

China and Malaysia enjoy profoundly traditional friendship.

The rapid development of economic cooperation between China and ASEAN nations has furthered the political and economic cooperation and cultural exchange between our two countries in recent years. In consequence of the successful annual China-ASEAN Expo and the recently launched initiative of the Pan-Beibu Gulf Rim Economic Cooperation, economic cooperation and cultural exchange between Guangxi and Malaysia have entered a new stage with strengthened ties and a series of achievements.

In order to further enhance the friendship between China and Malaysia and promote the economic cooperation and cultural exchange between Guangxi and Malaysia, Guangxi Business and Trade Delegation will be visiting Malaysia in May 2007. In the meantime, the People's Government of Guangxi Zhuang Autonomous Region will hold the *Malaysia · Boat of Guangxi Culture 2007* in Kuala Lumpur. As part of the event, the Lijiang Painting School Fine Arts Exhibition is intended to present theme paintings by Guangxi's Lijiang Painting School artists. Guangxi is known for its enticing and unique scenery and simple and unsophisticated yet colorful folkways of co-inhabited minorities in the region, such as green mountains and clear rivers, scenic Guilin-Chinese frequently refer to it as the world's most beautiful scenery, enthralling Beibu Gulf and dainty views along the border areas. These are all reflected in the paintings of the exhibition. I sincerely hope that you will enjoy their works.

Finally, I would like to give special thanks to China Artists Association, Malaysian Ministry of Culture, Arts & Heritage, Embassy of the People's Republic of China in Malaysia, SGM Culture Center of Persatuan Soka Gakkai Malaysia, Malaysian Contemporary Chinese Painting & Calligraphy Association, Malaysia Federation of Kwongsai and friendly individuals for their generous support and invaluable role, which made the exhibition possible and all organizational details run smoothly.

I wish the *Malaysia · Boat of Guangxi Culture 2007– Lijiang Painting School Fine Arts Exhibition* a great success!

May the friendship between Chinese and Malaysian people last forever!

Standing Member and Director of the Publicity of CPC Guangxi Committee *Shen Beihai*

序

中马两国有着悠久的传统友谊。

随着中国—东盟经济合作关系的深入发展，中马两国政治、经济、文化的合作与交流得到了新的促进。借助中国—东盟博览会的平台和泛北部湾经济合作的历史机遇，广西与马来西亚的各方面关系开创了前所未有的新局面，经贸合作与文化交流不断增强并取得了一定的成果。

为了进一步发展和加强中马两国人民的友谊，促进广西与马来西亚经贸合作和文化交流，广西经贸代表团将于2007年5月访问马来西亚。同时，广西壮族自治区人民政府在马来西亚举办"2007马来西亚·广西文化舟"活动。"漓江画派精品展"是文化舟活动的一个内容。画展展出漓江画派的创作成果。广西山川秀丽、民风淳朴，有"甲天下"的桂林山水，也有风景迷人的北部湾风光、古朴浓郁的少数民族风情、风光旖旎的边关风情等，广西广大美术家用手中的彩笔，描绘了家乡的绿水青山。希望这些美术作品，能给马来西亚人民带来美好的享受。

这次"2007马来西亚·广西文化舟"——漓江画派精品展活动，得到了中国美术家协会、马来西亚文化艺术及文物部、中国驻马来西亚大使馆、马来西亚创价学会综合文化中心、马来西亚国际现代书画联盟、马来西亚广西会馆等机构及友好人士的大力支持，使画展得以顺利举办，在此，谨表示衷心的感谢！

预祝"2007马来西亚·广西文化舟"——漓江画派精品展取得圆满成功！

祝中马两国人民的友谊天长地久！

中共广西壮族自治区委员会常委、宣传部长　　沈北海

目 录
Contents

Traditional
Chinese Paintings

中国画

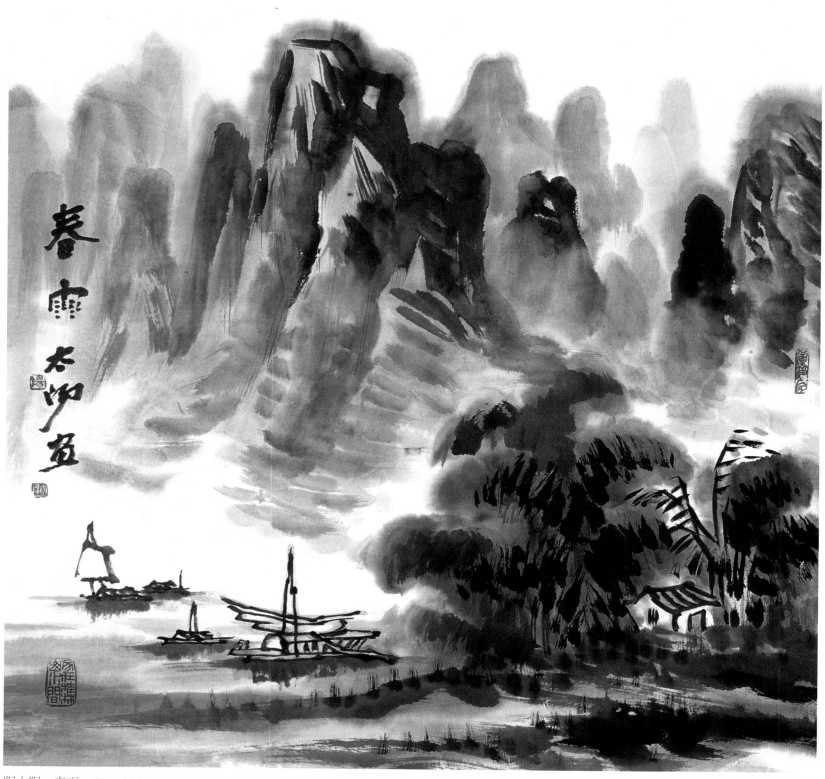

阳太阳　春雨　69cm × 70cm
Yang Taiyang　*Spring rain*　69cm × 70cm

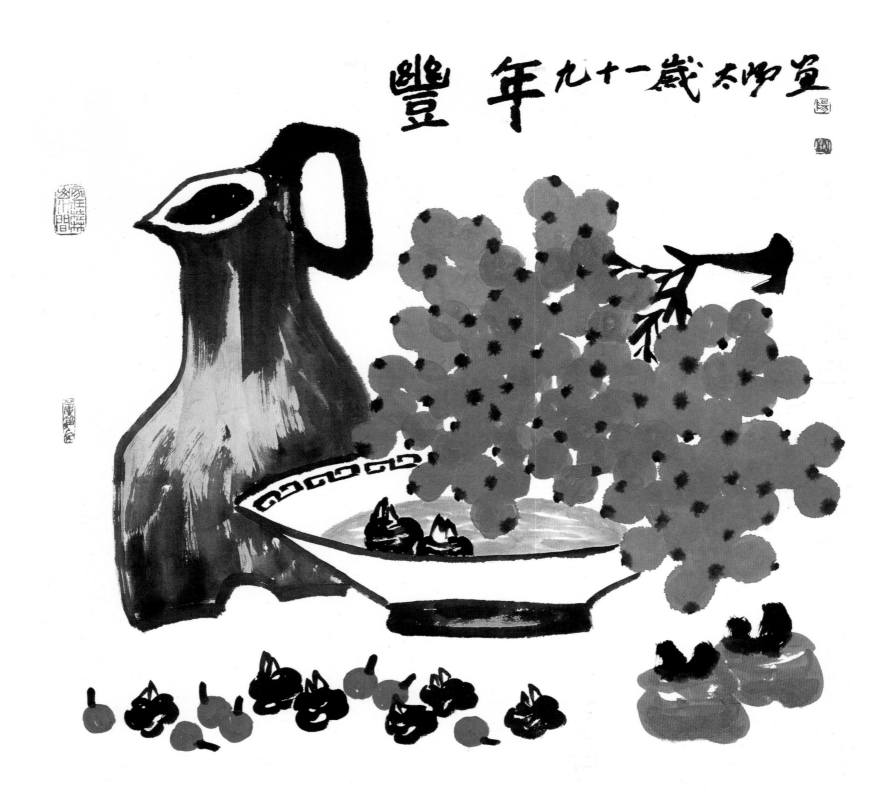

阳太阳　丰年　69cm × 70cm
Yang Taiyang　*Harvest year*　69cm × 70cm

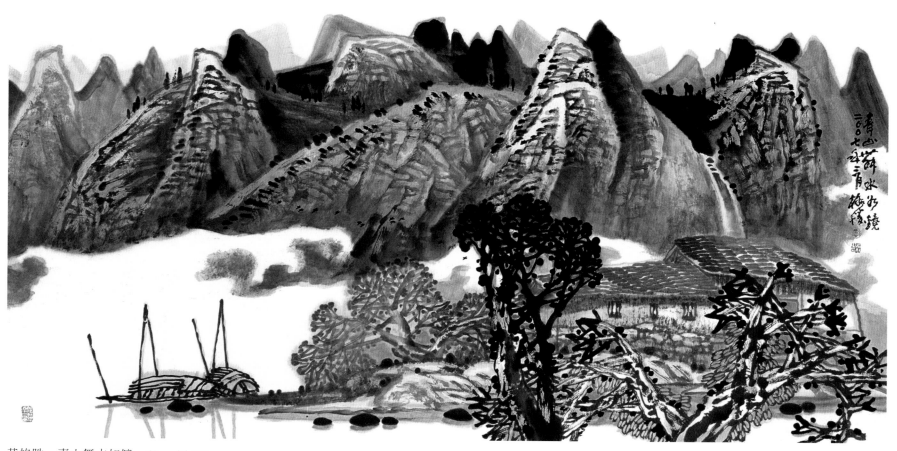

黄格胜　青山舞水如镜　68cm × 136cm
Huang Gesheng　*Green hill and still clear water*　68cm × 136cm

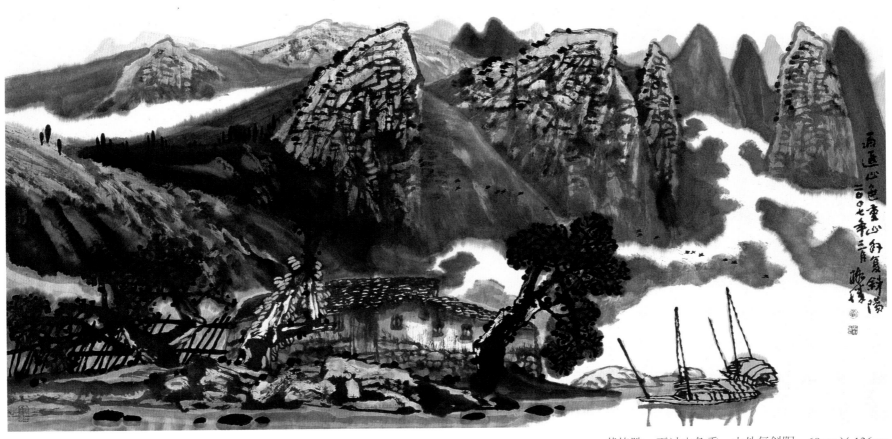

黄格胜　雨过山色重，山外复斜阳　68cm × 136cm
Huang Gesheng　*Mountain, sun and cloud after rain*　68cm × 136cm

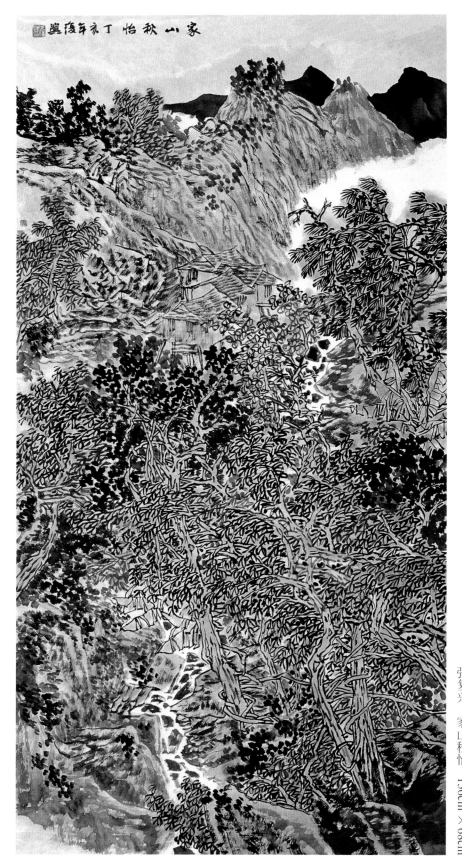

Zhang Fuxing *Mountain home in autumn* 136cm × 68cm
张复兴 家山秋怡 136cm × 68cm

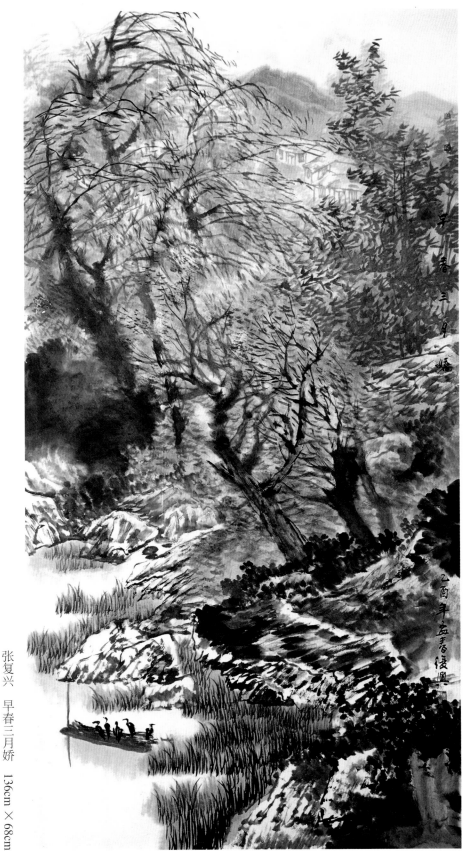

张复兴　早春三月娇　136cm × 68cm
Zhang Fuxing　*Beauty of early spring in March*　136cm × 68cm

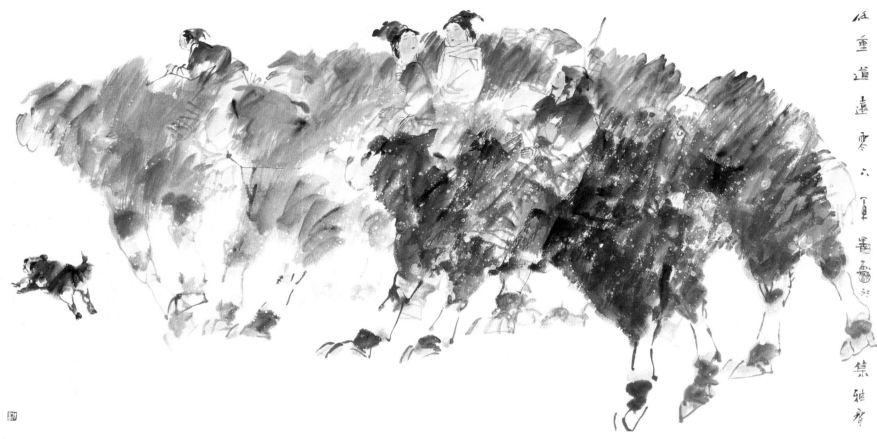

郑军里　任重道远　70cm × 137cm
Zheng Junli　*Still a long way to go*　70cm × 137cm

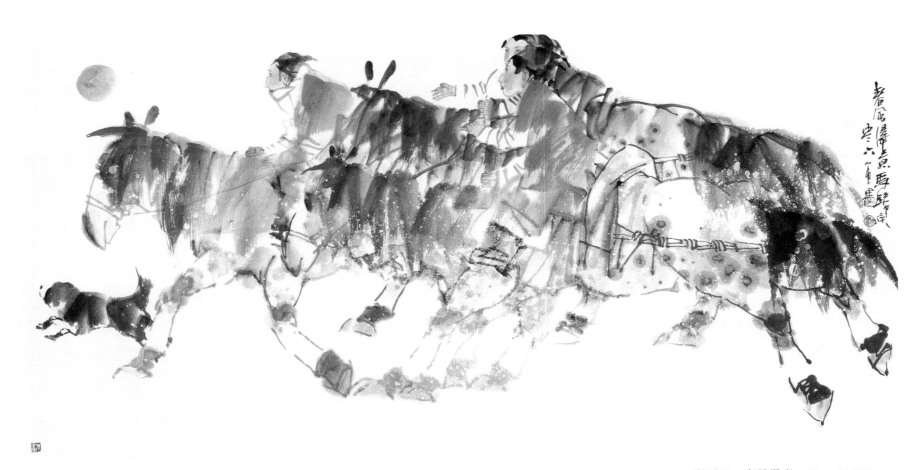

郑军里　春风得意　70cm × 137cm
Zheng Junli　*Beamish*　70cm × 137cm

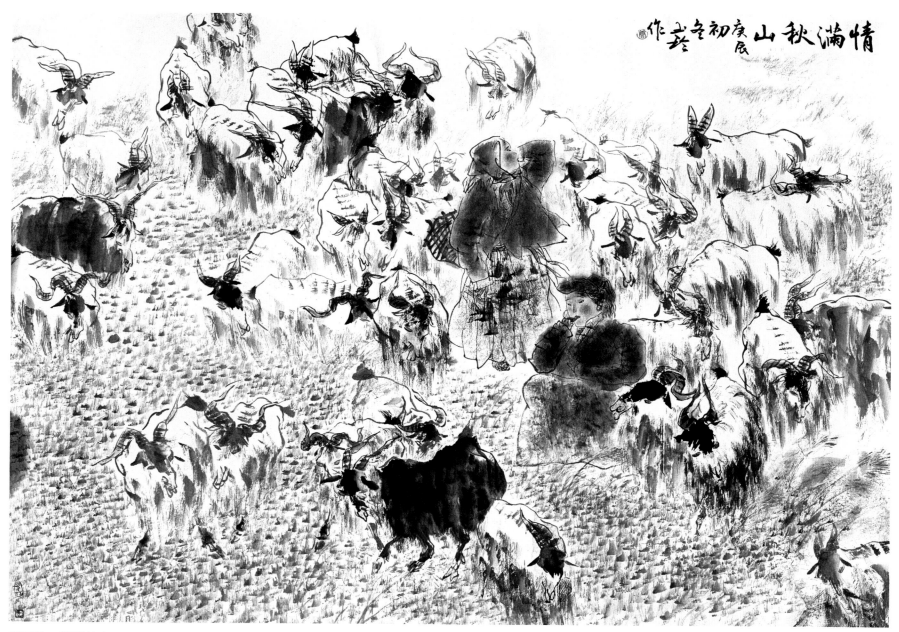

唐玉玲　情满秋山　124cm × 170cm
Tang Yuling　*Sentiment around mountain in autumn*　124cm × 170cm

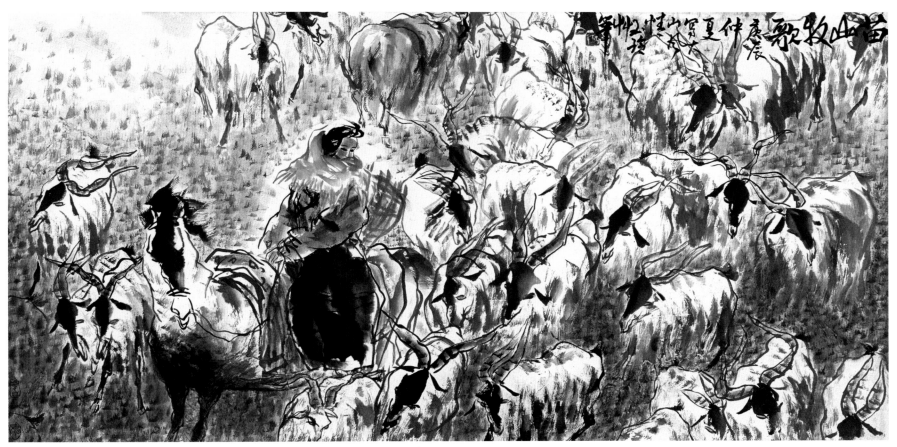

唐玉玲　苗山牧歌　68cm × 136cm
Tang Yuling　*Pastoral song from Mt. Miao*　68cm × 136cm

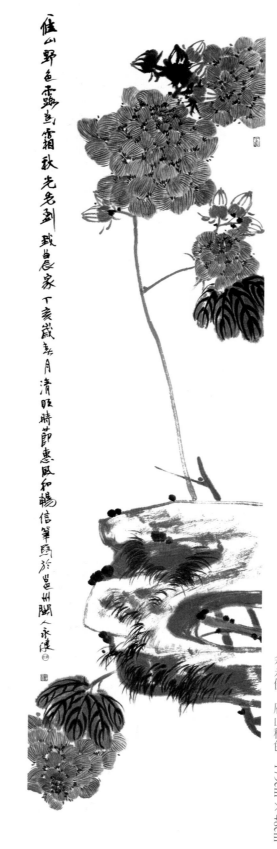

催山野色霜露色霜秋光光色到致曲晨家丁亥岁春月清旺時節惠風和暢信筆寫於瓯州閒人永健

Yu Yongjian *Autumn at Yanshan*

余永健 [雁山秋色] 179cm × 48cm

179cm × 48cm

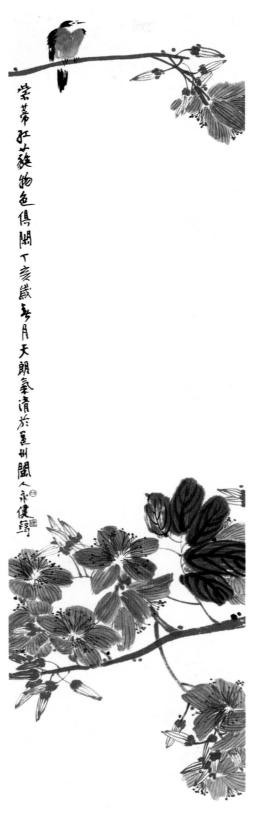

紫蒂紅藐物色俱開 丁亥歲春月天朗氣清於羹州閩人永健鄴

余永健　紫蒂紅藐

Yu Yongjian　*Violet stem and red leaves*

179cm × 48cm
179cm × 48cm

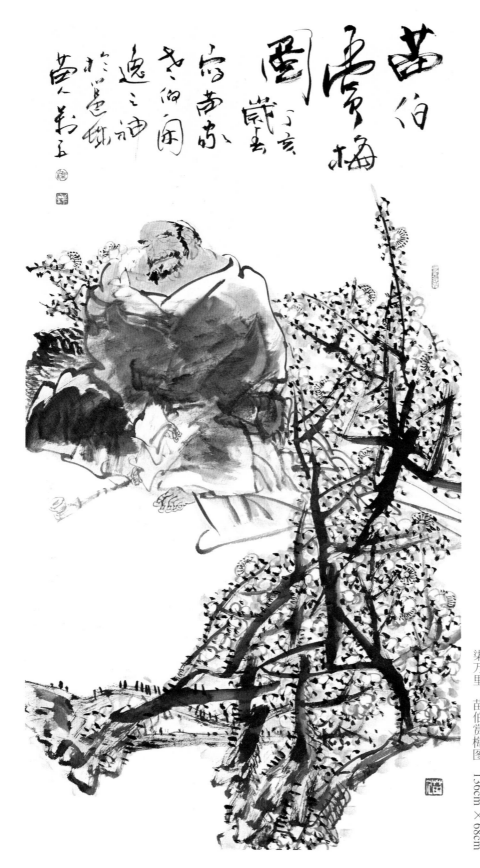

Qi Wanli *Old Miao man appreciating blossom plum flowers* 136cm × 68cm

柒万里 苗伯赏梅图 136cm × 68cm

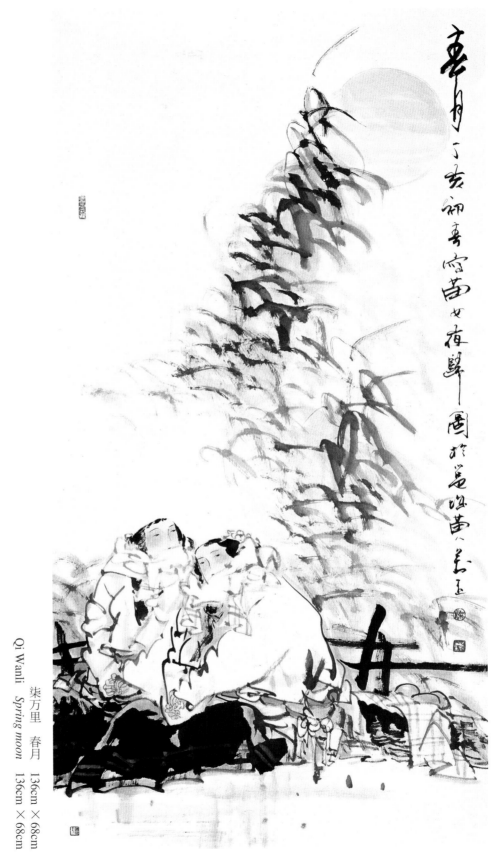

柒万里　春月　136cm×68cm
Qi Wanli　Spring moon　136cm×68cm

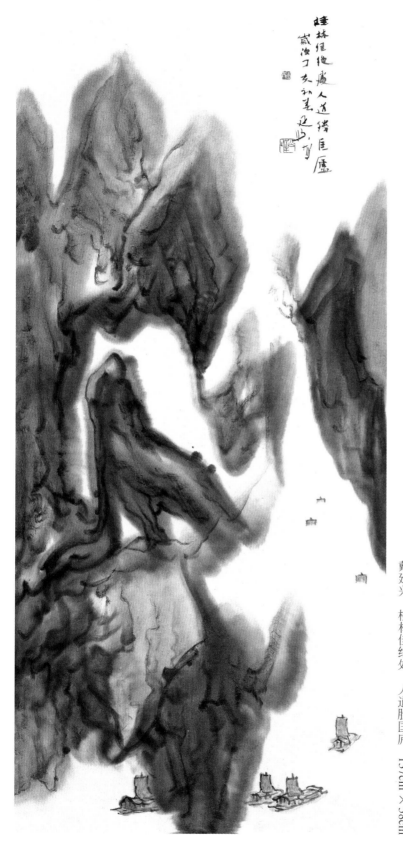

桂林佳绝处，人道胜匡庐
岁次丁亥初春延兴

Dai Yanxing　*Best places of interest of Guilin · Outweigh Lu Mountain*
戴延兴　桂林佳绝处，人道胜匡庐　137cm×58cm
137cm×58cm

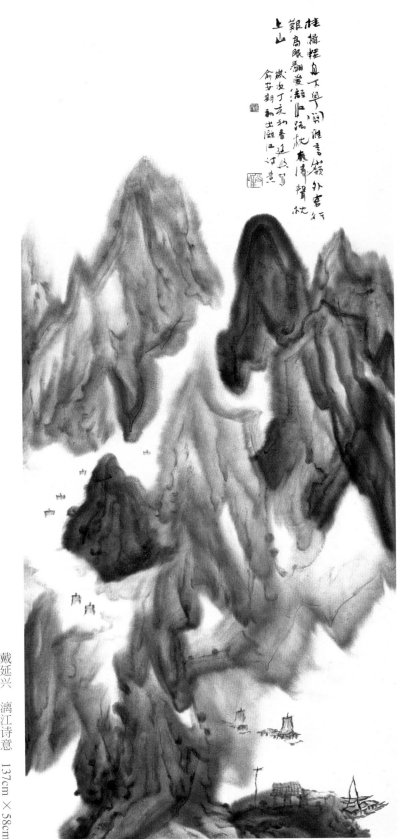

戴延兴　漓江诗意　137cm × 58cm
Dai Yanxing　*Lijiang poetics*　137cm × 58cm

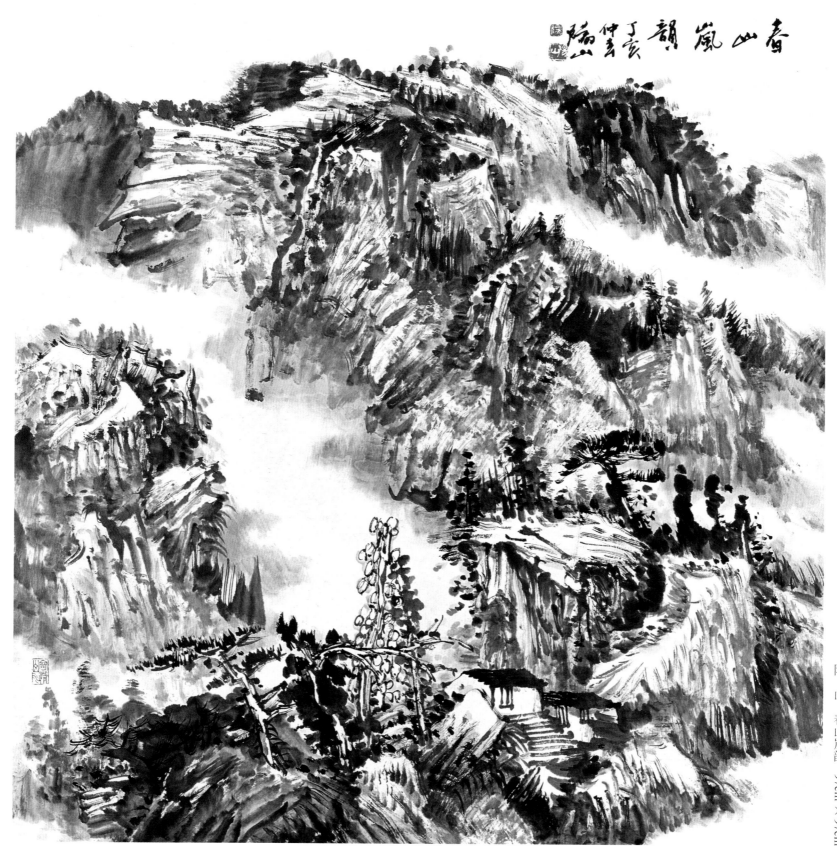

春山嵐韻 丁亥仲夏 陽山

Yang Shan *Haze in spring mountain* 97cm ×97cm

阳 山 春山岚韵 97cm ×97cm

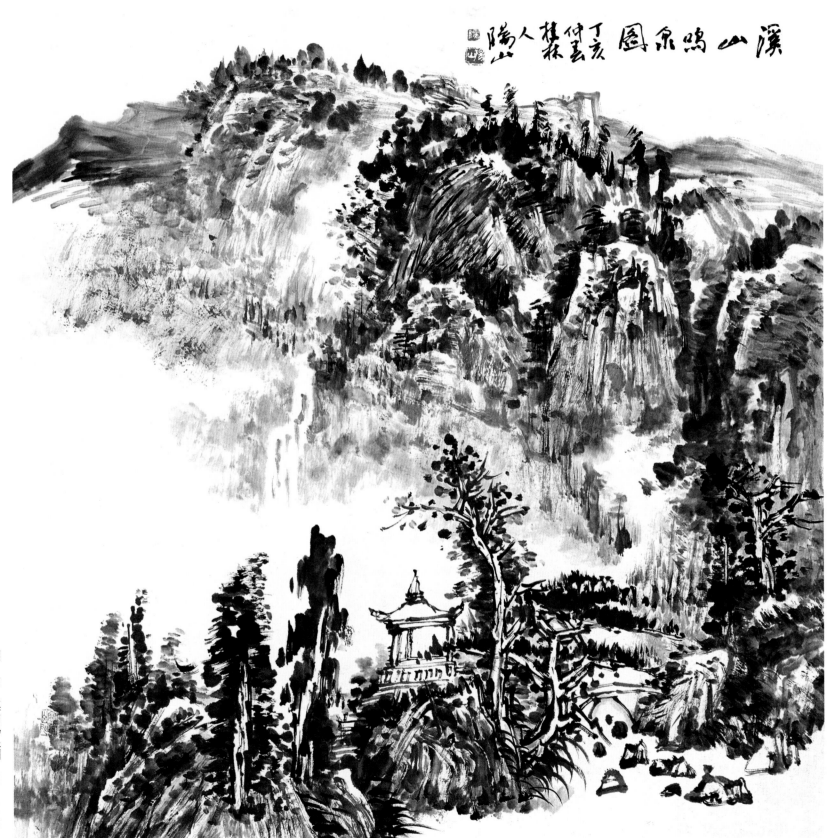

溪山鳴泉圖 丁亥仲夏 雲人樵林 陽山

阳 山　溪山鸣泉图　97cm×97cm
Yang Shan　*Howling spring*　97cm×97cm

二月春風洗花紅　丁亥年三石居小東

Wu Xiaodong　*Red flowers in February vernal breeze*

伍小东　二月春风洗花红　136cm×68cm

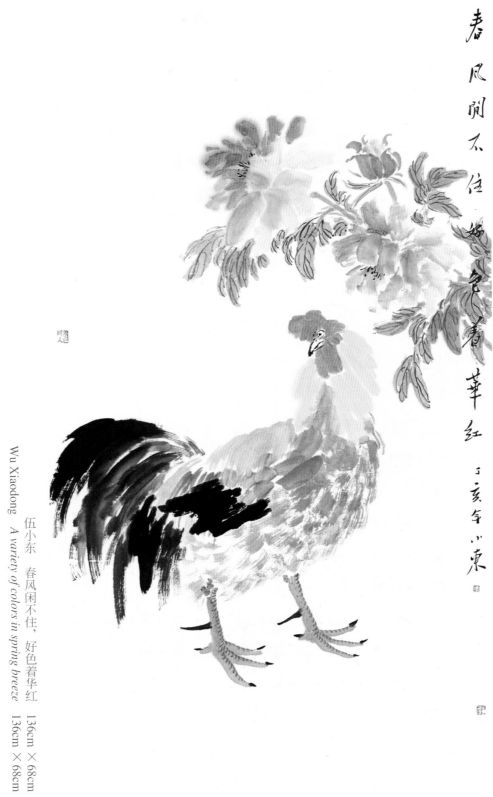

春风闲不住，好色着华红 丁亥年 小东

伍小东　春风闲不住，好色着华红　136cm×68cm
Wu Xiaodong　A variety of colors in spring breeze　136cm×68cm

吹面不寒楊柳風 宣湘畫記

黄宗湖　春风　68cm × 68cm
Huang Zonghu　*Spring breeze*　68cm × 68cm

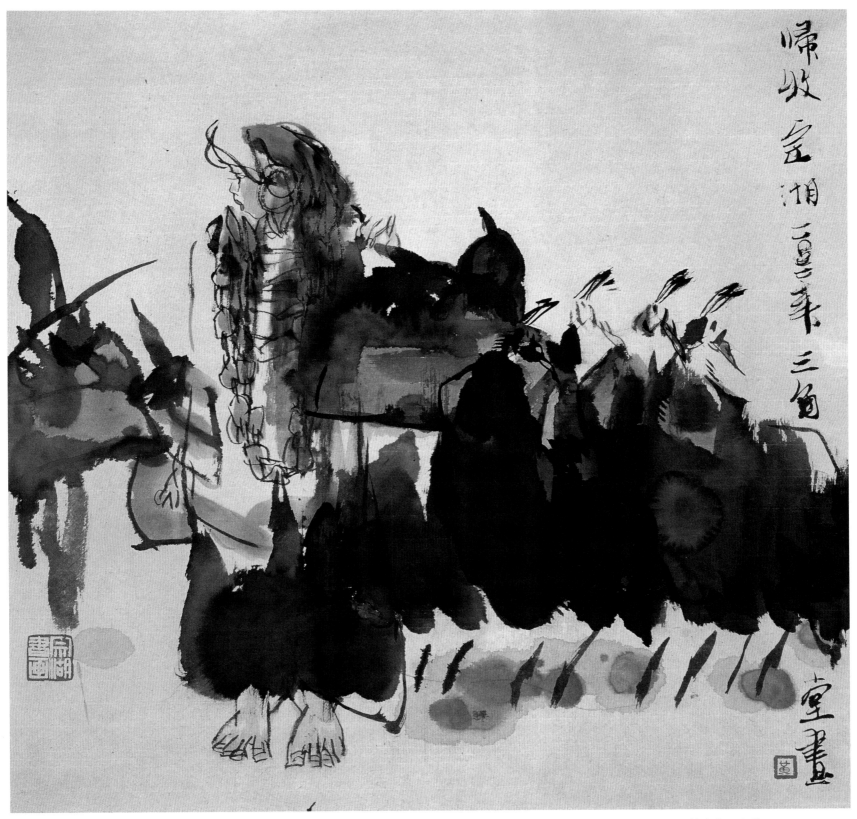

黄宗湖　归牧　68cm × 68cm
Huang Zonghu　*Return from herding*　68cm × 68cm

秋山
隐逸
图

岁在丙
戌年
画并
记阳光

Yang Guang *Mountain in autumn* 140cm × 70cm

阳光 秋山隐逸图 140cm × 70cm

云中飞流翠
間空歲年
闲空歲年
壬冬艺苑
壬冬艺苑
阳光

阳　光　云中飞流翠壑间　140cm × 70cm

Yang Guang　*Water falling down green gullies*　140cm × 70cm

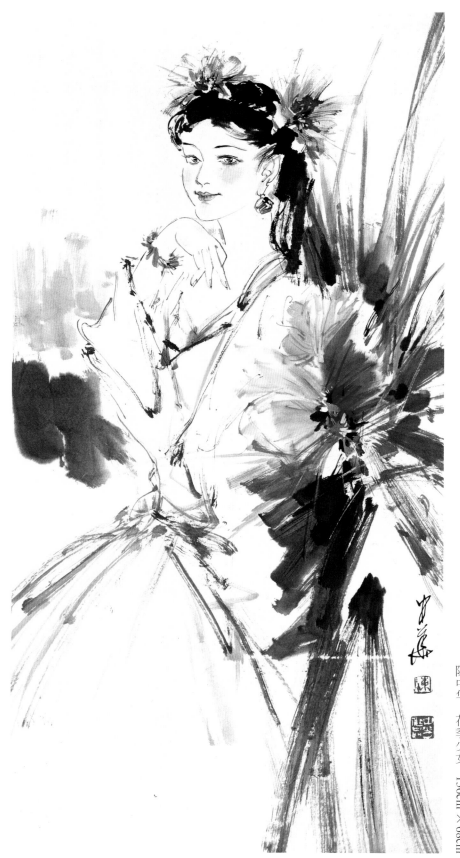

Chen Zhonghua *Beautiful girl* 136cm×68cm
陈中华 花季少女 136cm×68cm

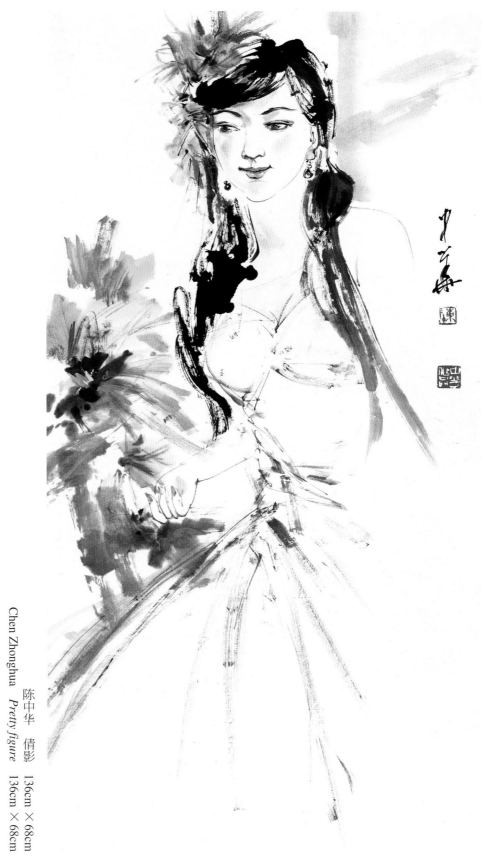

陈中华 倩影 136cm×68cm
Chen Zhonghua *Pretty figure* 136cm×68cm

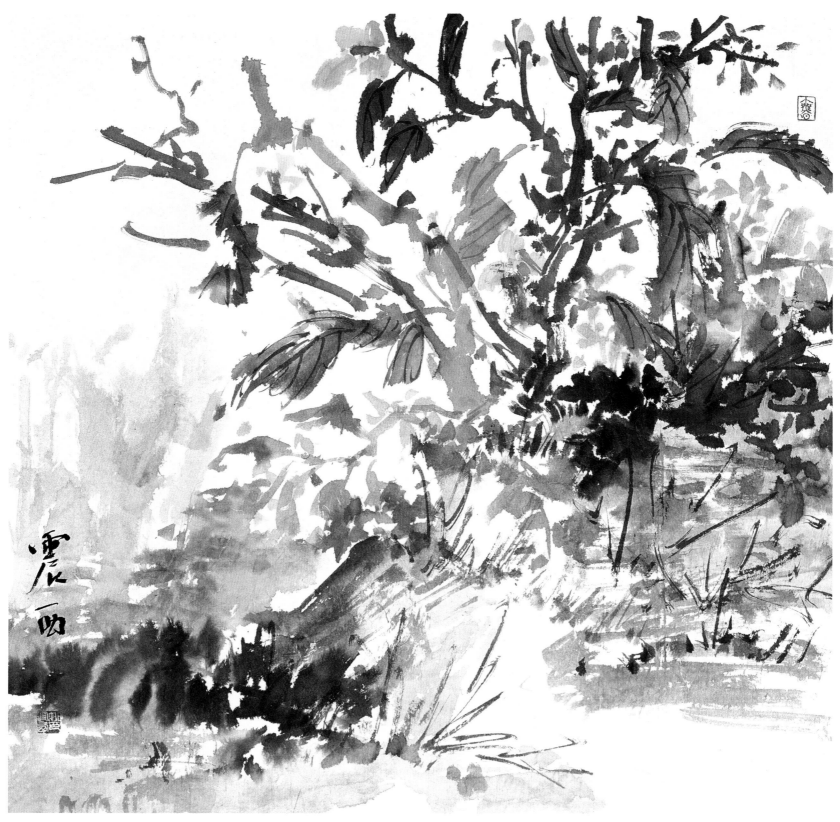

姚震西　陌上花开·之一　70cm × 70cm
Yao Zhenxi　*No.1 of road flowers*　70cm × 70cm

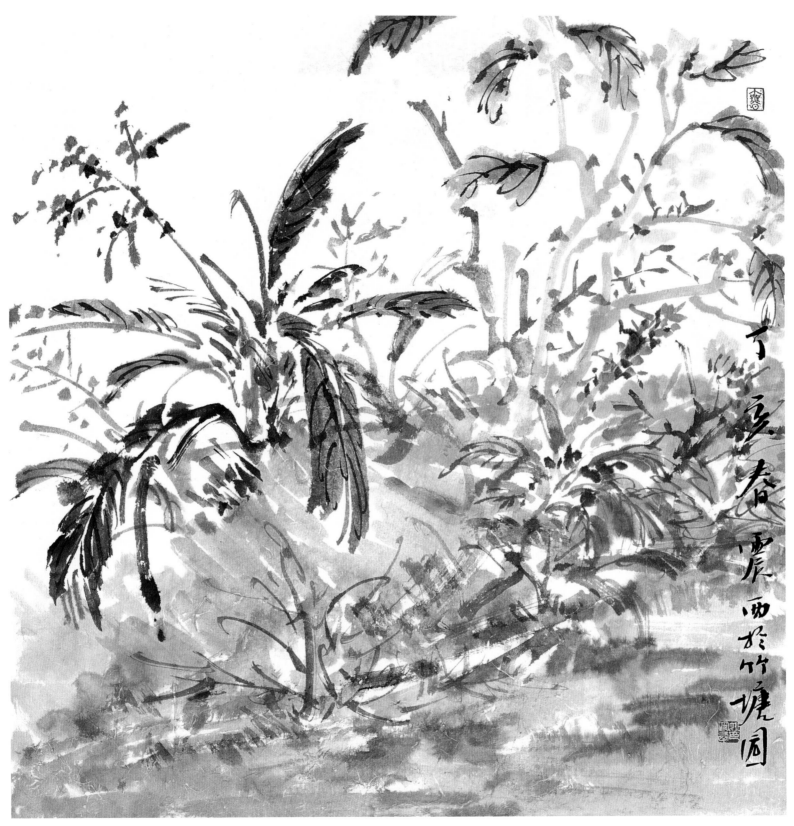

姚震西　陌上花开·之二　70cm × 70cm
Yao Zhenxi　*No.2 of road flowers*　70cm × 70cm

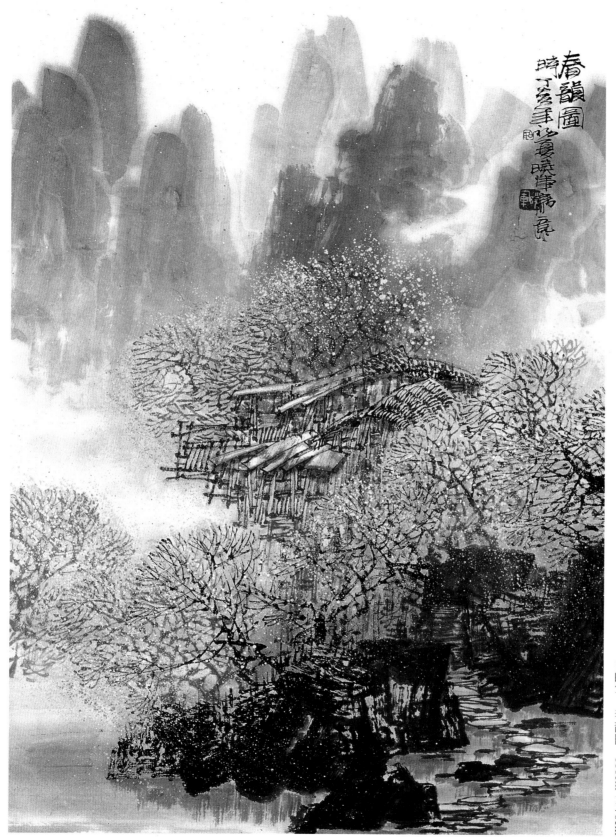

春韵图
时丁亥年仲夏于晓军精卷

Bai Xiaojun *Spring rhythm* 100cm × 70cm
白晓军 春韵图 100cm × 70cm

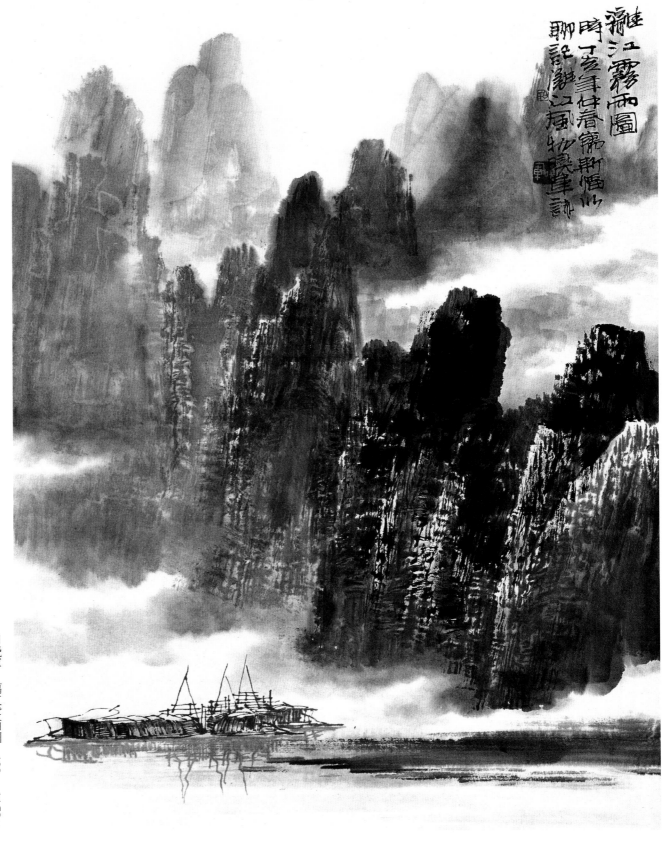

漓江霧雨圖

時丁亥年仲春寫錦斯幅以聊記漓江風物峰詠

白晓军 漓江雾雨图

Bai Xiaojun *Fog and rain over Lijiang River*

100cm × 70cm
100cm × 70cm

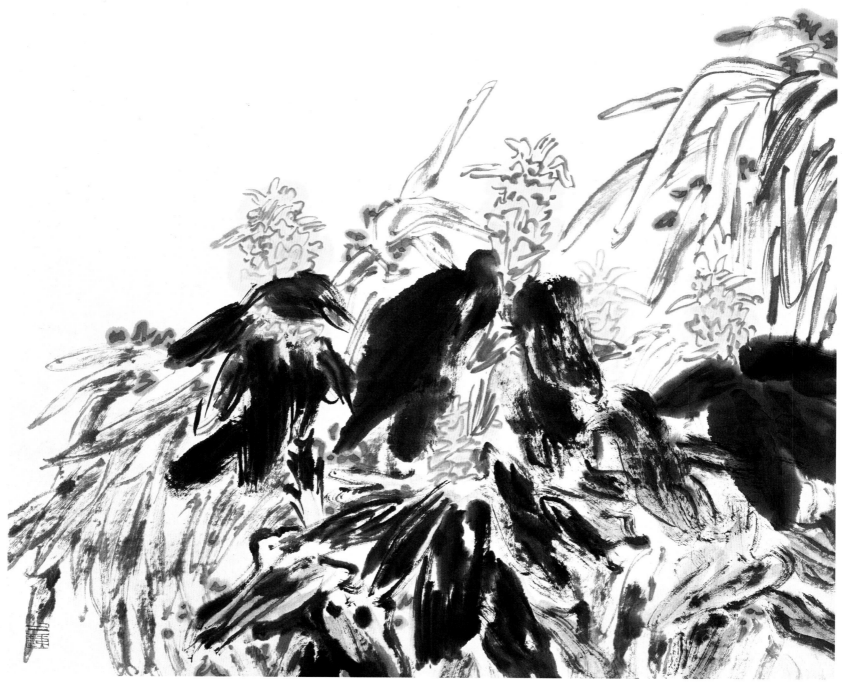

梁　耀　鹅黄引紫浴秋光　68cm × 68cm
Liang Yao　*Golden autumn*　68cm × 68cm

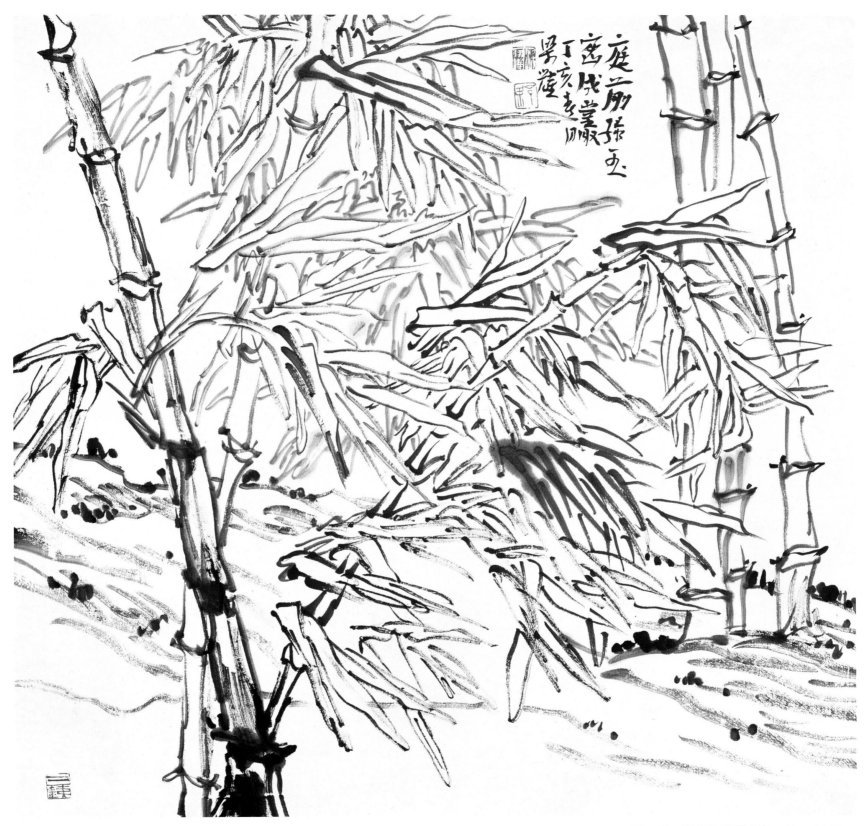

梁　耀　庭前绿玉密成堂　68cm × 68cm
Liang Yao　*Emerald green yard*　68cm × 68cm

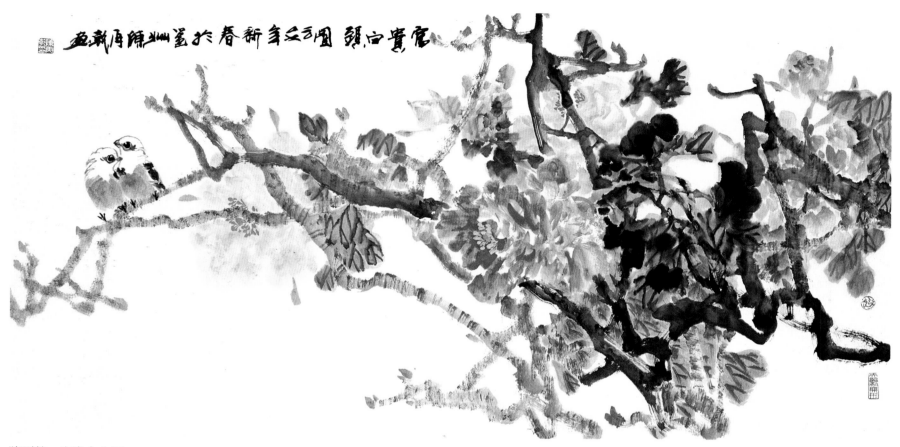

陈再乾　富贵白头图　68cm × 136cm
Chen Zaiqian　*Loving Chinese bulbuls*　68cm × 136cm

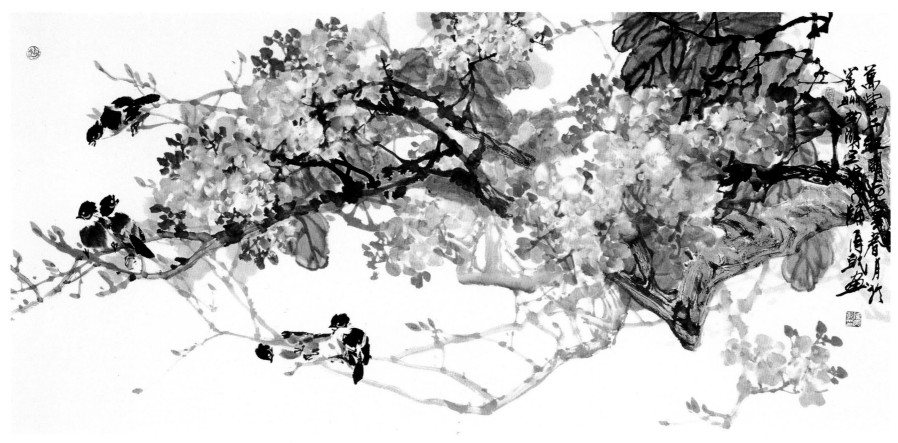

陈再乾　万紫千红图　68cm × 136cm
Chen Zaiqian　*A variety of blooming flowers*　68cm × 136cm

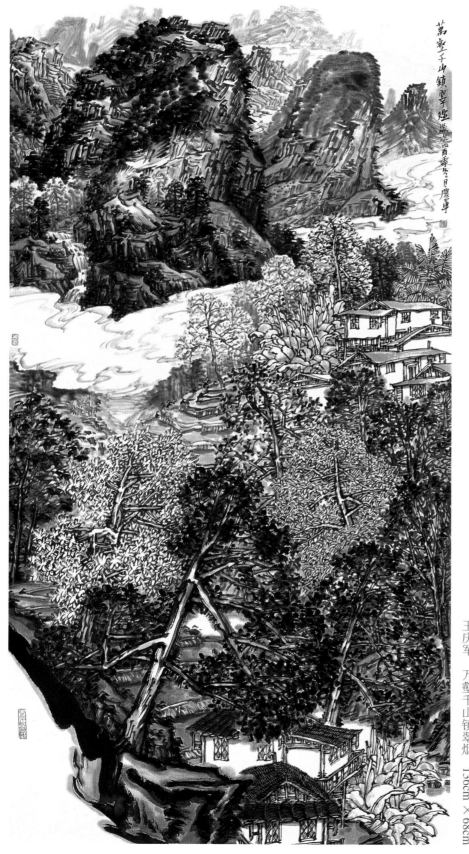

万壑千山镇翠烟，型芊烟茅尾九百亭戌己日庆军

Wang Qingjun *Curling upward smoke* 136cm×68cm
王庆军 万壑千山镇翠烟 136cm×68cm

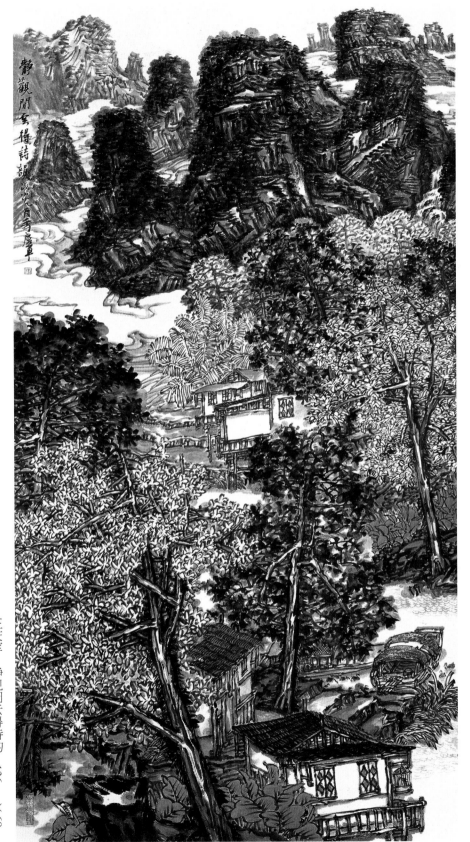

王庆军　静观闲云得诗韵　136cm×68cm

Wang Qingjun　*Poetic inspiration from clouds*　136cm×68cm

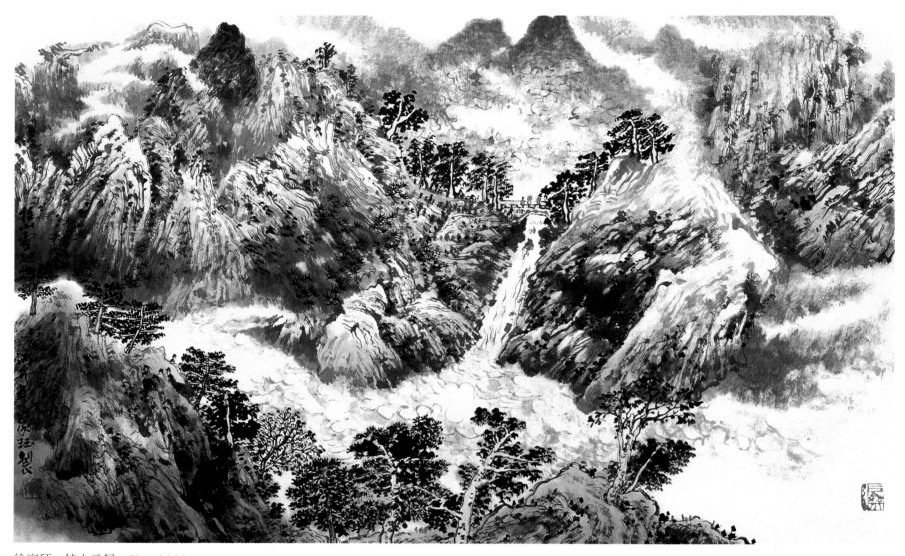

徐家珏　桂山云起　53cm × 85cm
Xu Jiajue　*Cloudy Guishan Mountain*　53cm × 85cm

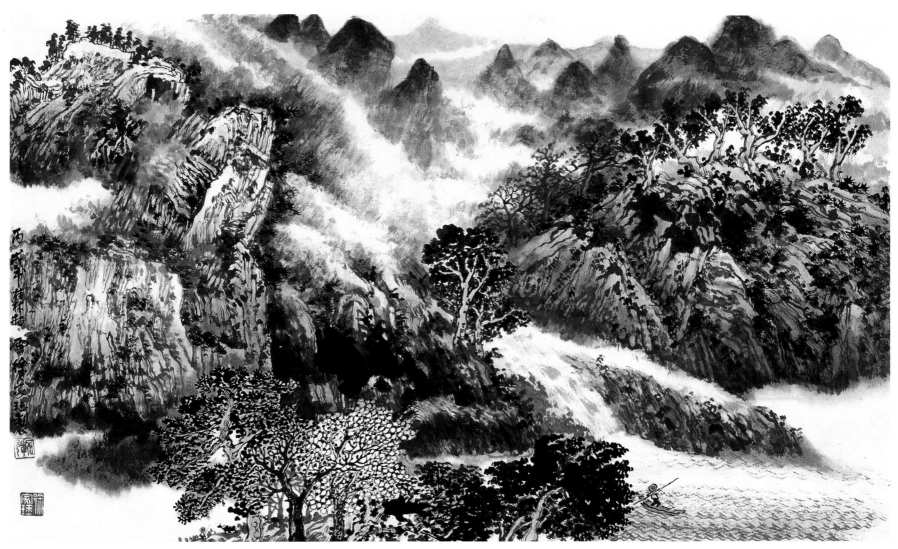

徐家珏　桂山烟峦　53cm × 85cm
Xu Jiajue　*Foggy Guishan Mountain*　53cm × 85cm

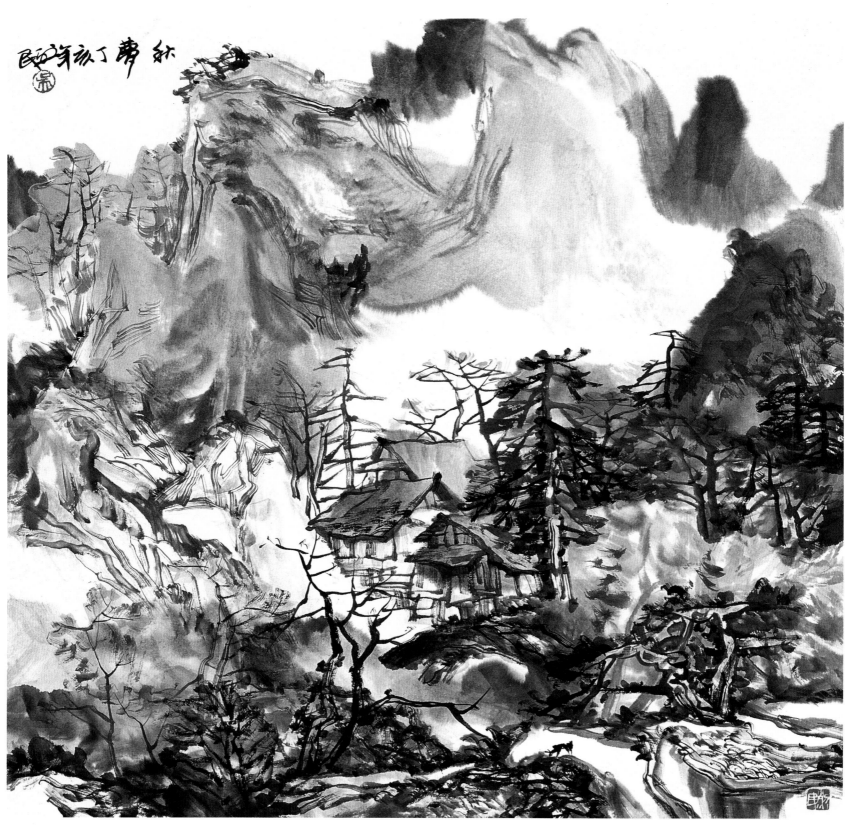

吴烈民　秋梦　67cm × 68cm
Wu Liemin　*Autumn dream*　67cm × 68cm

46

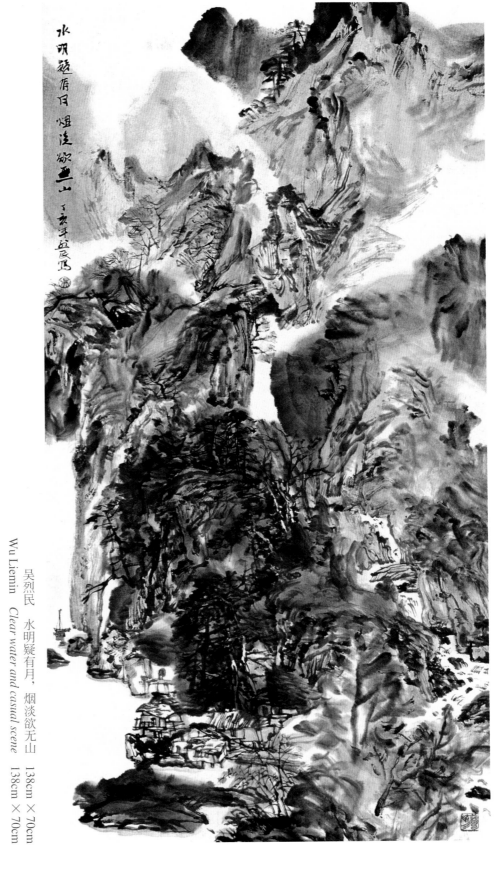

水明疑有月，烟淡欲无山

吴烈民　水明疑有月，烟淡欲无山　138cm×70cm
Wu Liemin　*Clear water and casual scene*　138cm×70cm

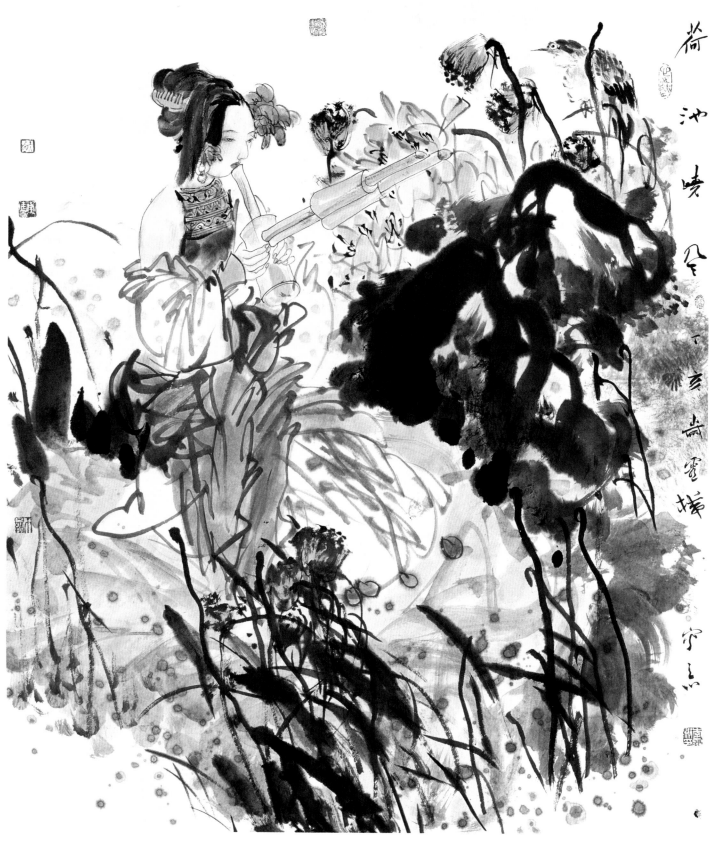

荷池晓风

Li Lingji *Breezing lotus pool*
李灵机 荷池晓风
100cm × 81cm
100cm × 81cm

一路春风 丁亥岁冬雪堂写生

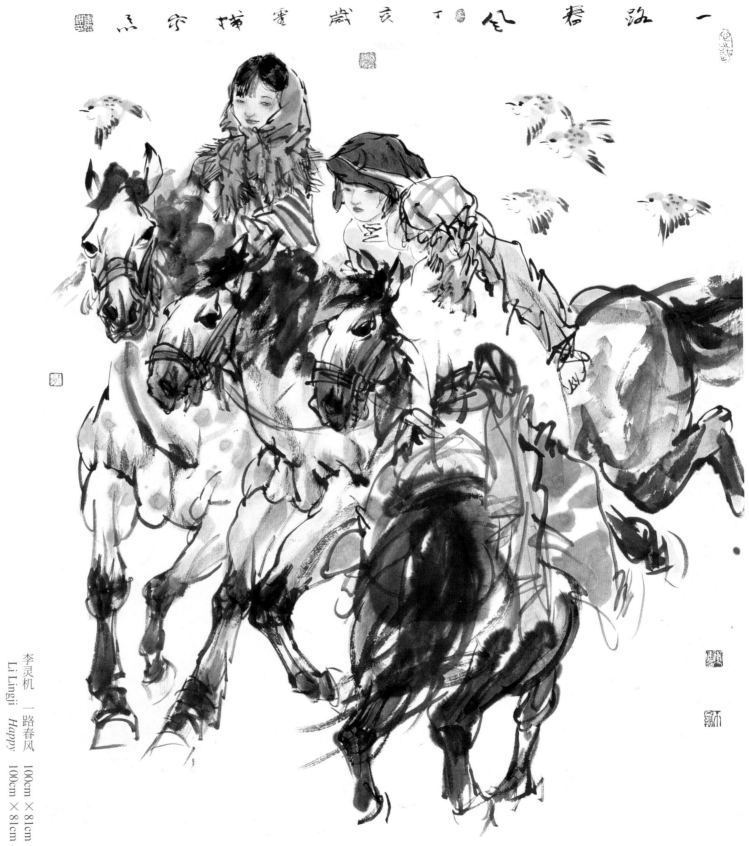

李灵机　一路春风
Li Lingji　*Happy*

100cm×81cm
100cm×81cm

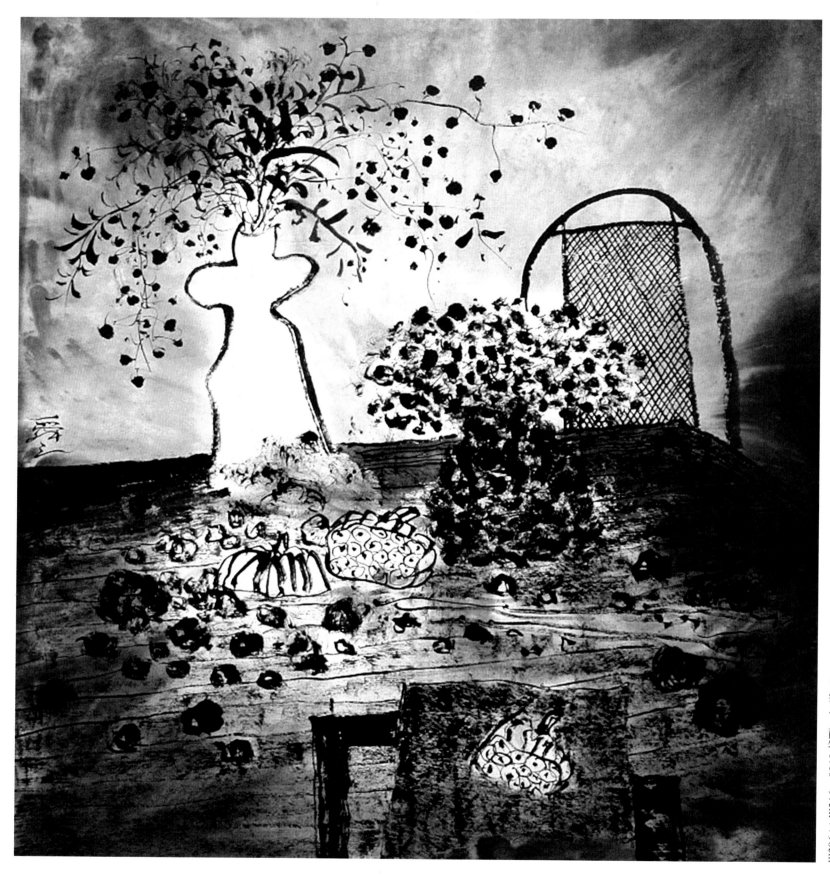

Xiao Shunzhi *Still-life 0710* 97cm × 90cm
肖舜之 静物0710 97cm × 90cm

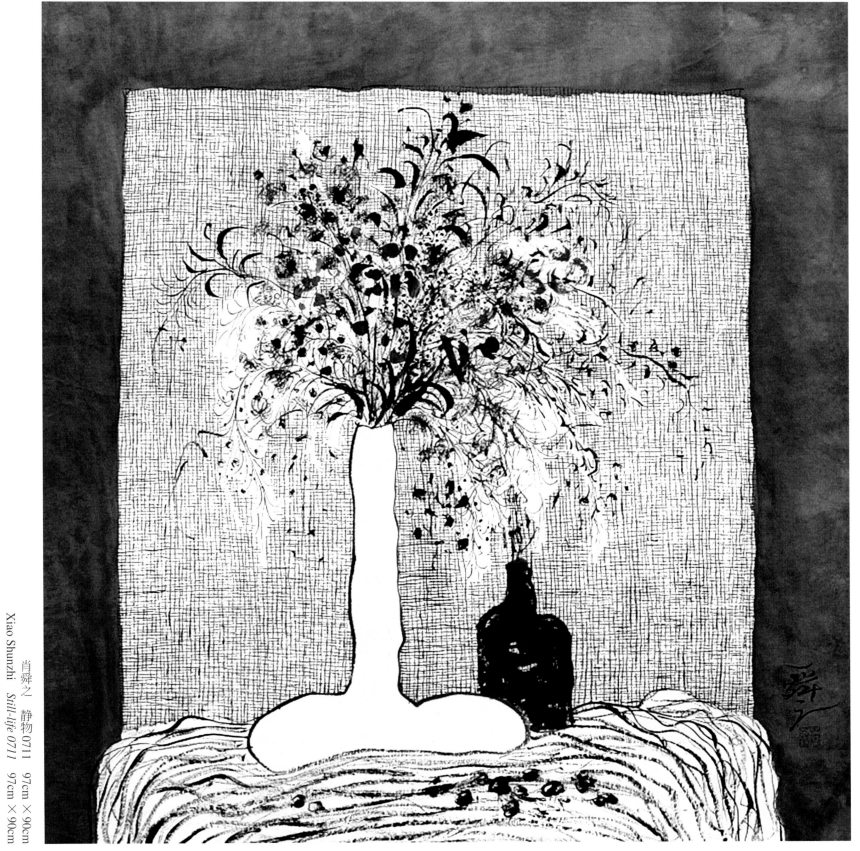

肖舜之　静物 0711　97cm × 90cm
Xiao Shunzhi　*Still-life 0711*　97cm × 90cm

51

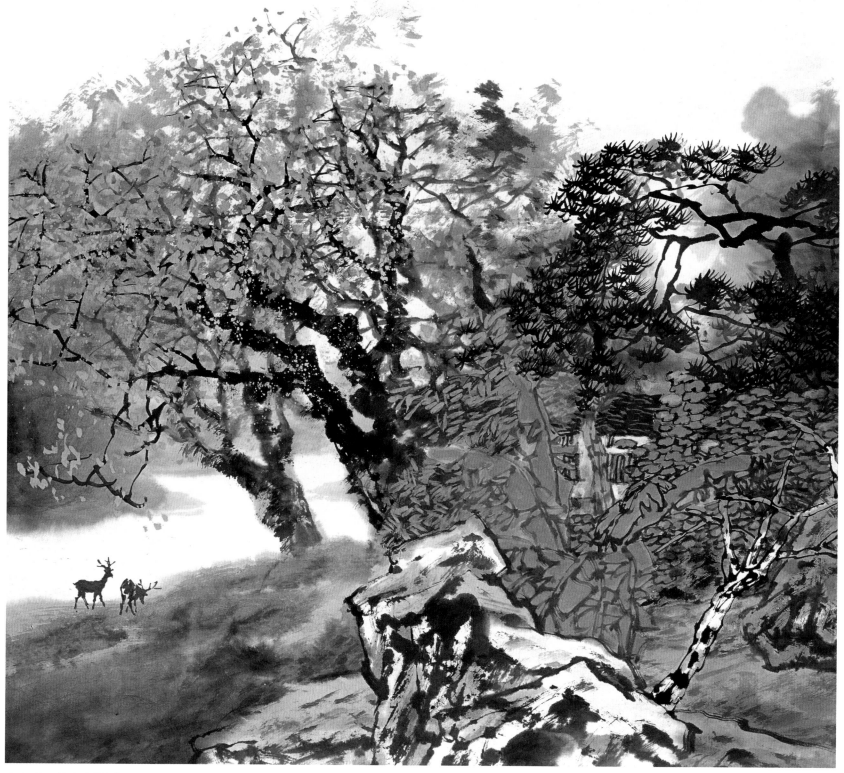

林空鹿饮溪 乙酉暑月报于山人豪家写于昌平林画苑

韦广寿　林空鹿饮溪　68cm × 68cm
Wei Guangshou　*Deer drinking water in forest*　68cm × 68cm

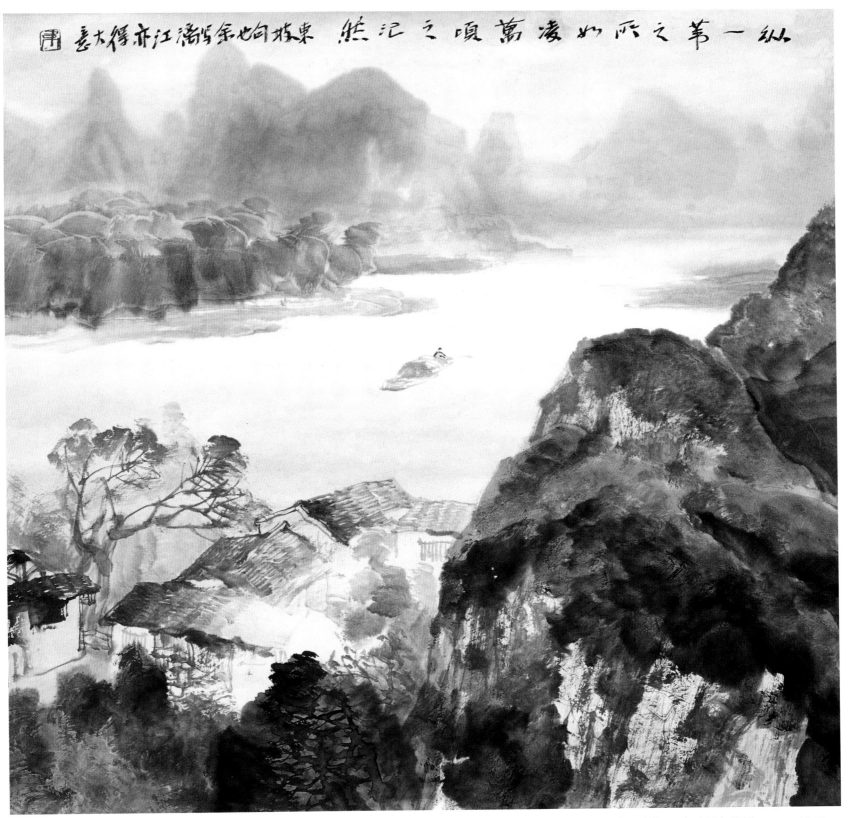

纵一苇之所如，凌万顷之茫然 东坡赤壁赋句 向壁鸣金漏写江亭得大意

韦广寿　纵一苇之所如，凌万顷之茫然　68cm × 68cm
Wei Guangshou　*Let the mind flow*　68cm × 68cm

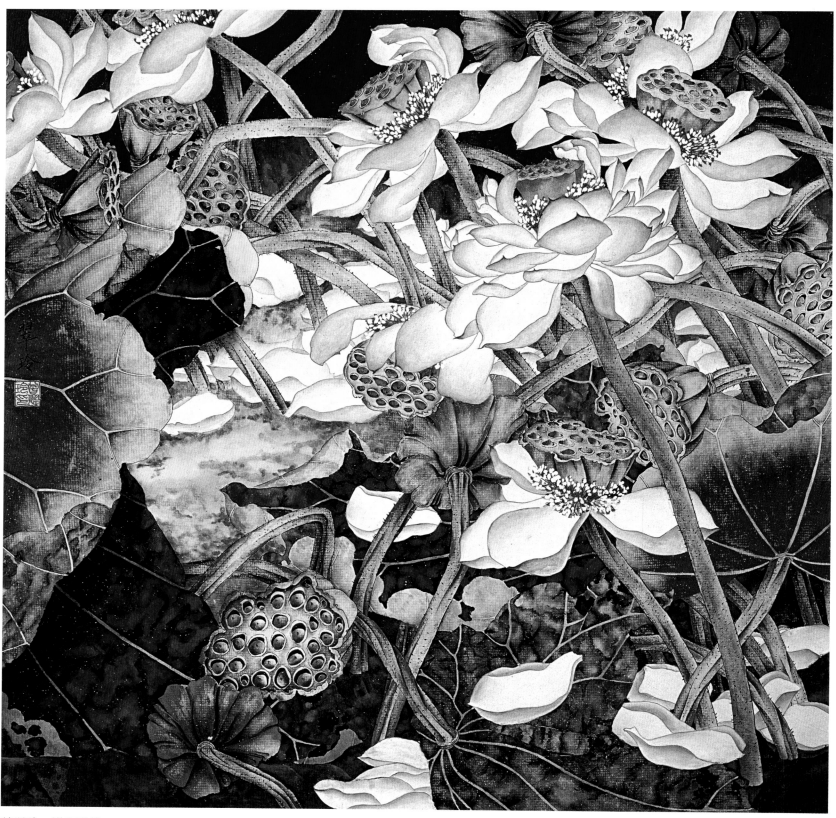

曾翠玲　祥和世界　68cm × 68cm
Zeng Cuiling　*Serene world*　68cm × 68cm

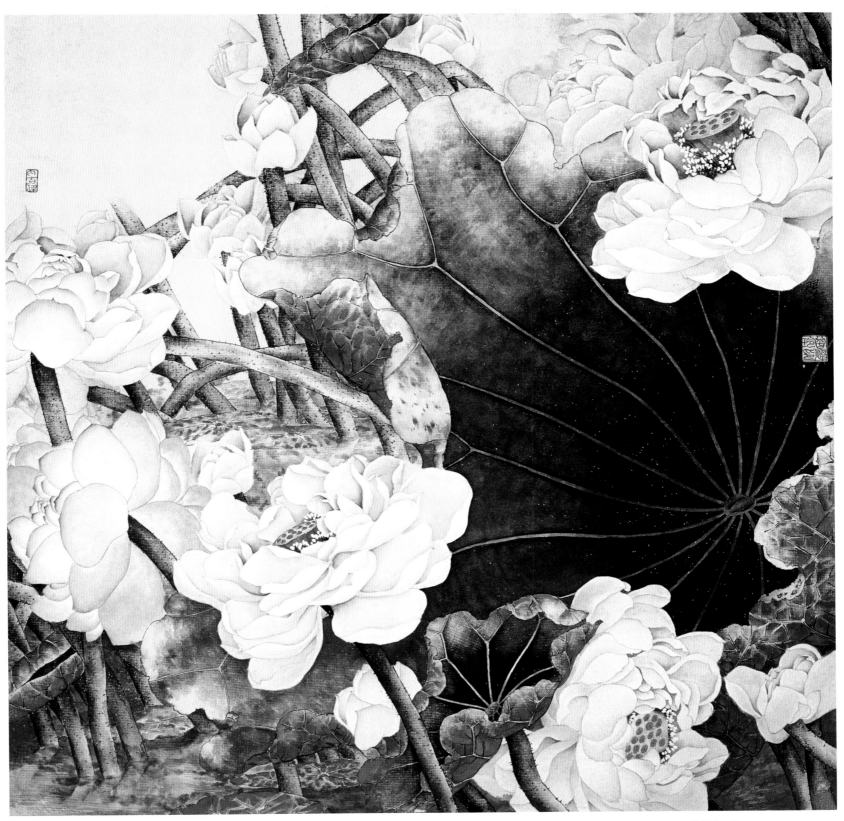

曾翠玲　清秋絮语　68cm × 68cm
Zeng Cuiling　*Incessant chatter in autumn*　68cm × 68cm

牛嶺

八月 熊丁寫於蘭四園之景如寫清州村秋紅丁亥

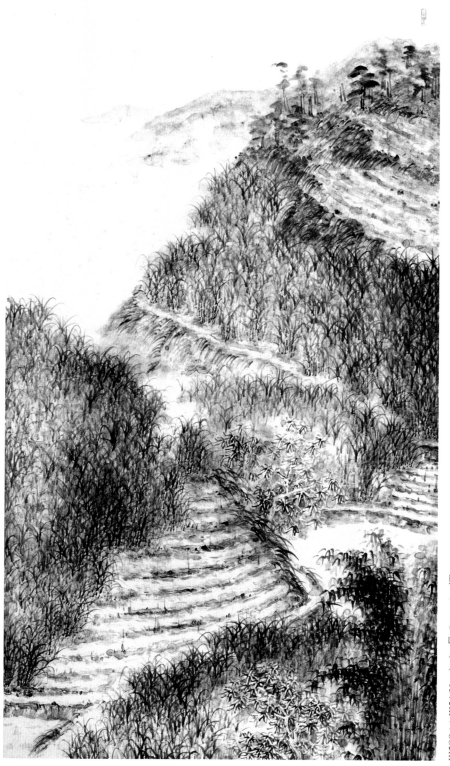

Xiong Ding *Niuling Hill in August* 137cm × 68cm

熊　丁　牛岭八月　137cm × 68cm

南坡蔗歌 記桂南田園之景 丁亥清明熊丁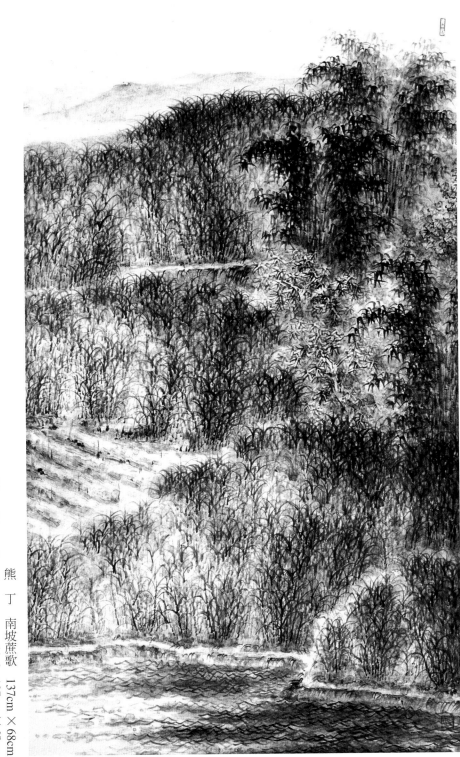

熊　丁　南坡蔗歌　137cm × 68cm

Xiong Ding　*Song in sugarcane filed*　137cm × 68cm

57

油 画 Oil Paintings

刘绍昆　灵湖　60cm × 120cm
Liu Shaokun　*Ling Lake*　60cm × 120cm

刘绍昆　春天抚摸大地　65cm × 160cm
Liu Shaokun　*Land in spring*　65cm × 160cm

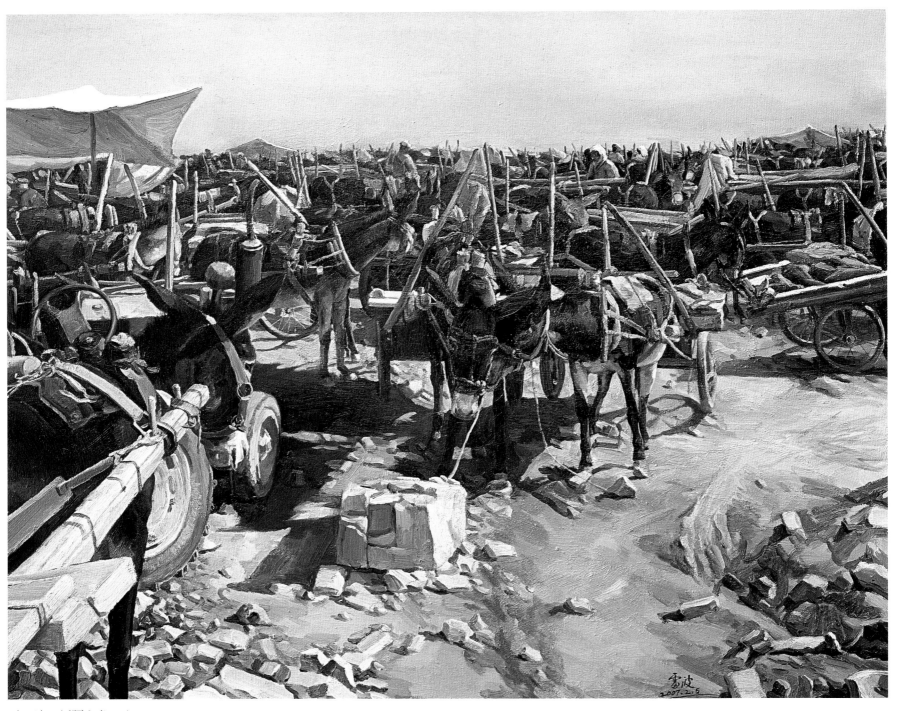

雷　波　新疆印象·之一　65cm × 80cm
Lei Bo　*No.1 of Xinjiang impression*　65cm × 80cm

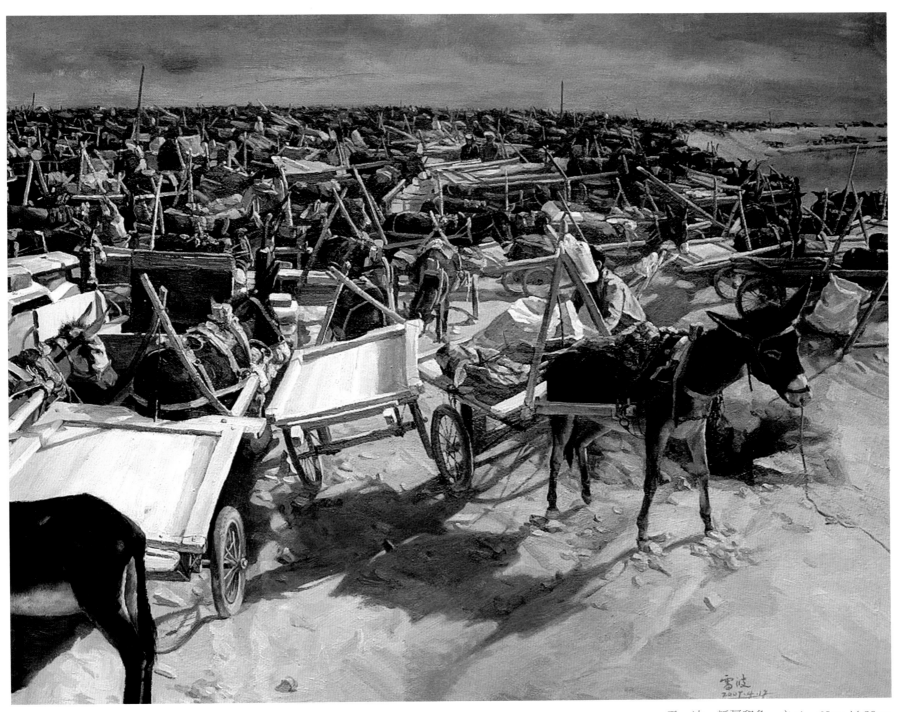

雷　波　新疆印象·之二　65cm × 80cm
Lei Bo　*No.2 of Xinjiang impression*　65cm × 80cm

谢 麟 云山·之一 90cm × 100cm
Xie Lin *No.1 of cloudy mountain* 90cm × 100cm

谢　麟　渔港晨雾　80cm × 85cm
Xie Lin　*Foggy port in the morning*　80cm × 85cm

65

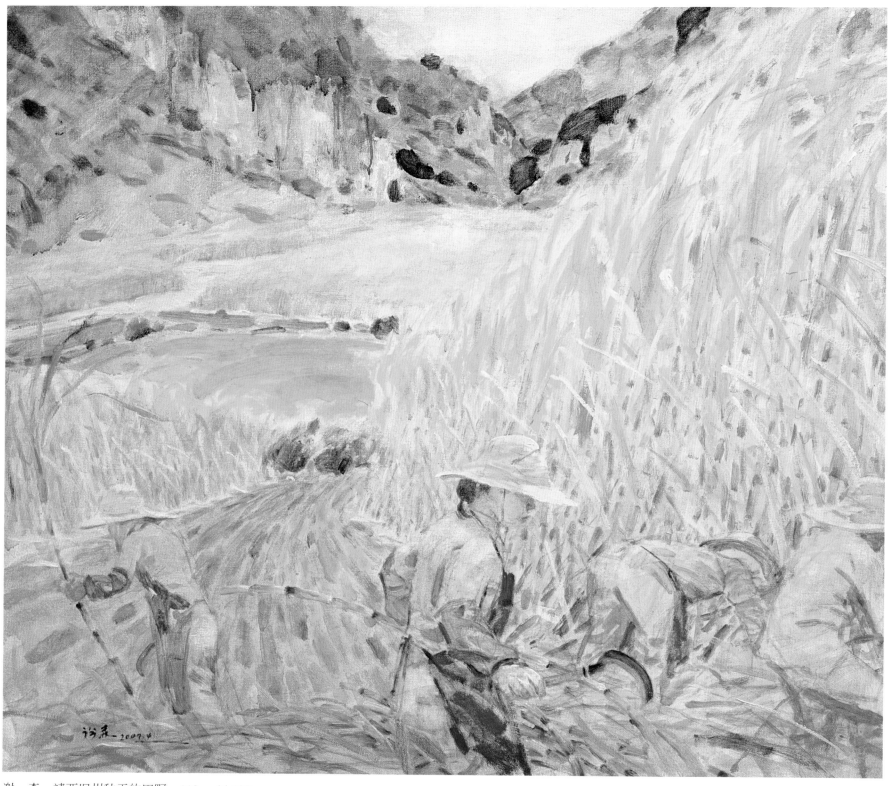

谢　森　靖西旧州秋天的田野　　110cm × 120cm
Xie Sen　*Field in autumn Jiuzhou, Jingxi*　　110cm × 120cm

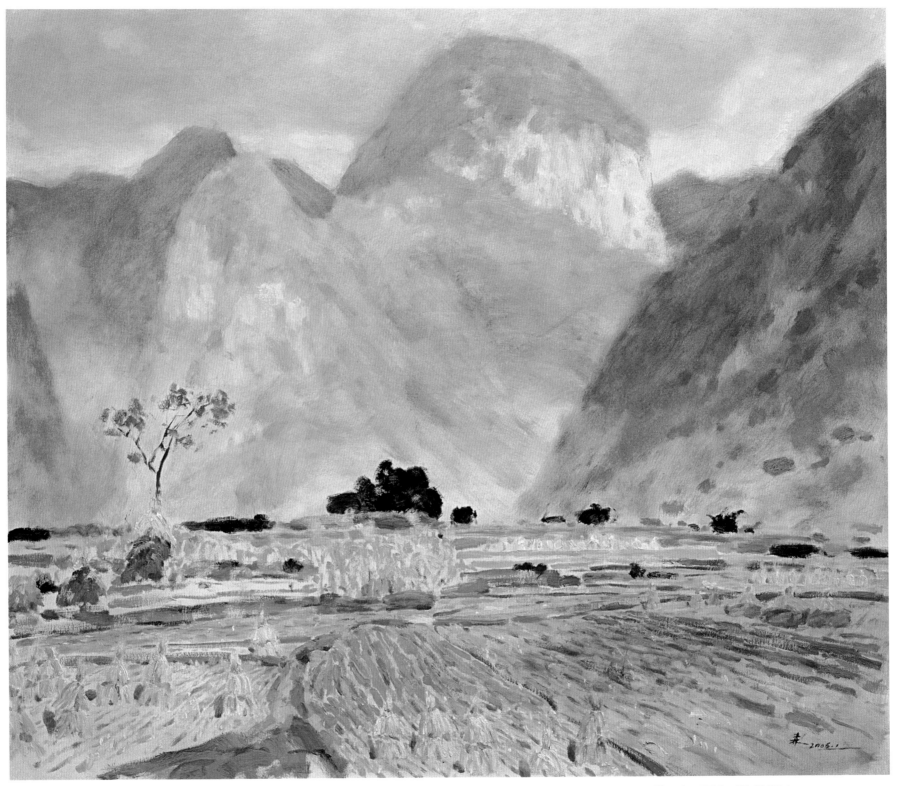

谢　森　阳光下的甘蔗田　110cm × 120cm
Xie Sen　*Sugarcane field in the sun*　110cm × 120cm

黄　菁　群峰秀　100cm × 100cm
Huang Jing　*Beautiful mountains*　100cm × 100cm

黄　菁　荷开时节　100cm × 100cm
Huang Jing　*Blossoming lotus*　100cm × 100cm

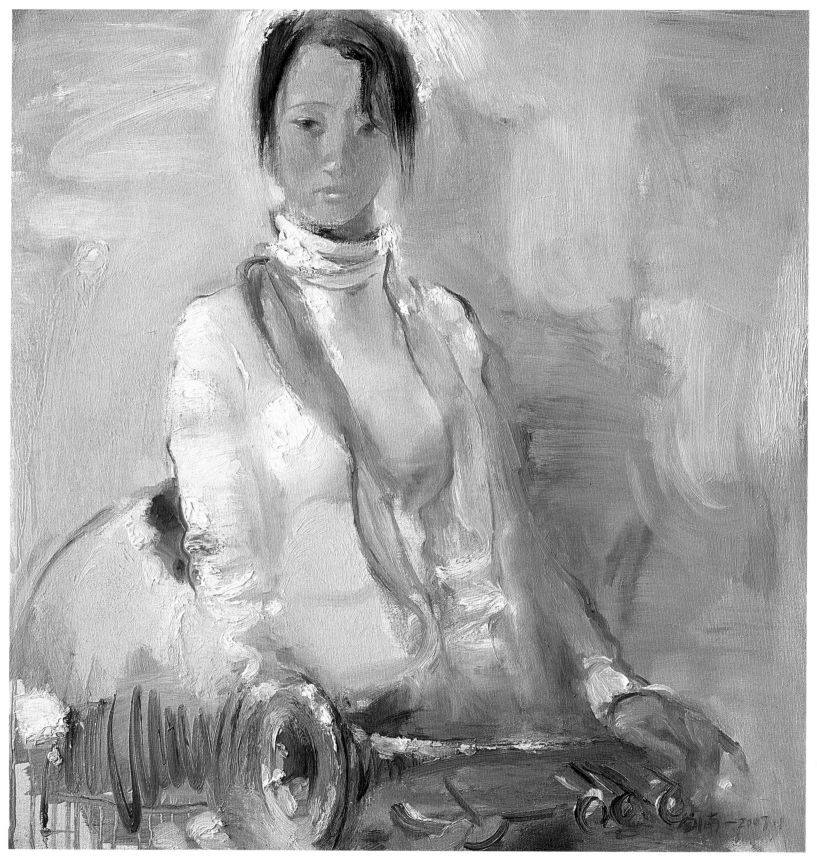

Liu Nanyi *Trumpeter* 65cm × 60cm
刘南一 号手 65cm × 60cm

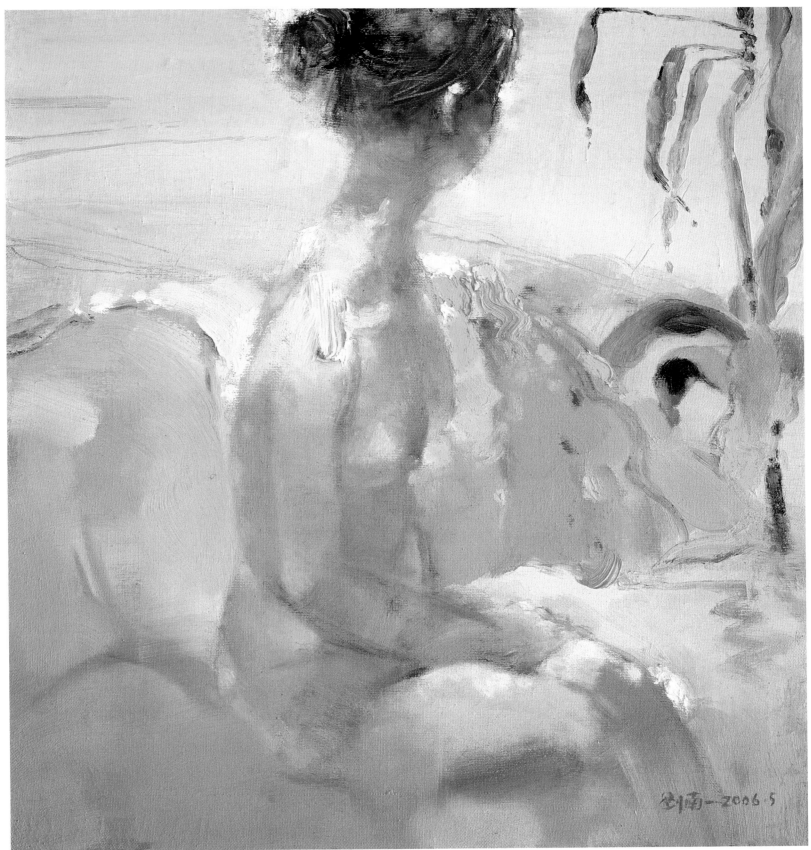

刘南一　课堂习作　65cm × 60cm
Liu Nanyi　*A study in the class*　65cm × 60cm

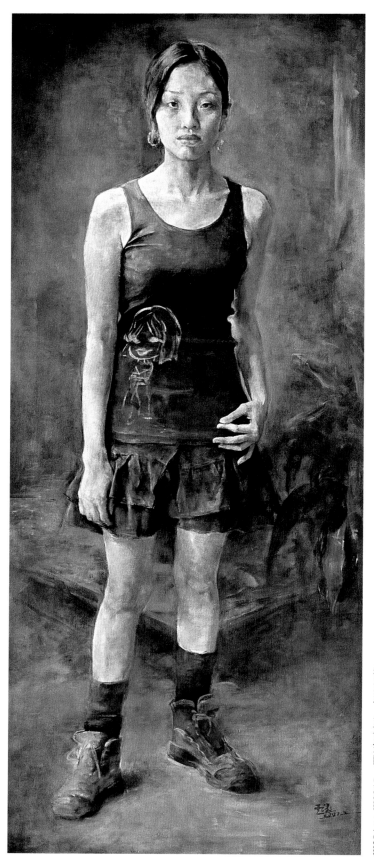

Xu Guizhong　*Gray space*　170cm × 70cm
徐贵忠　灰色空间　170cm × 70cm

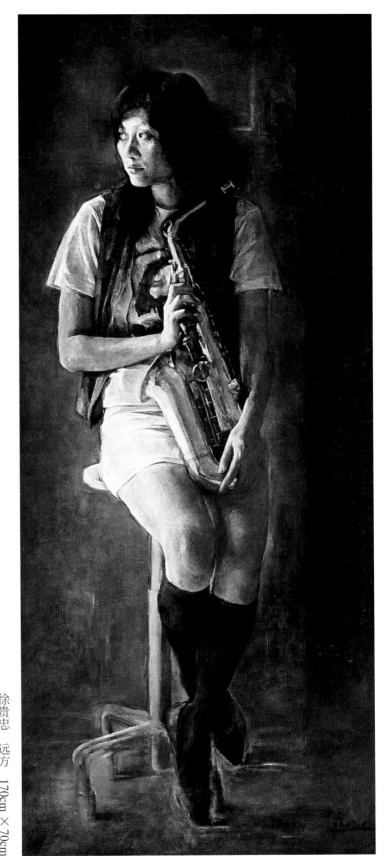

徐贵忠 远方 170cm × 70cm

Xu Guizhong *Distance* 170cm × 70cm

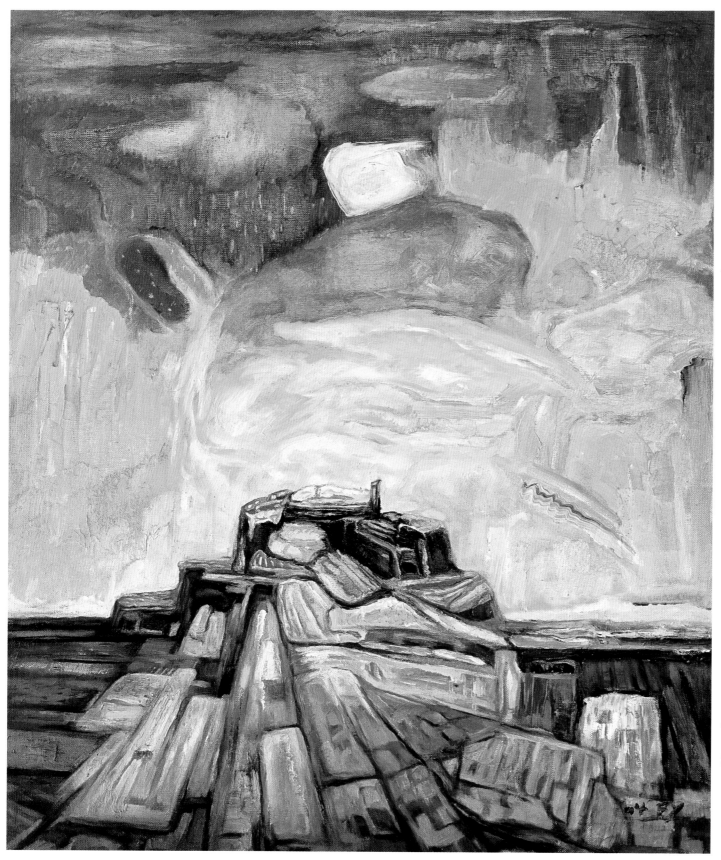

Li Fuyan　*No.1 of erosion*　80cm × 65cm

李福岩　蚀·之一　80cm × 65cm

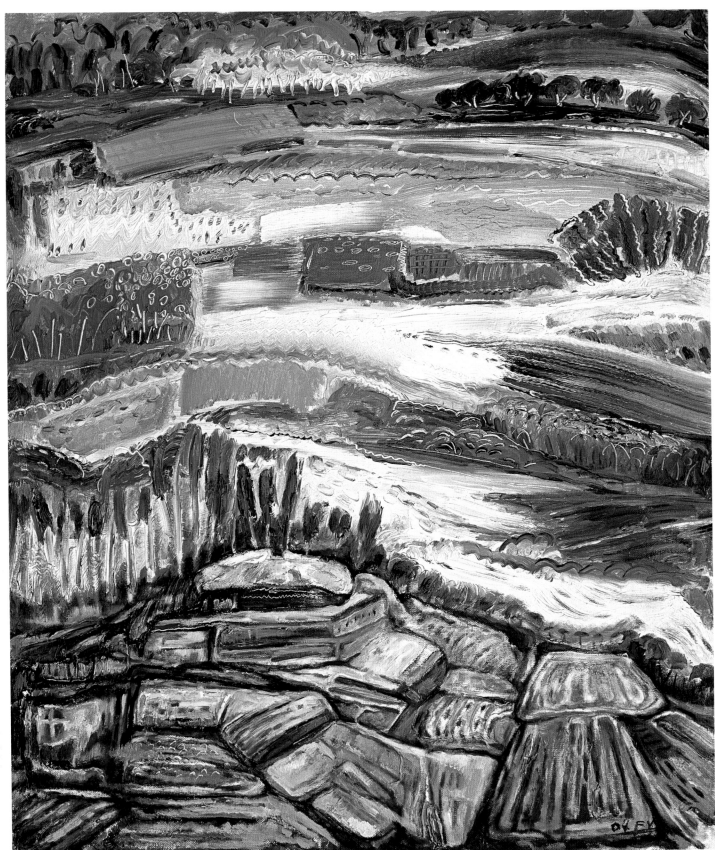

李福岩　异地风景　80cm×65cm
Li Fuyan　*Exotic landscape*　80cm×65cm

75

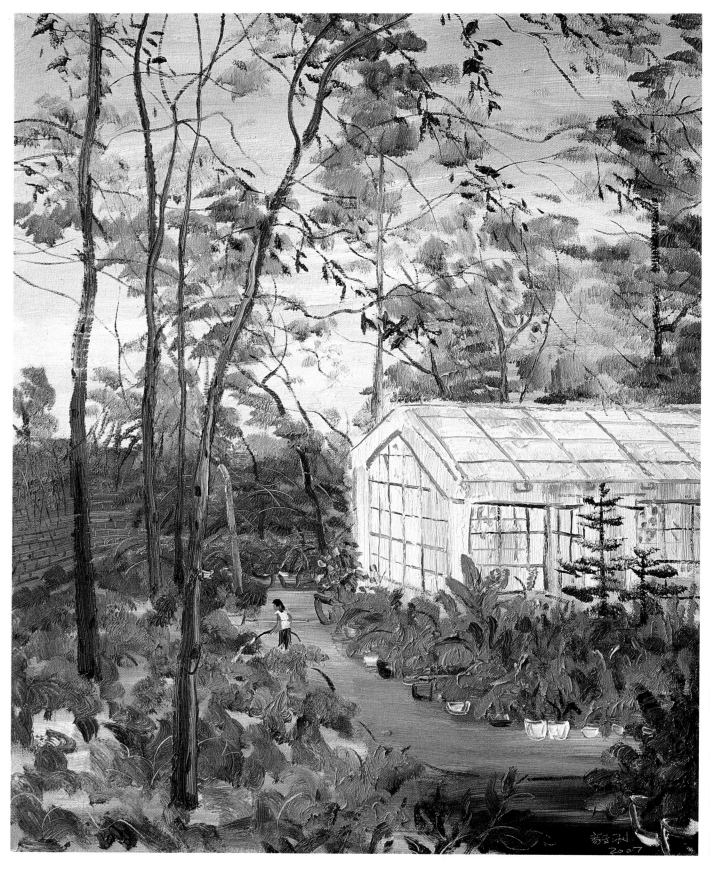

Chen Yigang *Cool breeze in summer* 91cm×72cm
陈毅刚 夏日清风 91cm×72cm

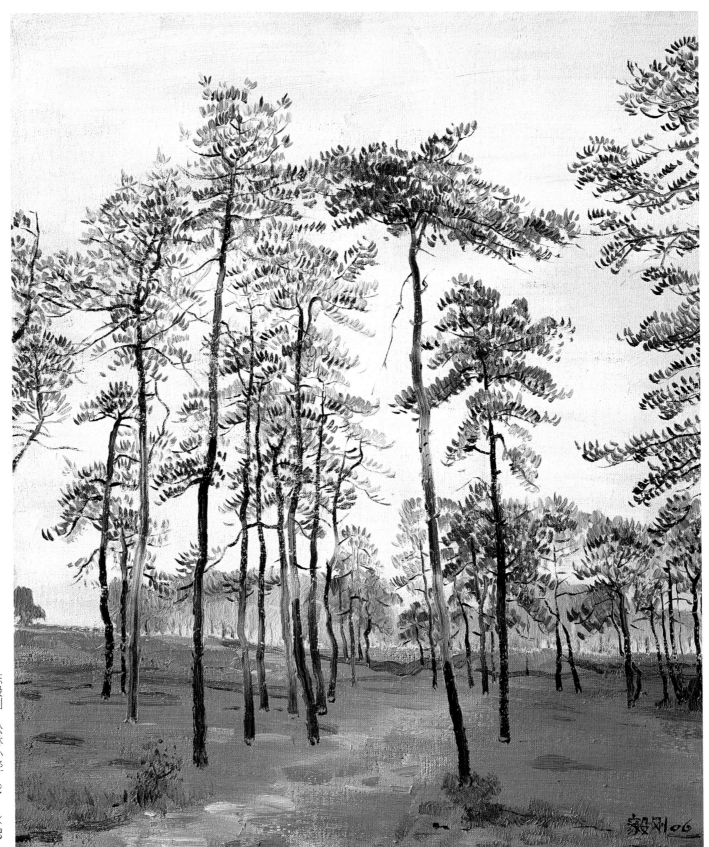

陈毅刚　松林小径　91cm×72cm
Chen Yigang　*Path in pine forest*　91cm×72cm

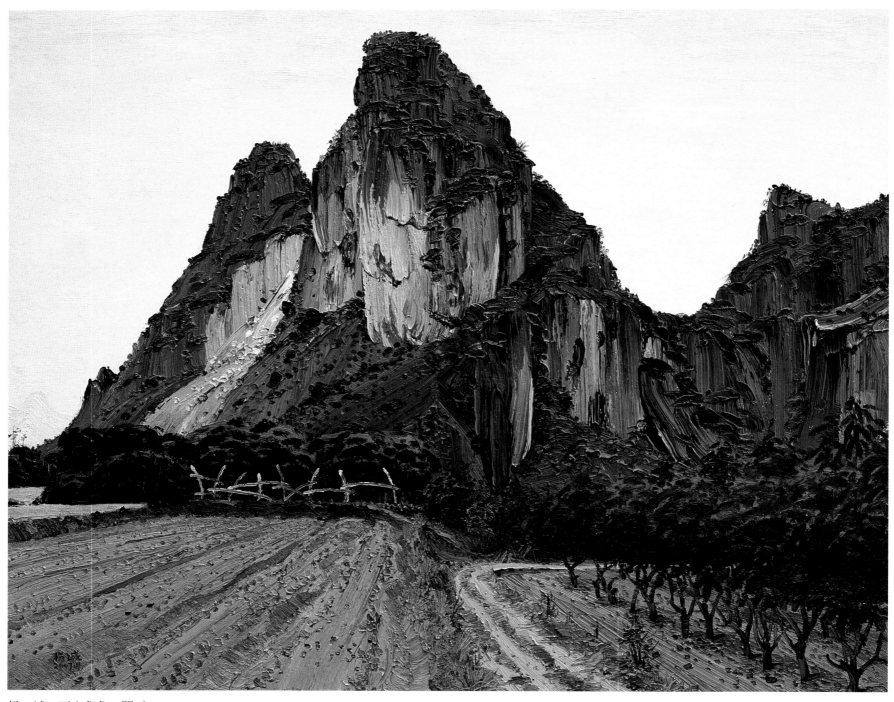

杨　诚　石山印象·阴天　80cm×100cm
Yang Cheng　*Rock Mountain impression in cloudy sky*　80cm×100cm

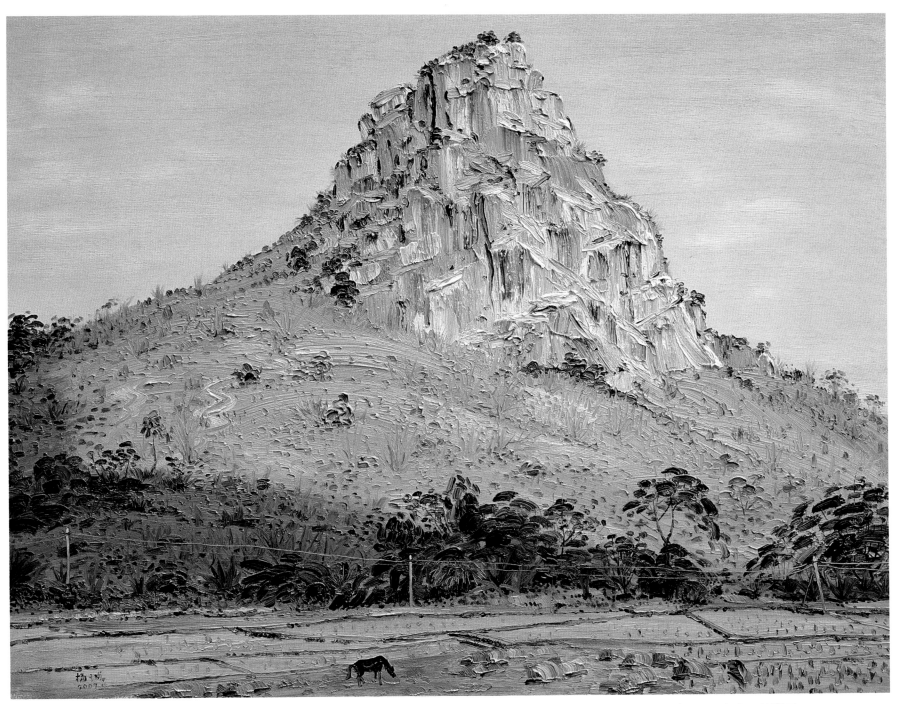

杨　诚　石山印象·艳阳天　80cm × 100cm
Yang Cheng　*Rock Mountain impression in bright sky*　80cm × 100cm

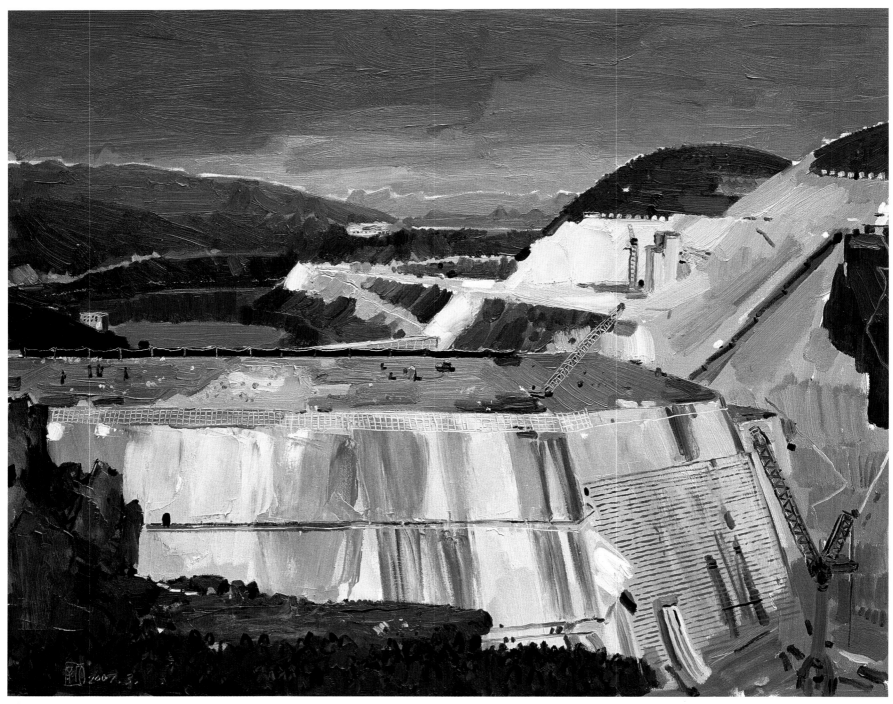

刘　新　建设中的山区水坝　80cm × 100cm
Liu Xin　*Dam in construction*　80cm × 100cm

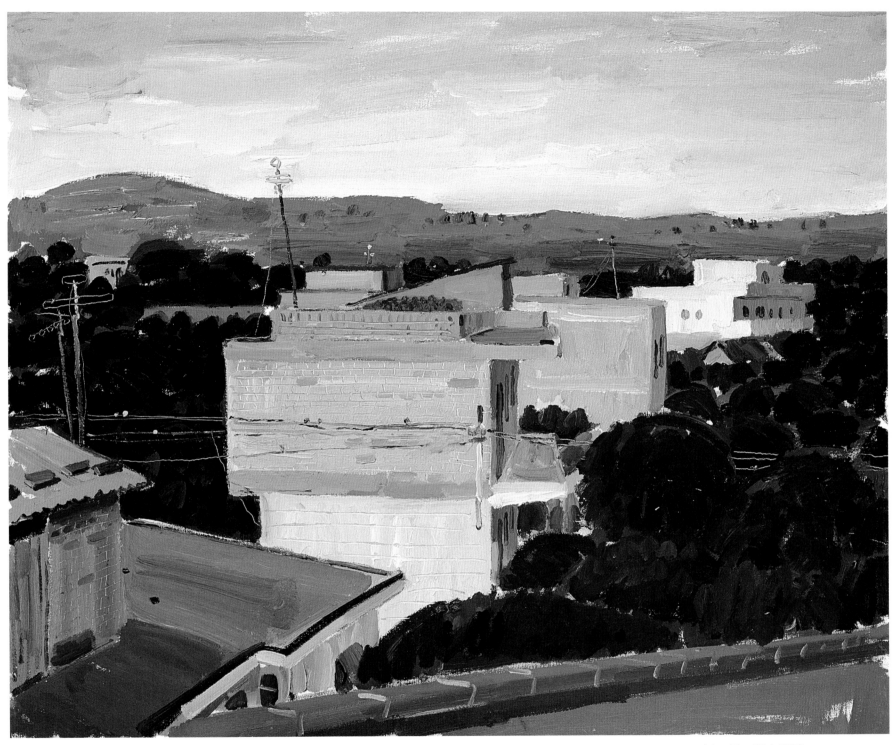

刘　新　果农新屋　60cm × 70cm
Liu Xin　*New house of fruit farmer*　60cm × 70cm

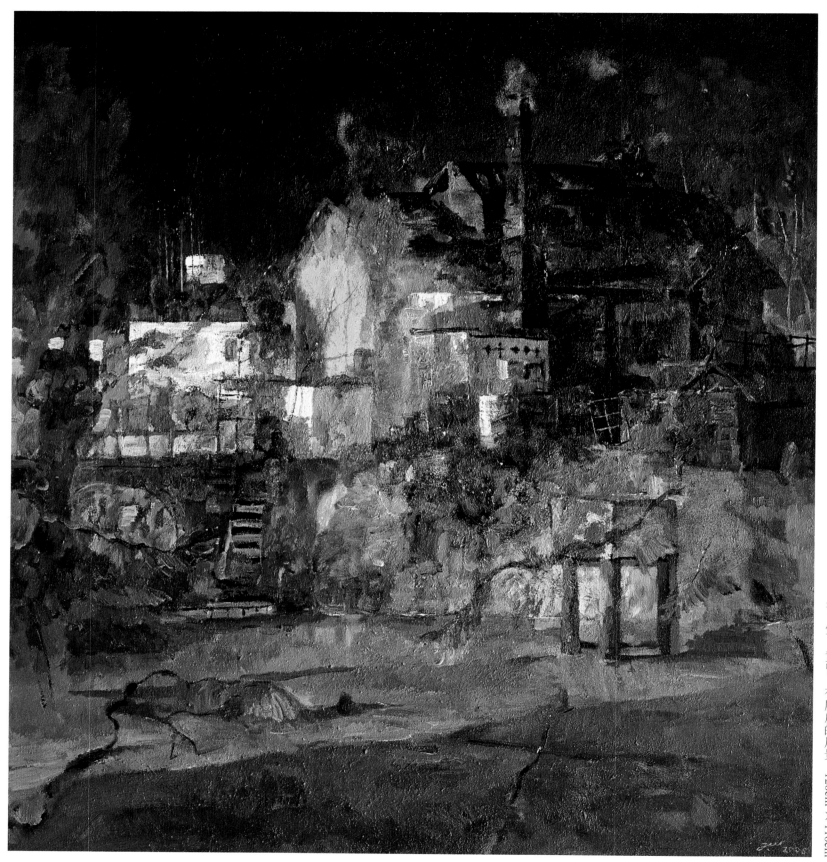

Wei Jun *Landscape with a kitchen in the evening fall* 120cm × 110cm
韦 军 黄昏·有厨房的风景 120cm × 110cm

82

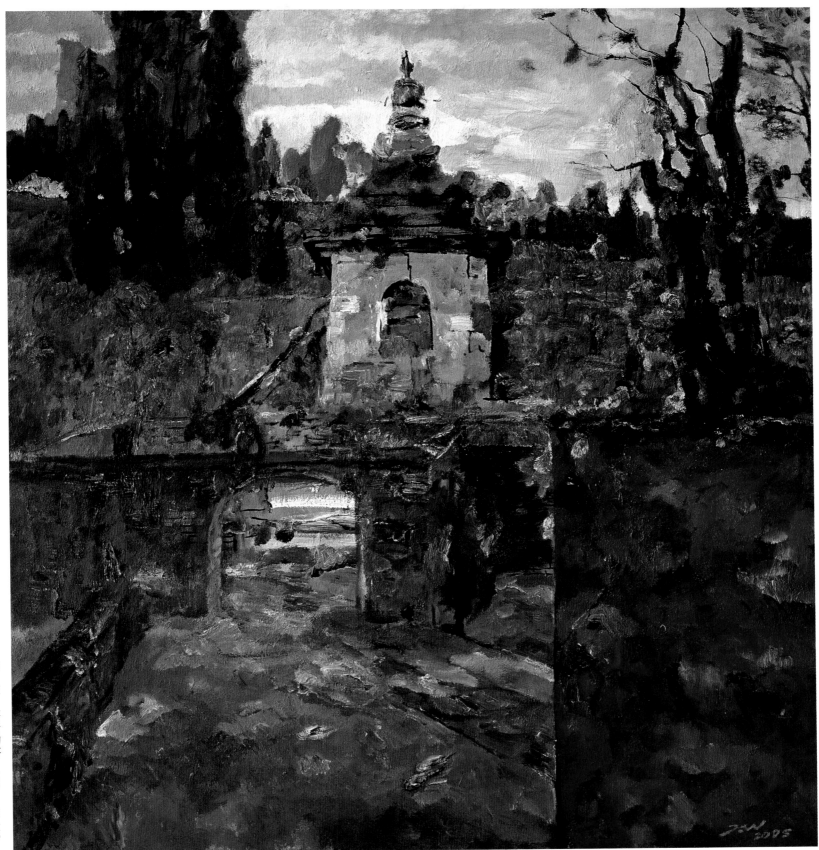

韦 军 苍老的塔 120cm×110cm
Wei Jun *Aged tower* 120cm×110cm

83

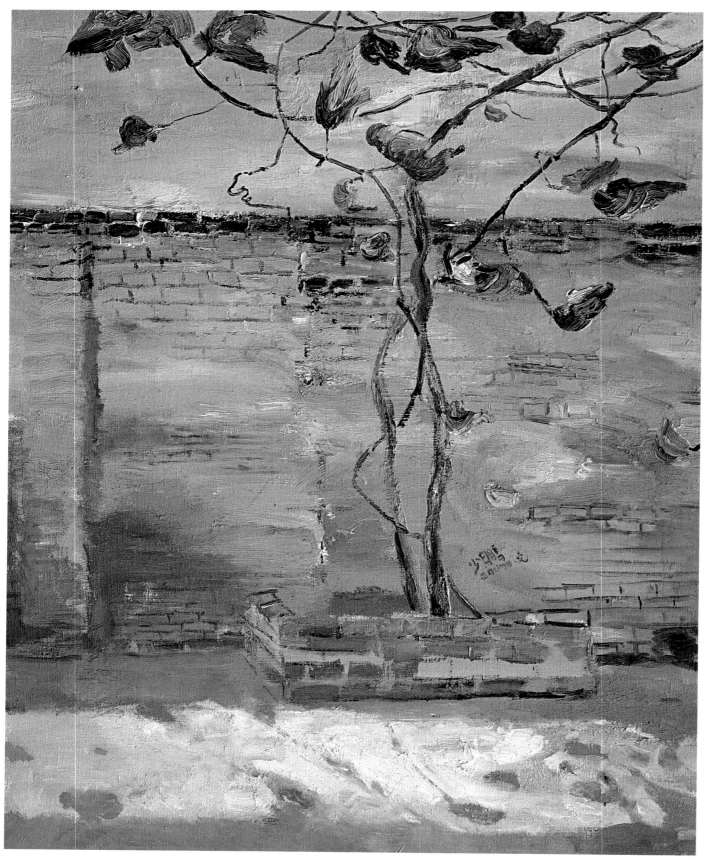

Huang Shaopeng　*Autumn sunlight*　100cm × 80cm
黄少鹏　秋天的阳光　100cm × 80cm

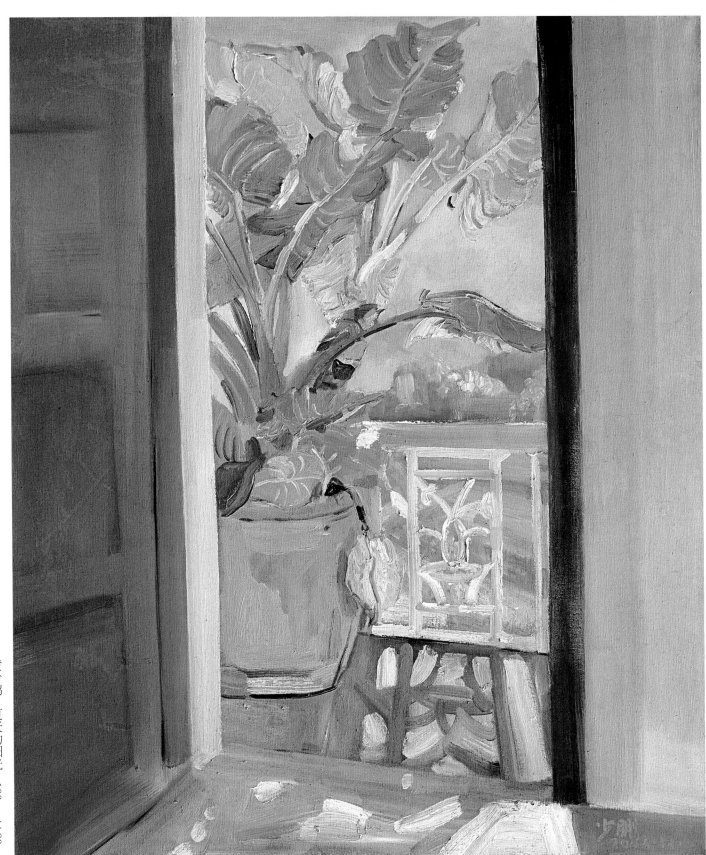

黄少鹏　夏天的阳光
Huang Shaopeng　*Summer sunlight*
100cm × 80cm
100cm × 80cm

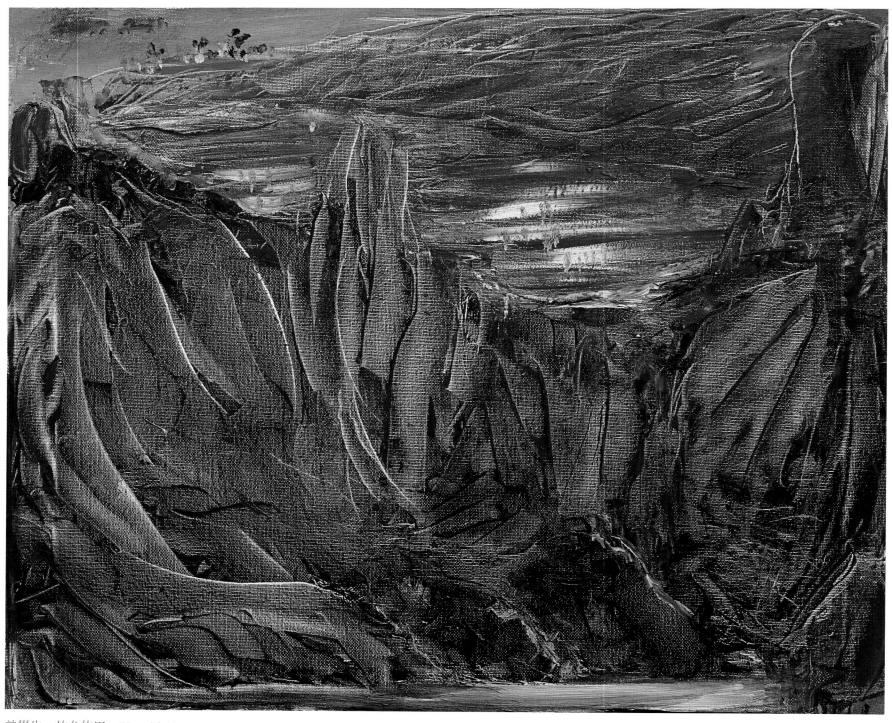

曾邕生　故乡的田　50cm × 60cm
Zeng Yongsheng　*Fields in hometown*　50cm × 60cm

曾邕生　故乡的月光　46cm × 60cm
Zeng Yongsheng　*Moon in hometown*　46cm × 60cm

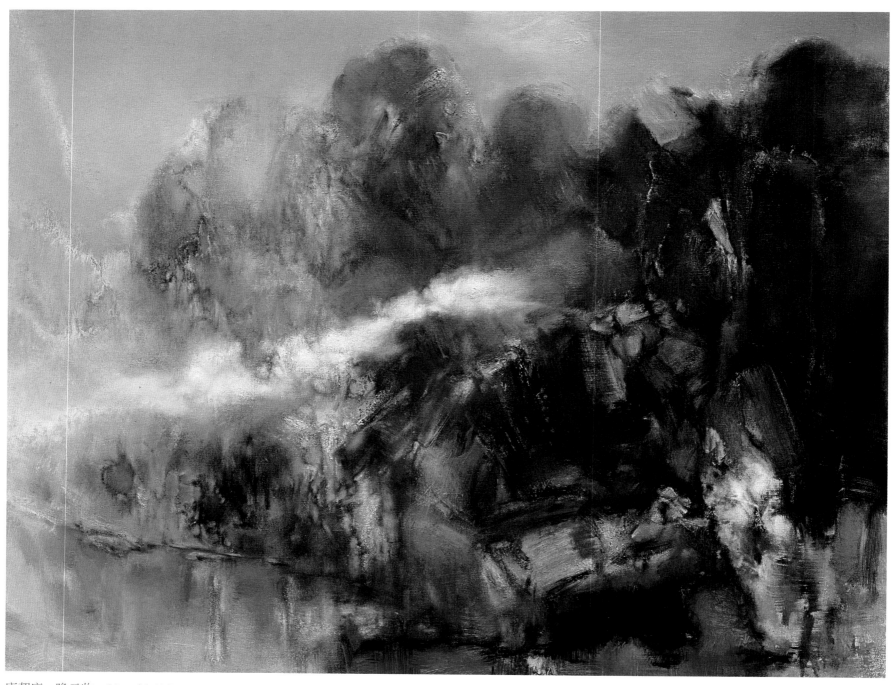

唐朝庆　晚云收　91cm × 116cm
Tang Chaoqing　*Evening clouds*　91cm × 116cm

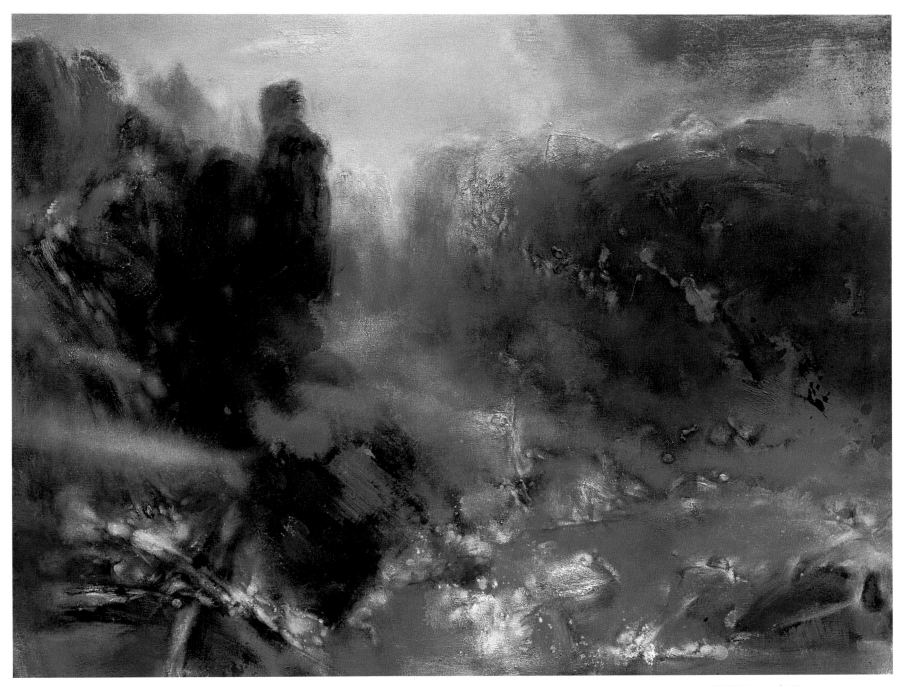

唐朝庆　绿水流　91cm × 116cm
Tang Chaoqing　*Flowing clear water*　91cm × 116cm

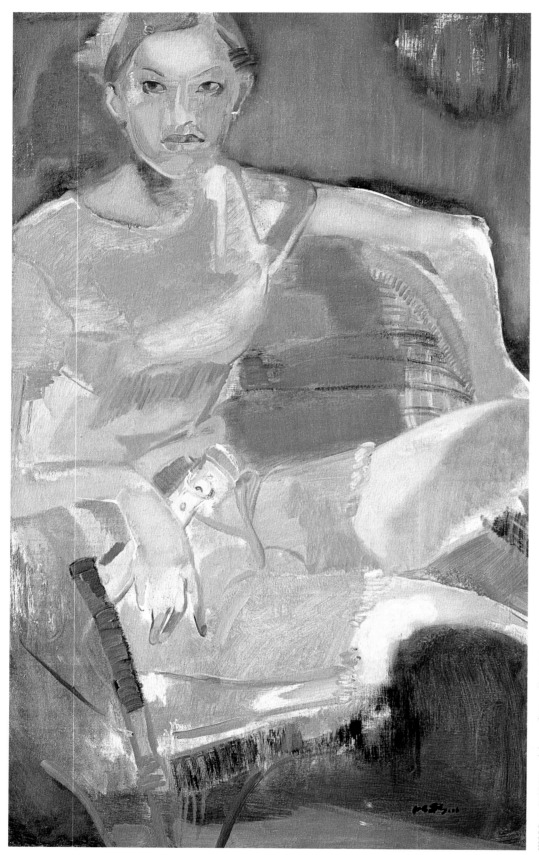

Wu Yicai *No.1 portrait*　100cm × 60cm
吴以彩　肖像·之一　100cm × 60cm

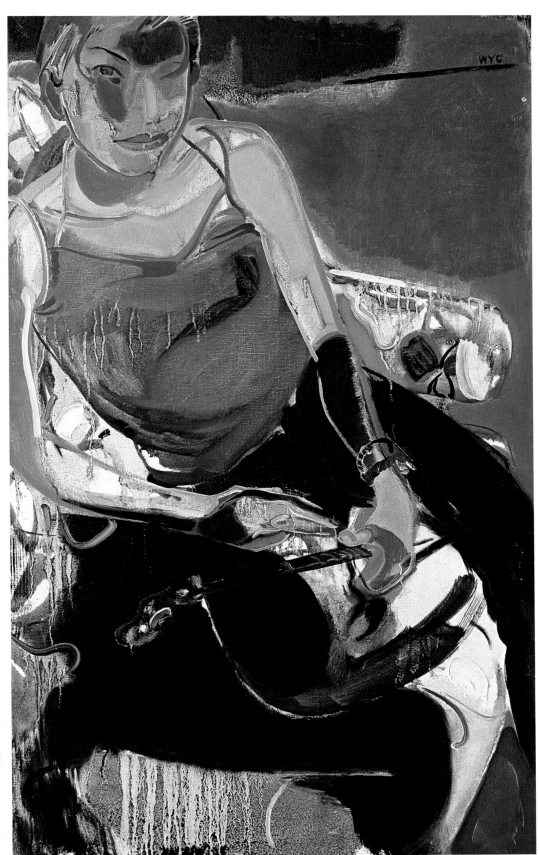

吴以彩　肖像·之二　100cm × 60cm
Wu Yicai　No.2 portrait　100cm × 60cm

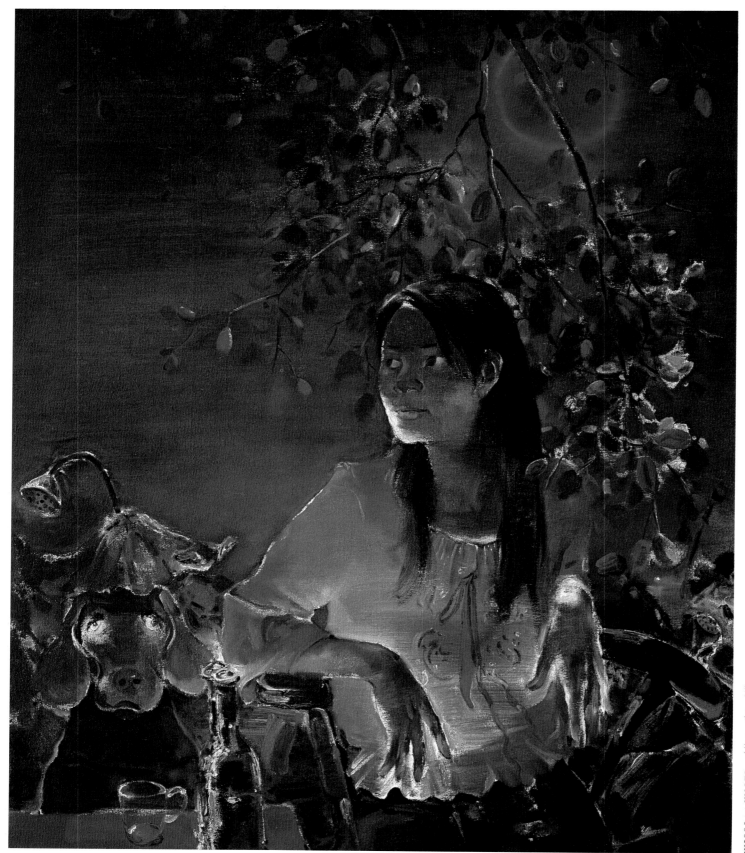

Liang Bing *Moon night* 120cm × 100cm

梁 冰 月夜 120cm × 100cm

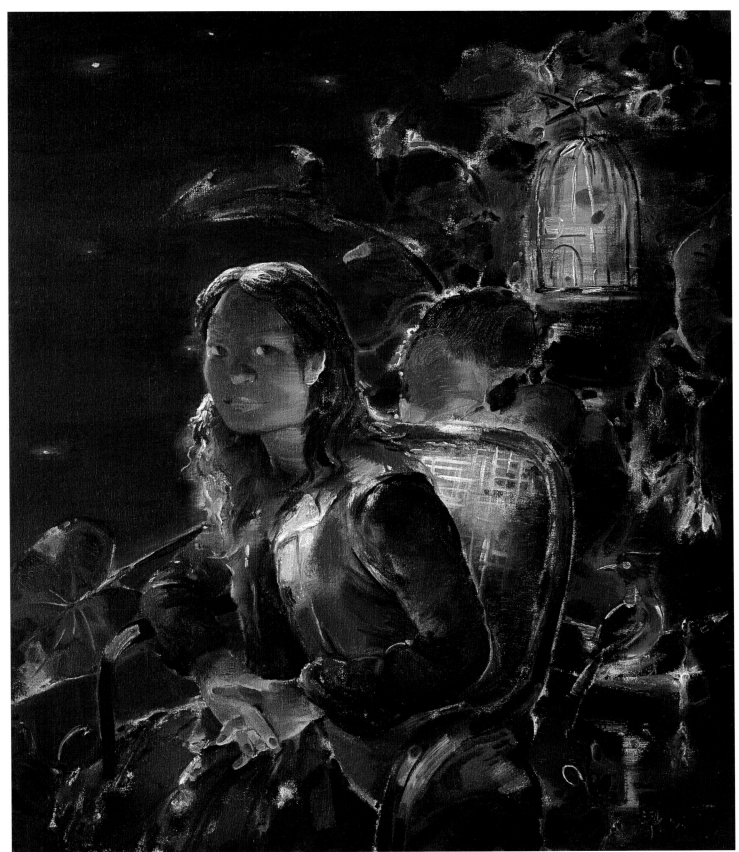

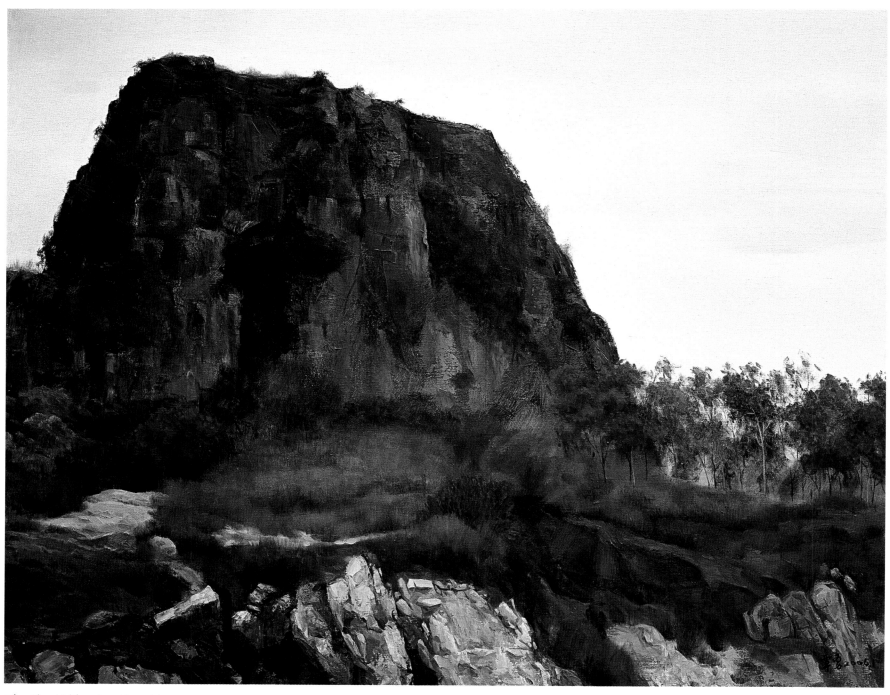

覃　勇　风景·山　80cm × 100cm
Qin Yong　*Mountain scenery*　80cm × 100cm

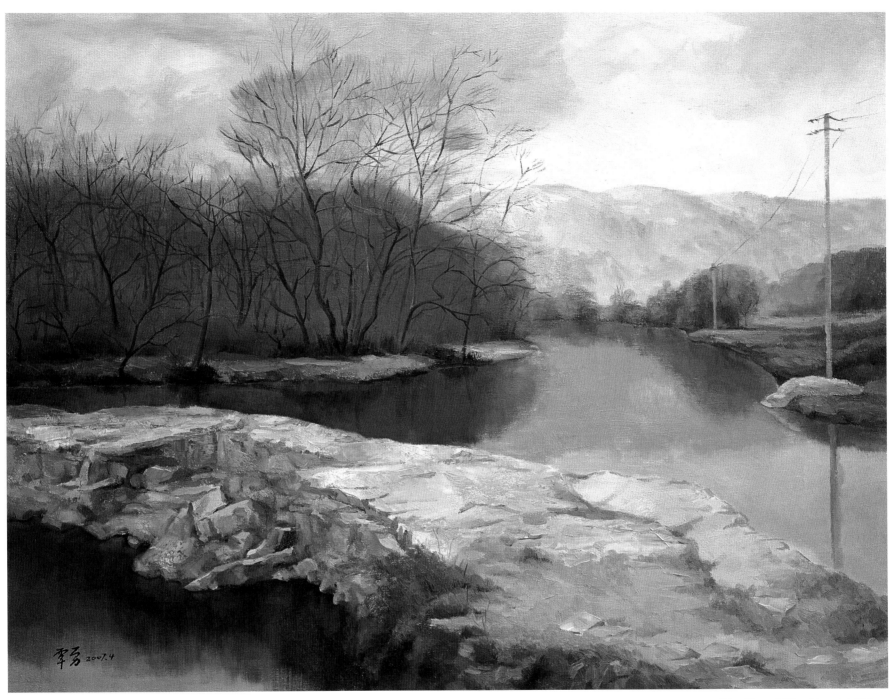

覃　勇　水渠　80cm × 100cm
Qin Yong　*Water ditch*　80cm × 100cm

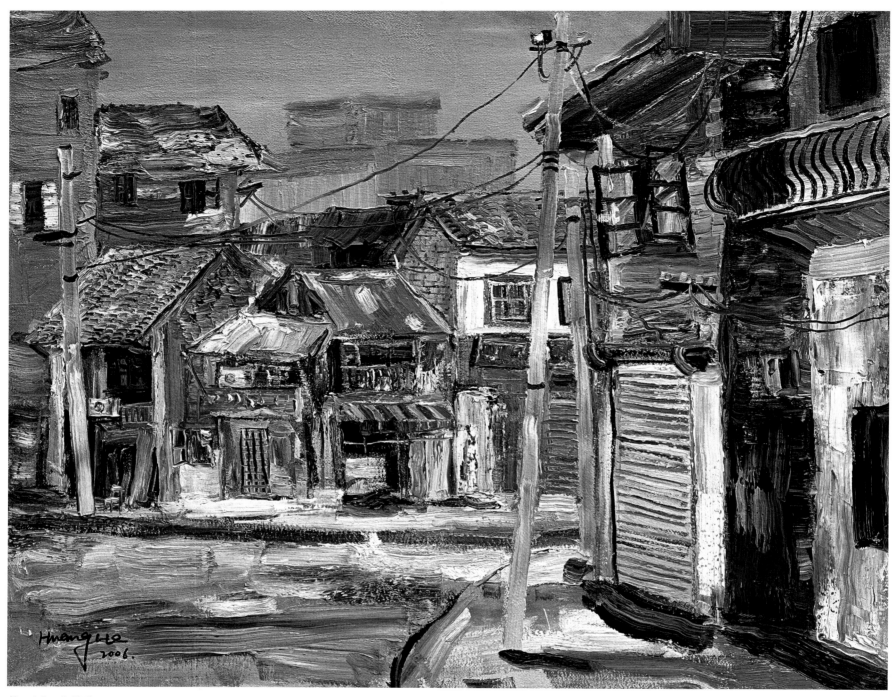

黄　河　金丝巷　80cm × 100cm
Huang He　*Jingsi Lane*　80cm × 100cm

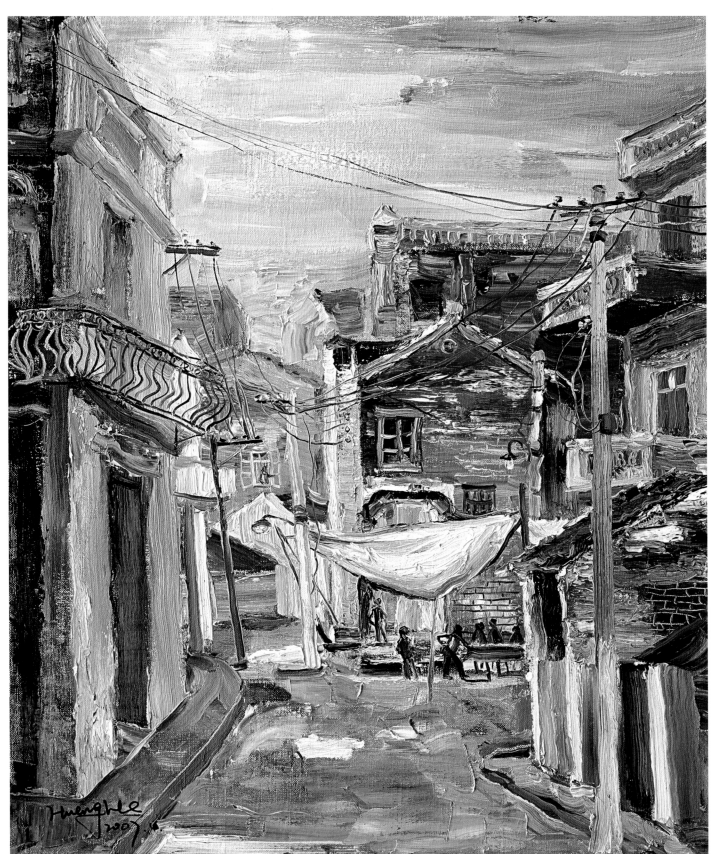

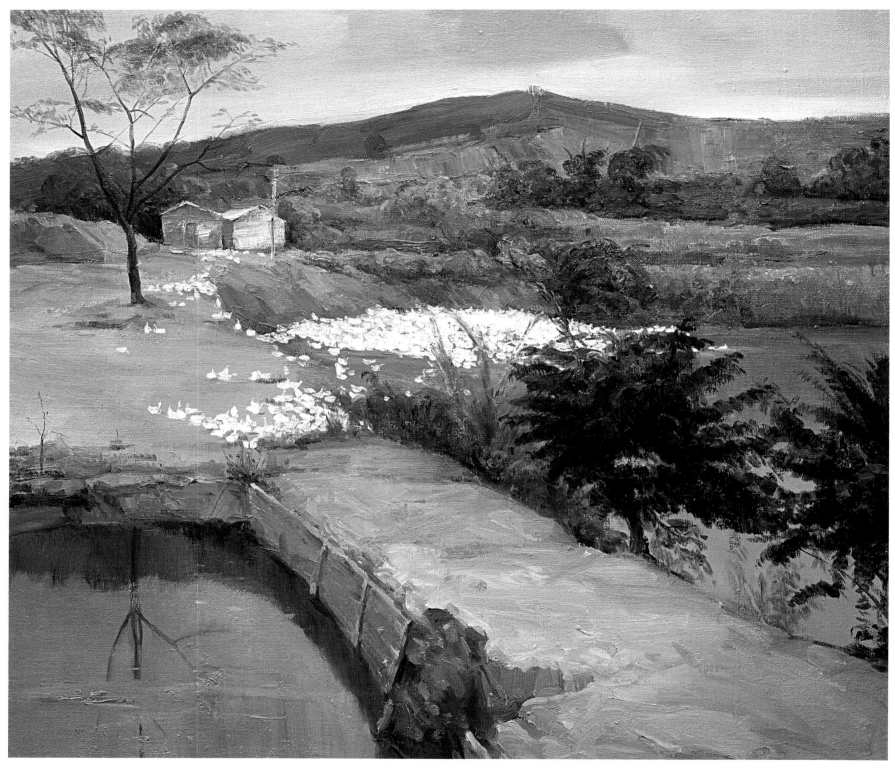

邓乐民　鱼塘小景　90cm × 100cm
Deng Lemin　*A view of pound*　90cm × 100cm

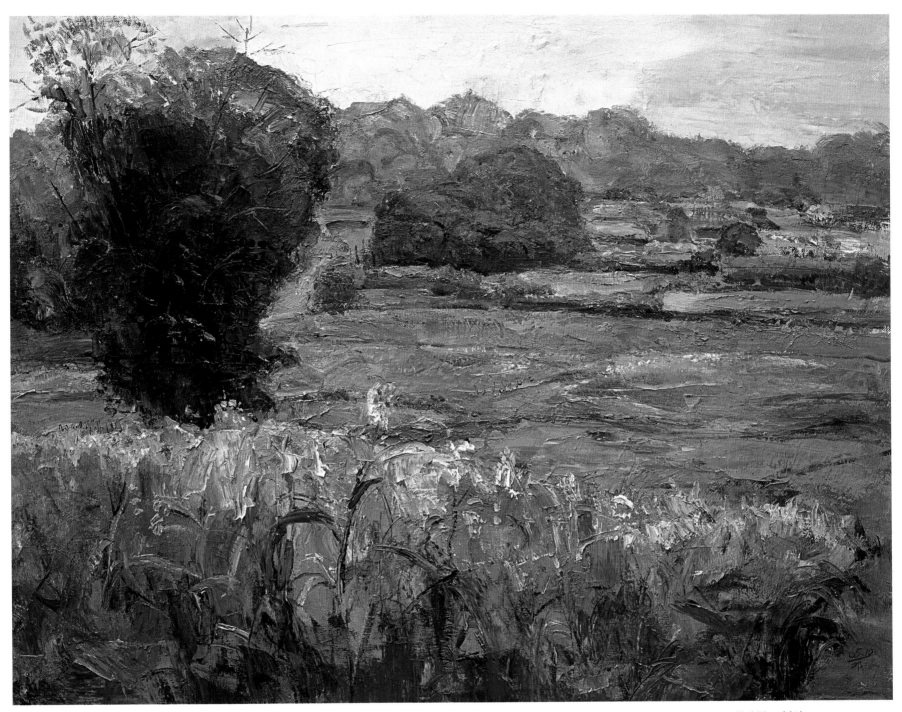

邓乐民　村边　60cm × 80cm
Deng Lemin　*Beside the village*　60cm × 80cm

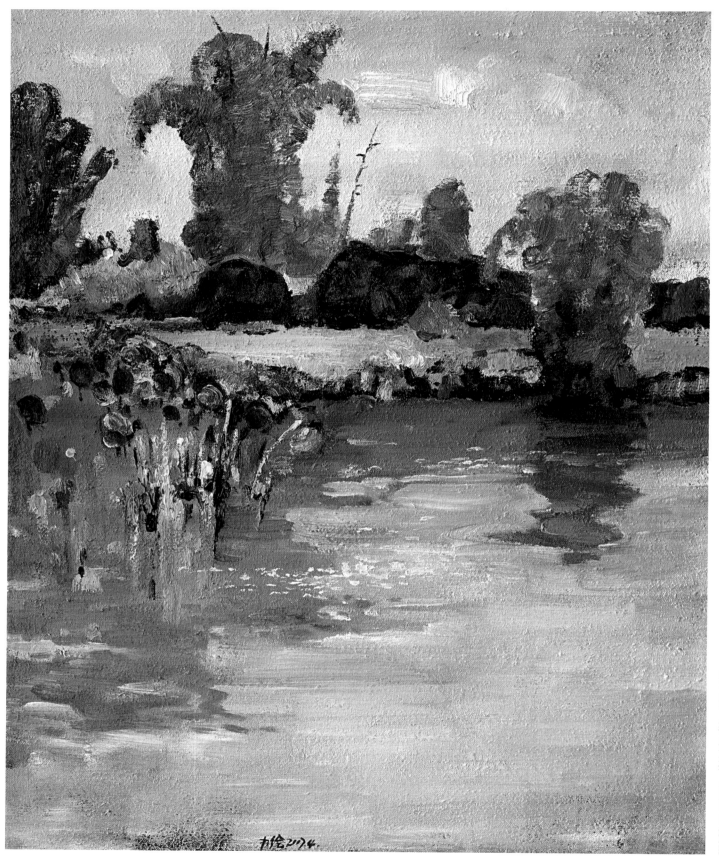

Zhang Lihui *Light breeze* 81cm × 65cm

张力绘 轻风无痕 81cm × 65cm

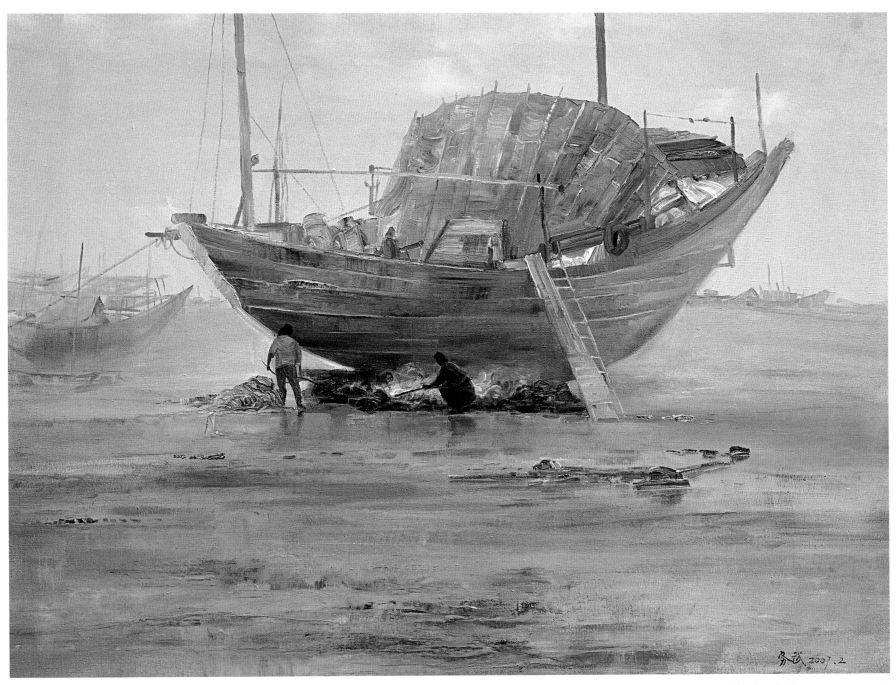

雷务武　冬晨　80cm × 100cm
Lei Wuwu　*Winter morning*　80cm × 100cm

版画

Prints

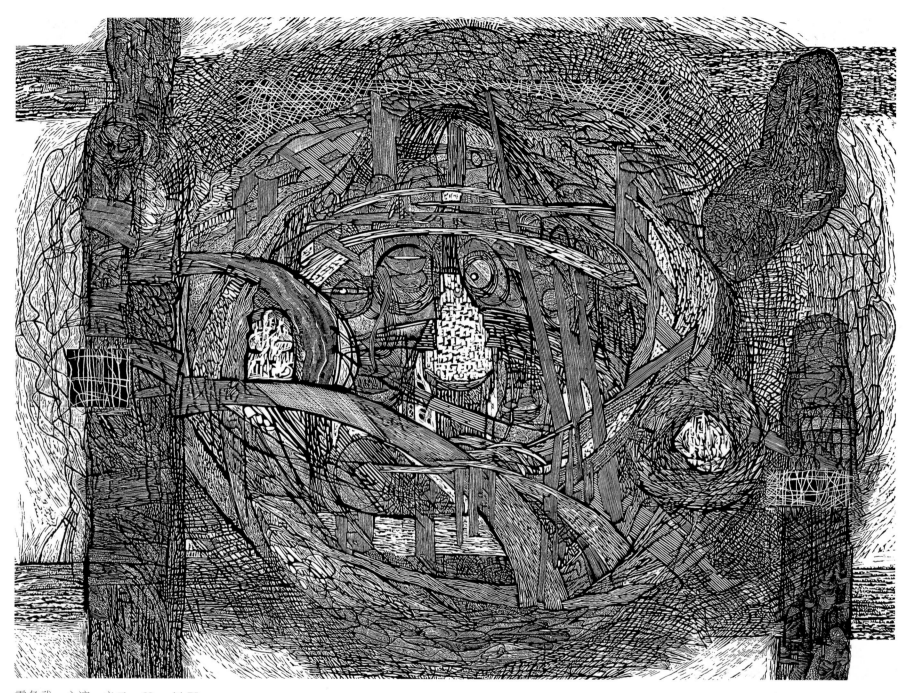

雷务武　心迹·之二　60cm × 78cm
Lei Wuwu　*No.2 of true feelings*　60cm × 78cm

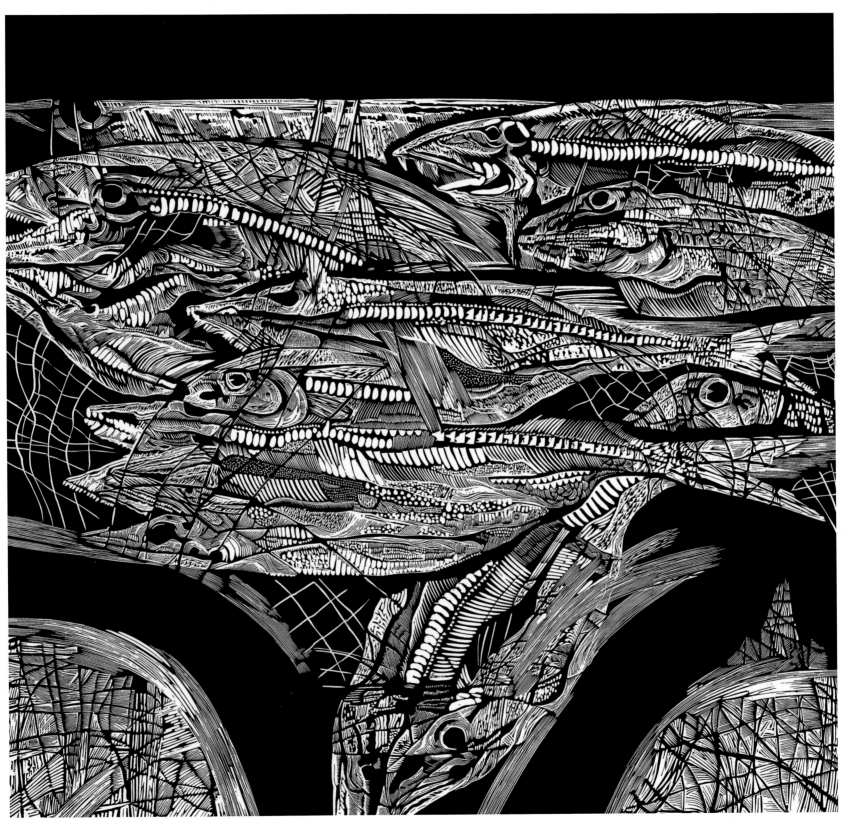

雷务武　突围　90cm × 90cm
Lei Wuwu　*Break through*　90cm × 90cm

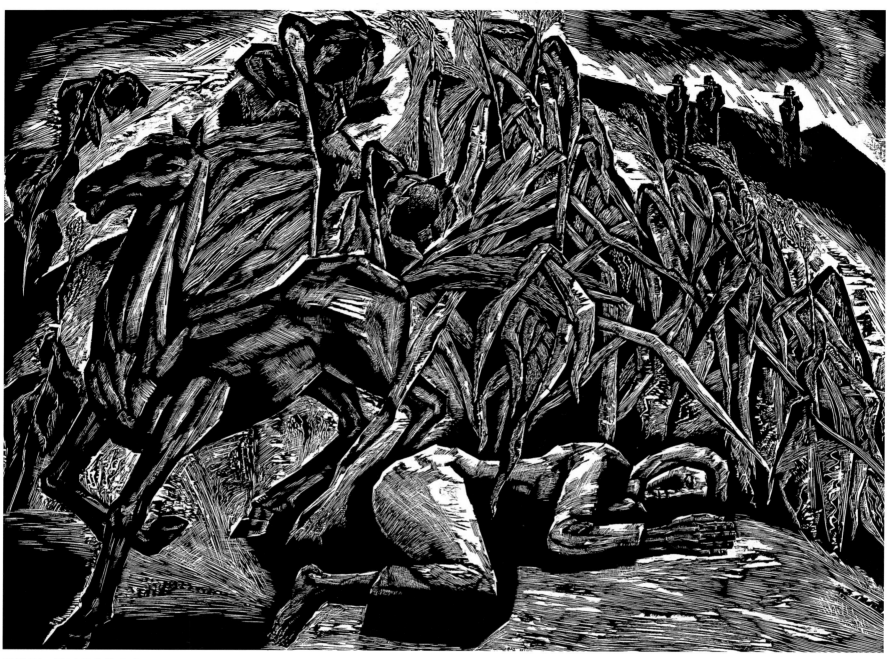

姚浩刚　风里传来的合奏　60cm × 80cm
Yao Haogang　*Wind ensemble*　60cm × 80cm

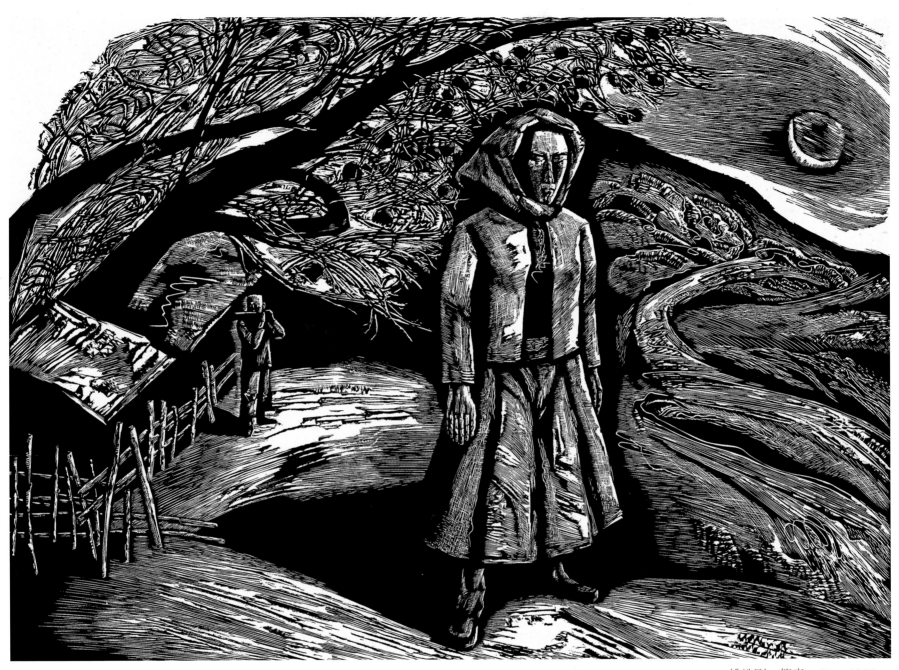

姚浩刚　笛声　60cm × 80cm
Yao Haogang　*Flute whistle*　60cm × 80cm

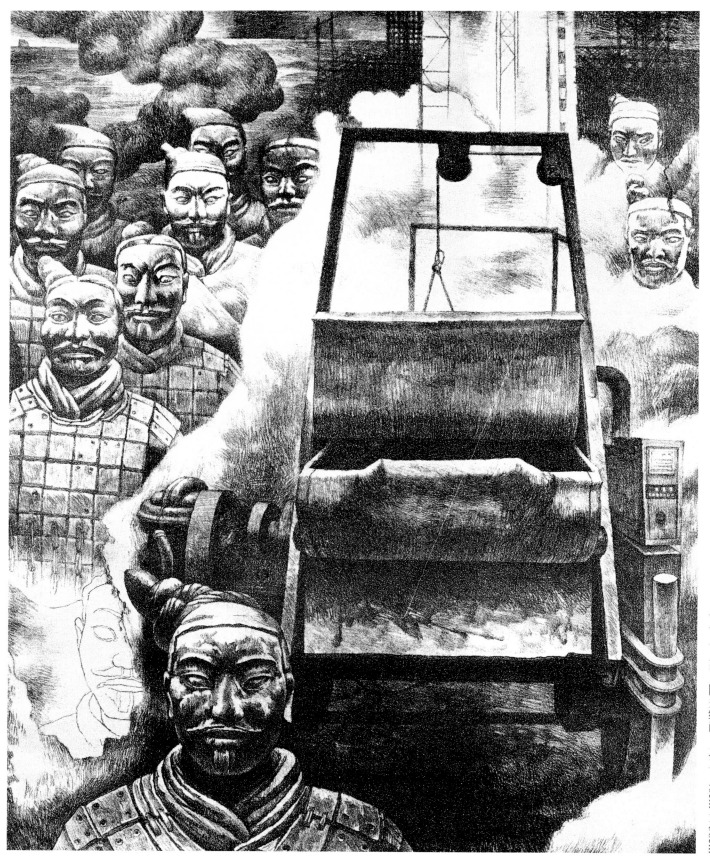

Fu Junshan　*No.3 of west towards Yangguan*　46cm×36cm
傅俊山　西出阳关组画·之三　46cm×36cm

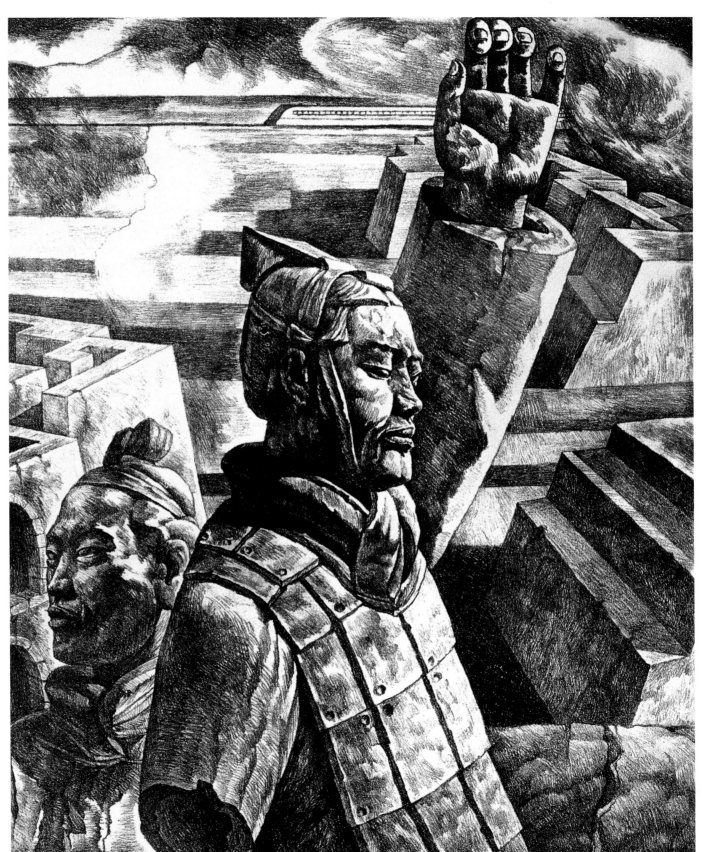

傅俊山　西出阳关组画·之四　46cm × 36cm

Fu Junshan　*No.4 of west towards Yangguan*　46cm × 36cm

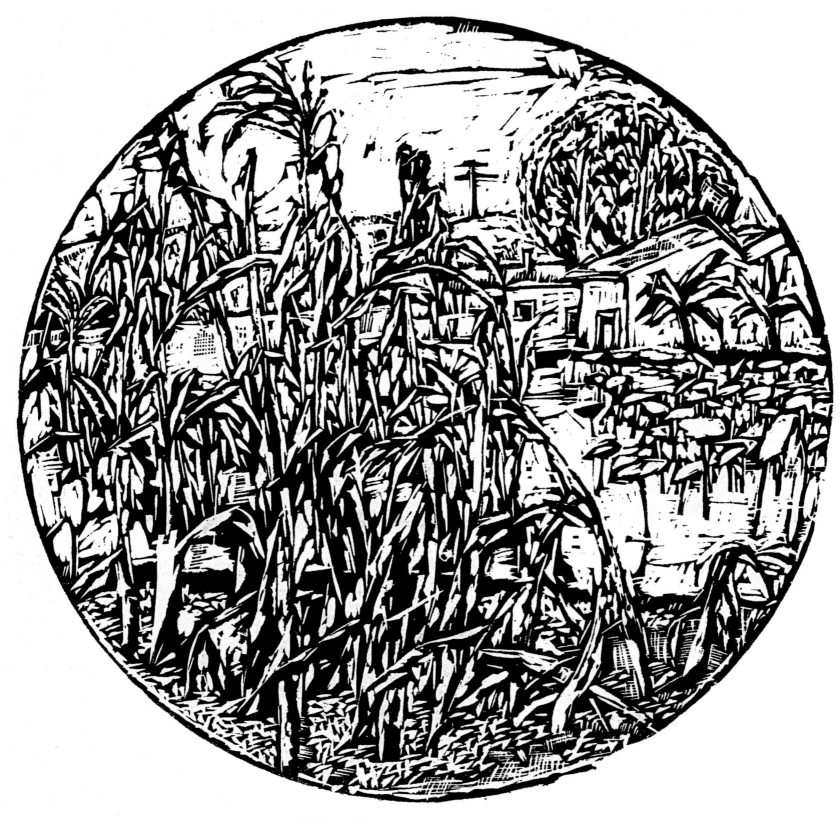

罗思德　家园　30cm × 30cm
Luo Side　*Sweet home*　30cm × 30cm

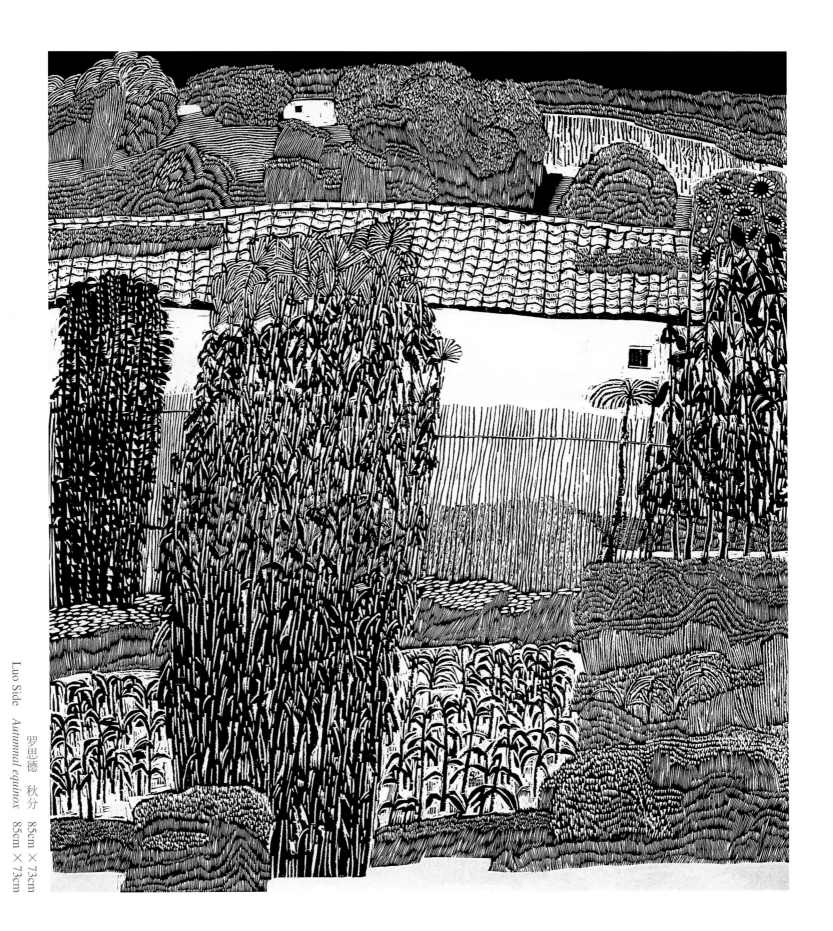

罗思德　秋分　85cm×73cm
Luo Side　*Autumnal equinox*　85cm×73cm

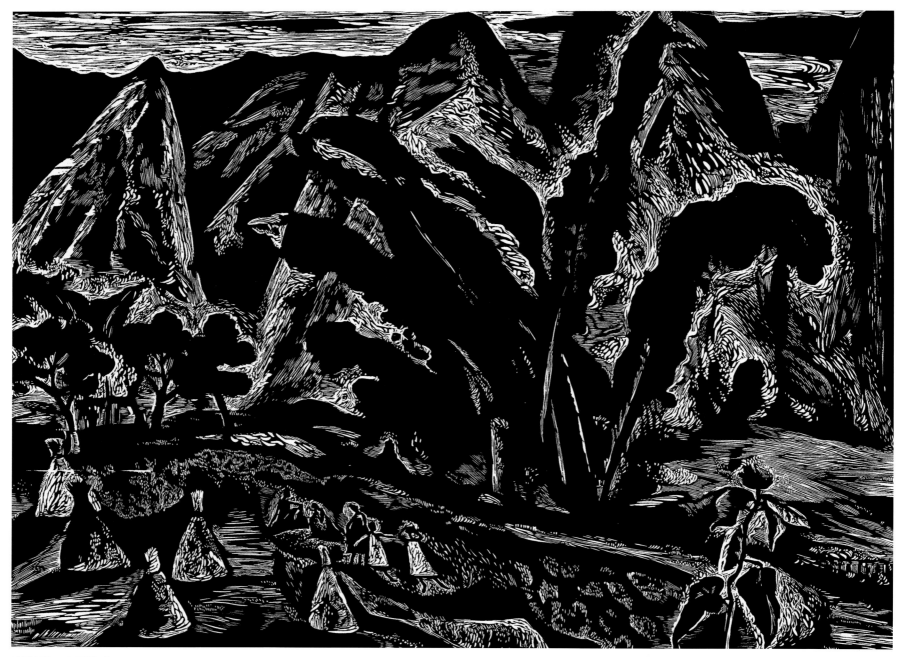

庞海燕　山雨欲来　60cm × 80cm
Pang Haiyan　*Before the rain*　60cm × 80cm

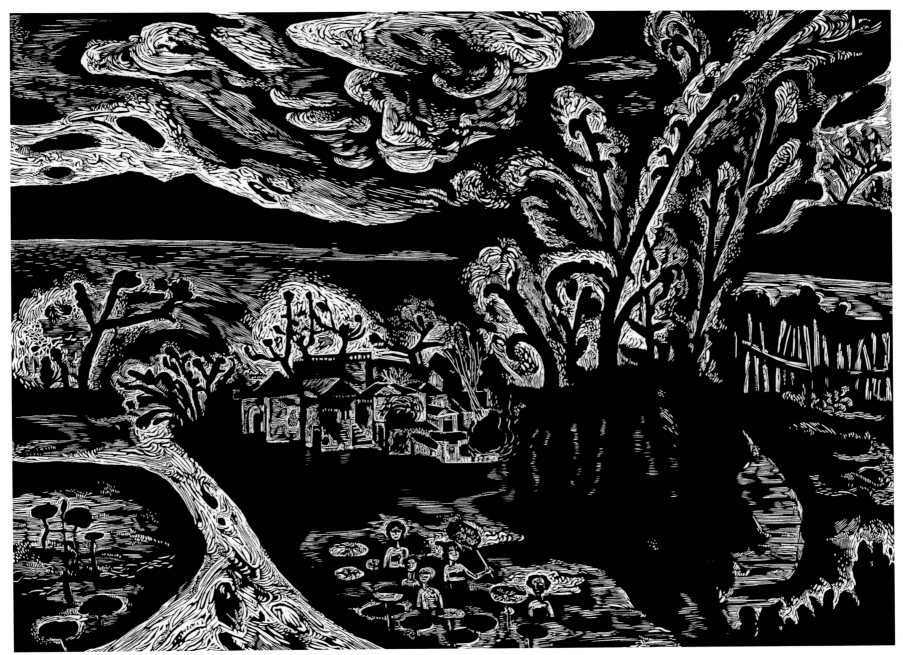

庞海燕　荷影与竹　60cm × 80cm
Pang Haiyan　*Lotus shadow and bamboo*　60cm × 80cm

李　翔　天使之舞　40cm × 50cm
Li Xiang　*Dance of angel*　40cm × 50cm

李　翔　无题　40cm×50cm
Li Xiang　*Untitled*　40cm×50cm

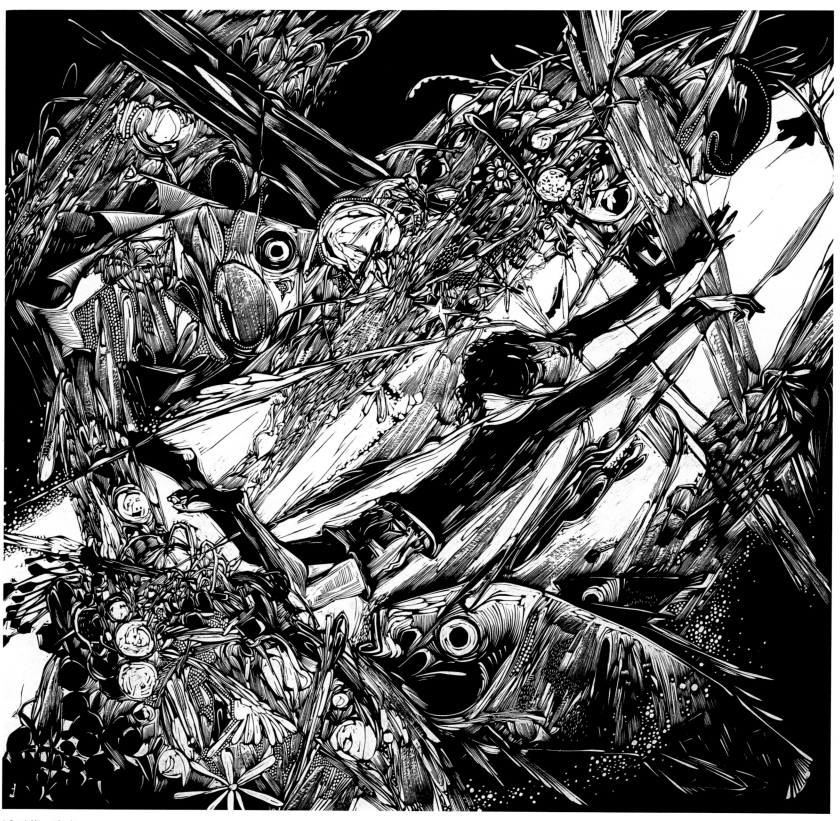

潘丽萍　泳者　61cm × 61cm
Pan Liping　*Swimmer*　61cm × 61cm

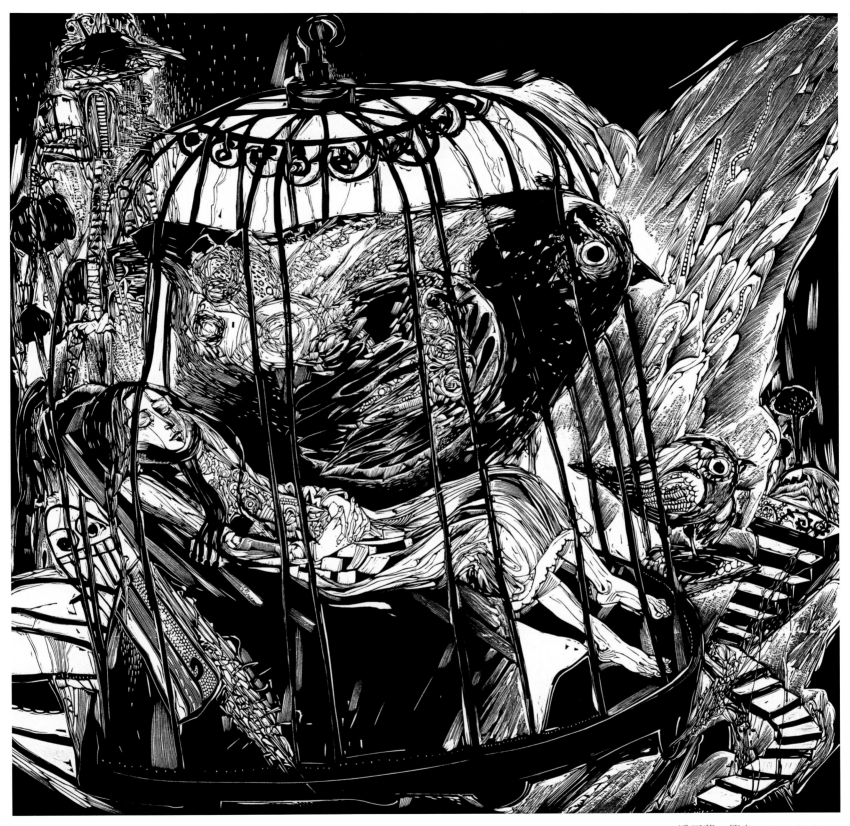

潘丽萍　笼鸟　61cm × 61cm
Pan Liping　*Bird in cage*　61cm × 61cm

水彩画 Watercolors

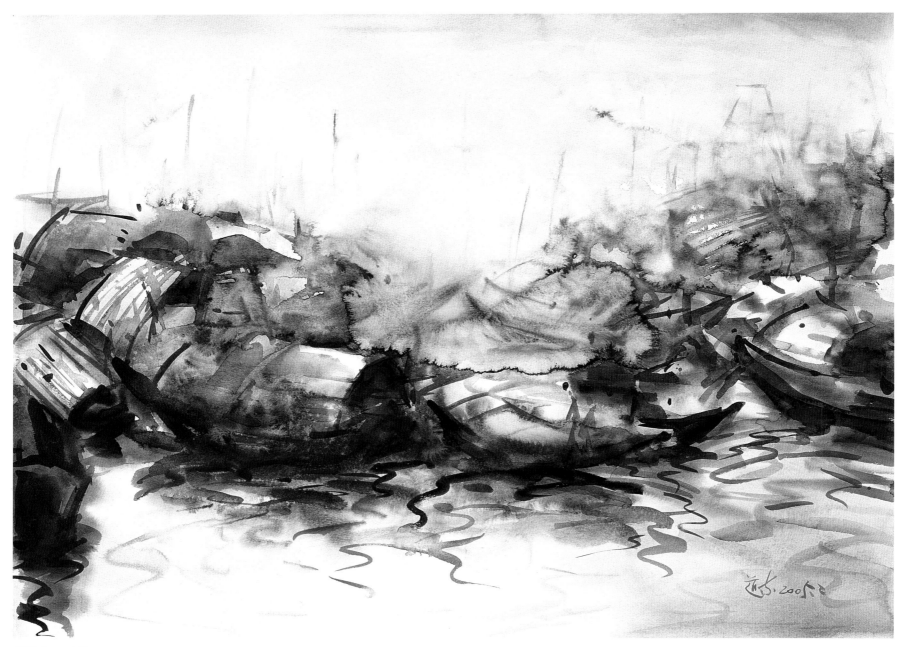

蔡道东　三月　79cm × 108cm
Cai Daodong　*March*　79cm × 108cm

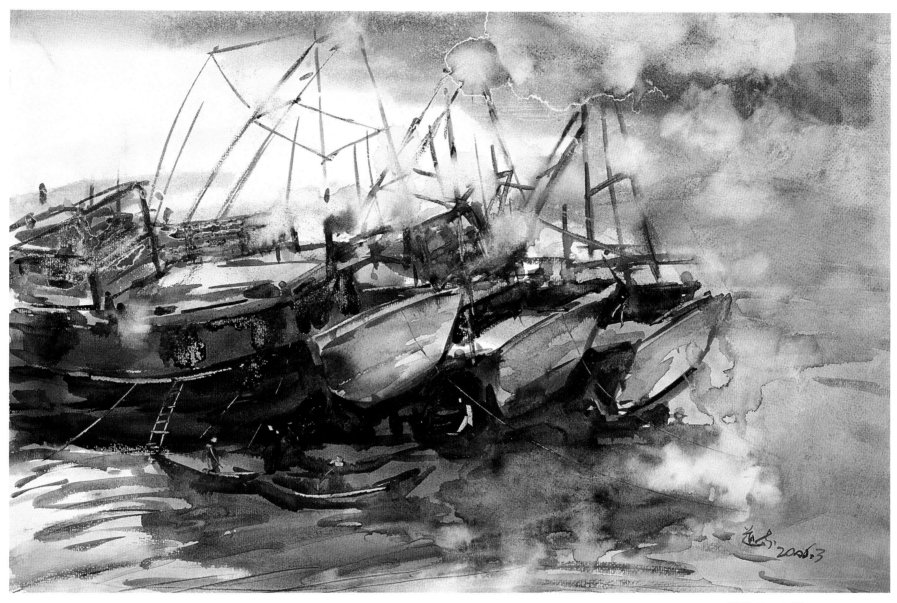

蔡道东　夕照　54cm × 79cm
Cai Daodong　*Evening glow*　54cm × 79cm

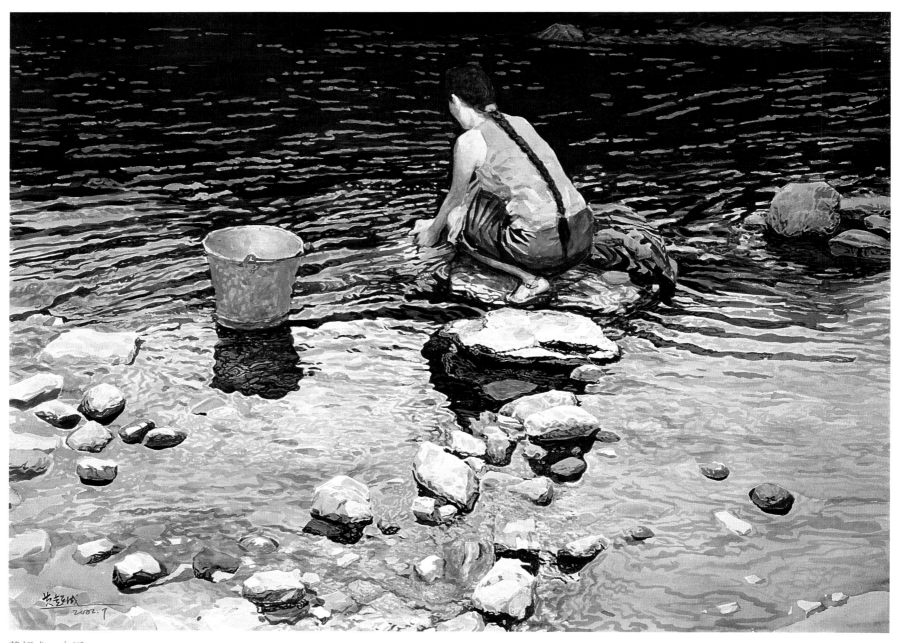

黄超成　小河　79cm × 108cm
Huang Chaocheng　*Creek*　79cm × 108cm

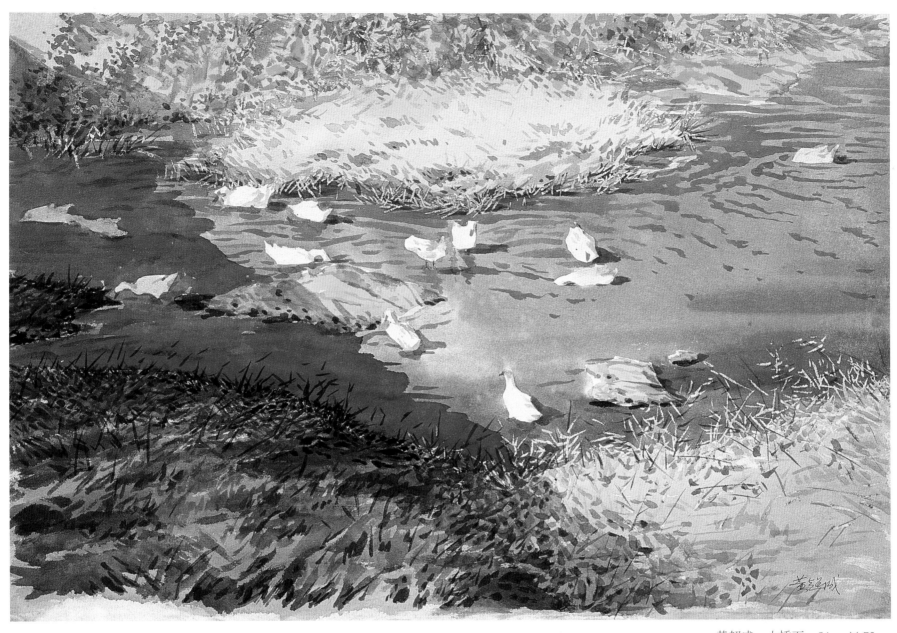

黄超成　小桥下　54cm × 72cm
Huang Chaocheng　*Under the footbridge*　54cm × 72cm

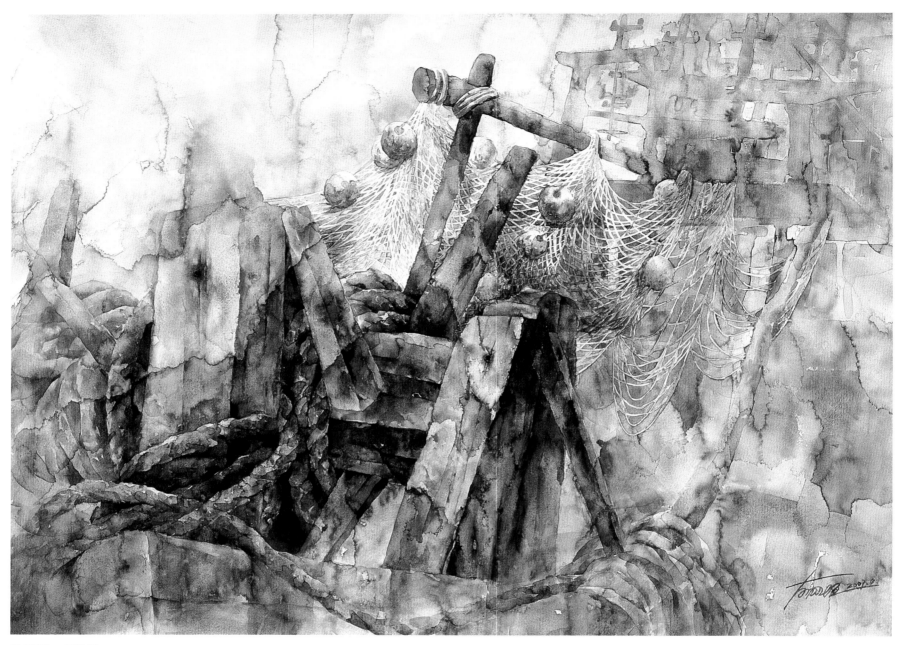

肖畅恒 老帆船 54cm × 79cm
Xiao Changheng *Old sailing boat* 54cm × 79cm

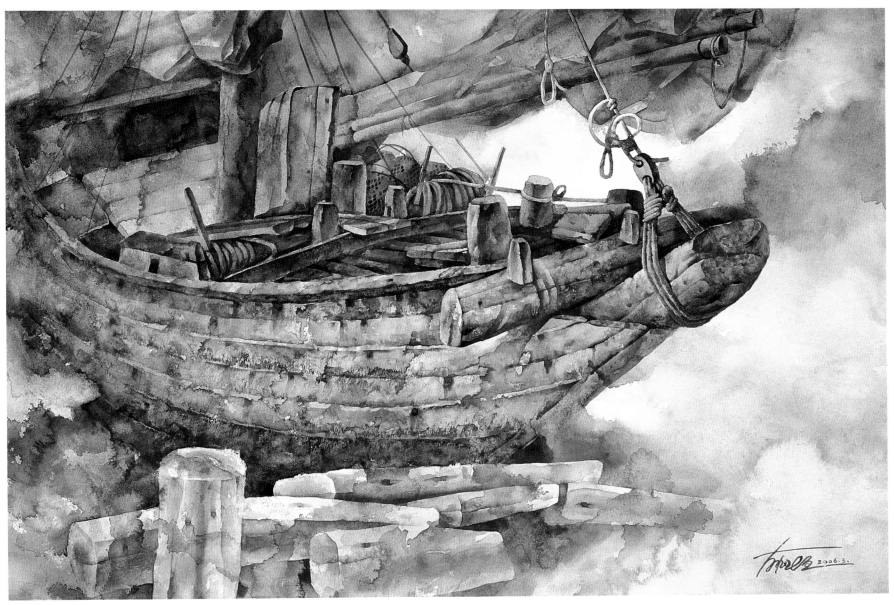

肖畅恒　船工物语　79cm × 108cm
Xiao Changheng　*Sailors' story*　79cm × 108cm

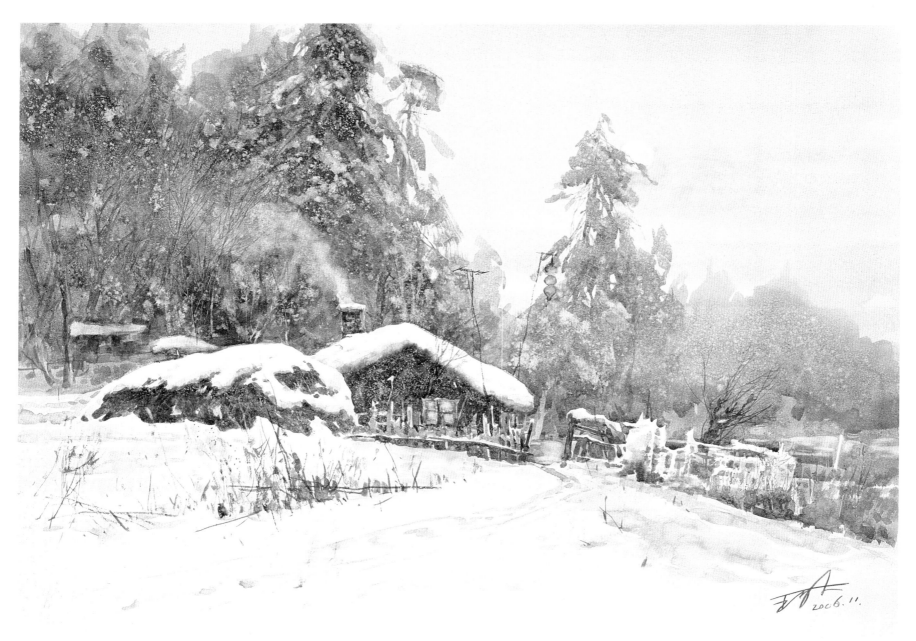

王可大　山里人家　76cm × 106cm
Wang Keda　*A house in the mountain village*　76cm × 106cm

王可大　春雨　106cm×77cm
Wang Keda　*Spring rain*　106cm×77cm

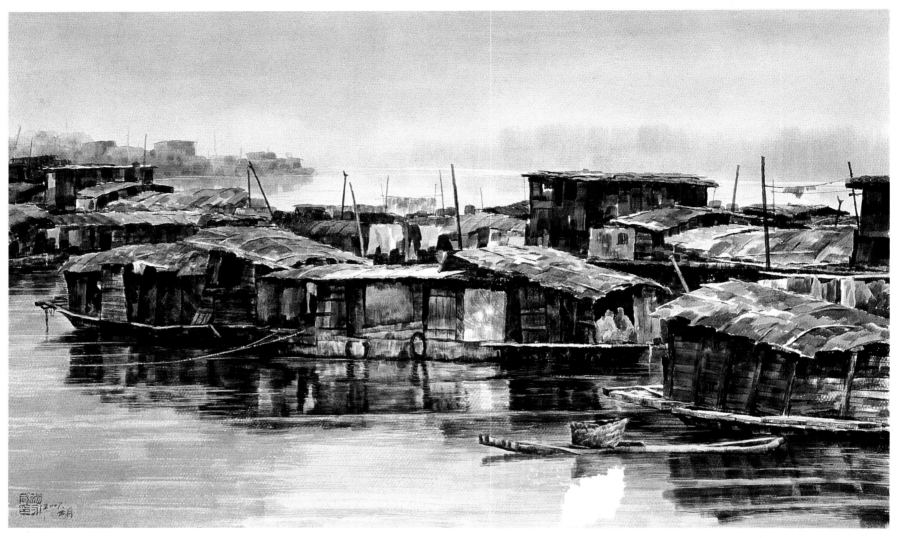

杨永葳　漓江鱼船·之一　46cm × 78cm
Yang Yongwei　*No.1 of fishing boat on Lijiang*　46cm × 78cm

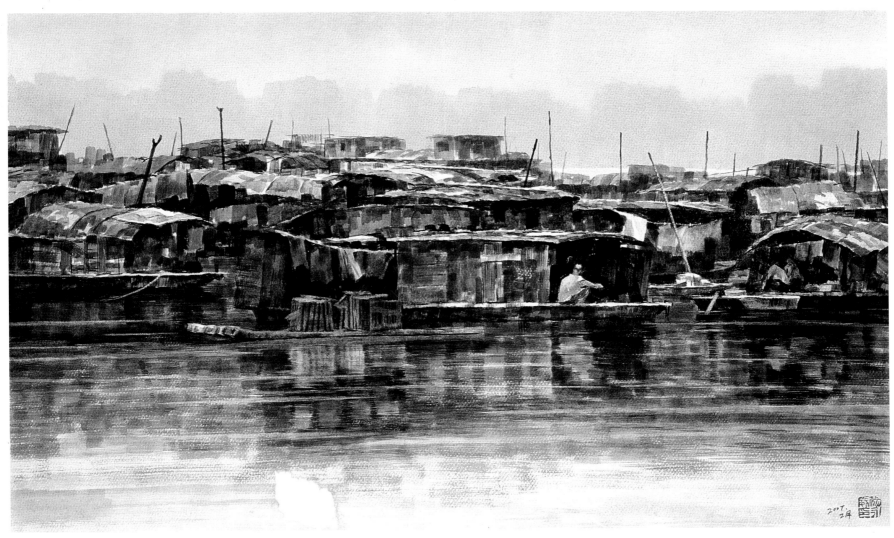

杨永葳　漓江鱼船·之二　46cm × 78cm
Yang Yongwei　*No.2 of fishing boat on Lijiang*　46cm × 78cm

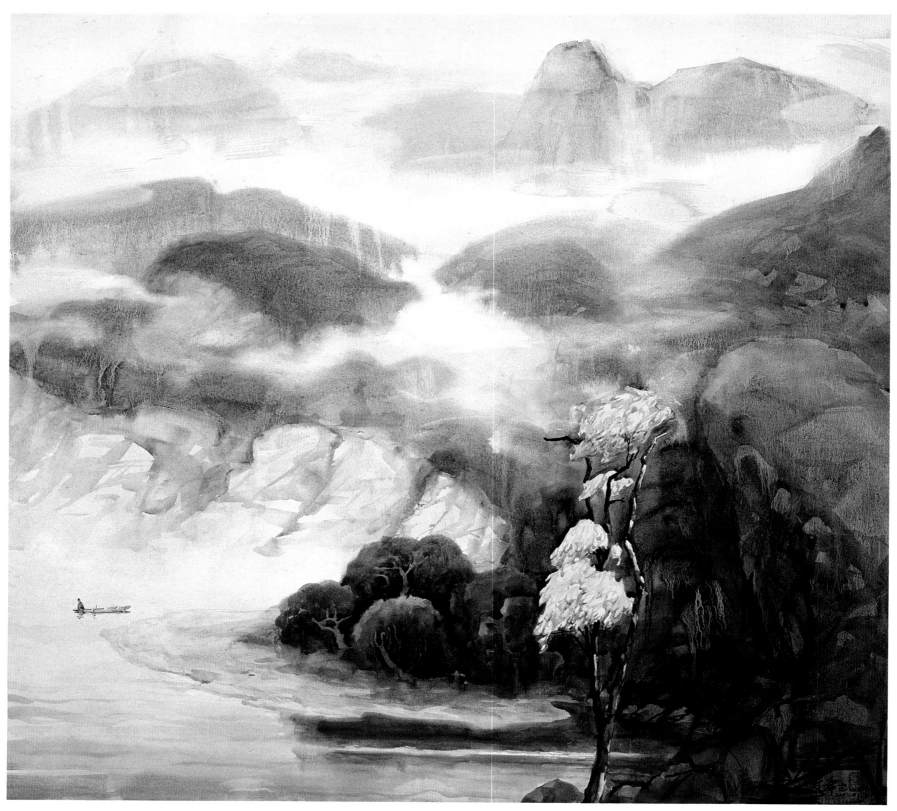

蒋友舜　云起秋山　73cm × 79cm
Jiang Youshun　*Clouds around mountain in autumn*　73cm × 79cm

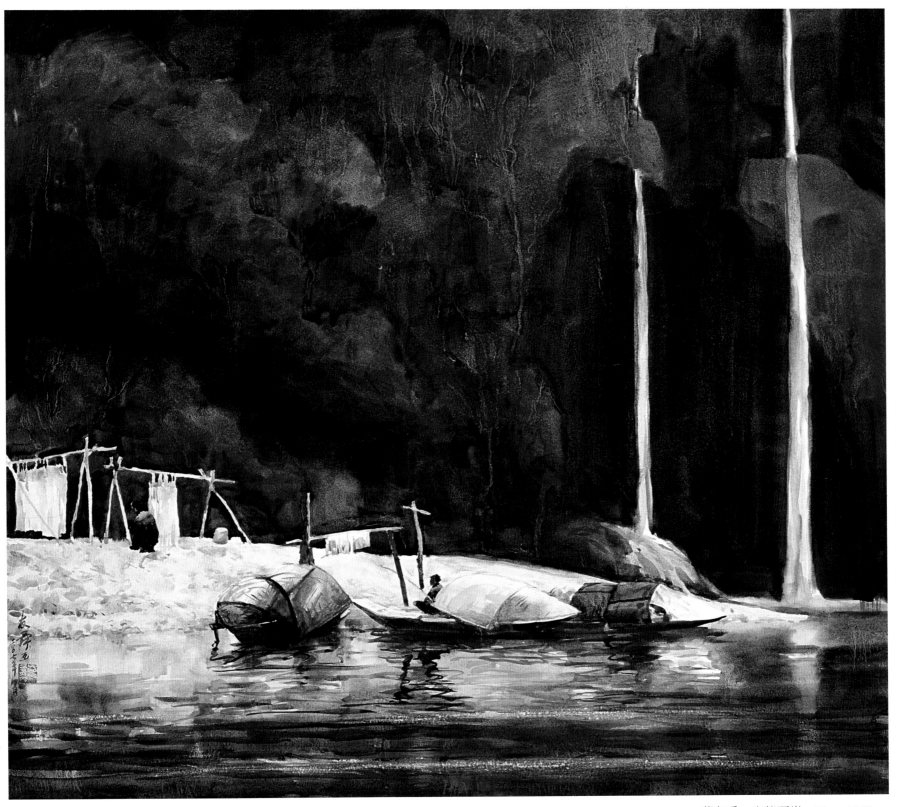

蒋友舜　夜傍西岩　73cm × 79cm
Jiang Youshun　*Curtain of night in Xiyan*　73cm × 79cm

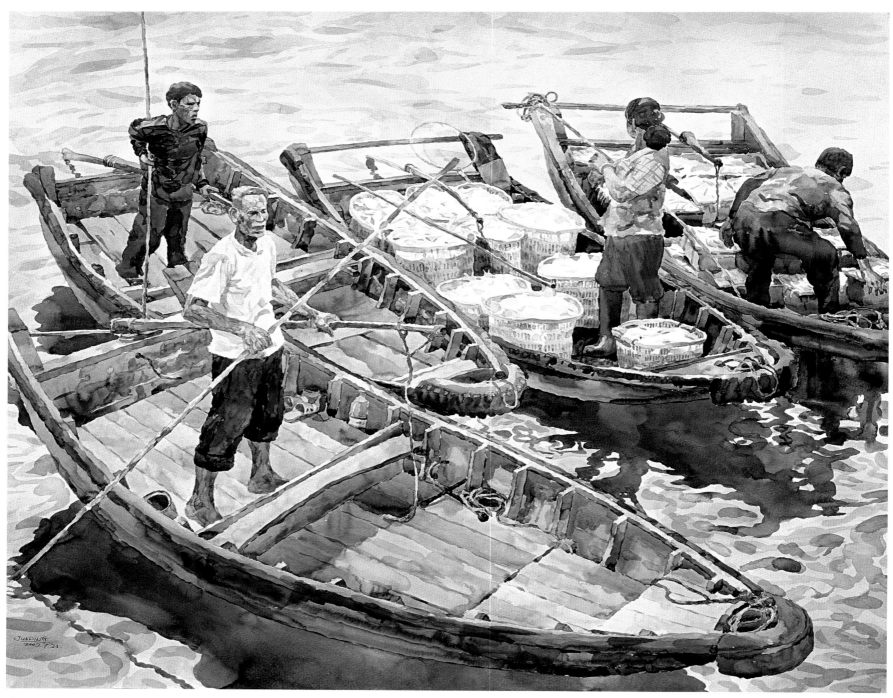

韦俊平　月光曲　76cm × 97cm
Wei Junping　*Moon light*　76cm × 97cm

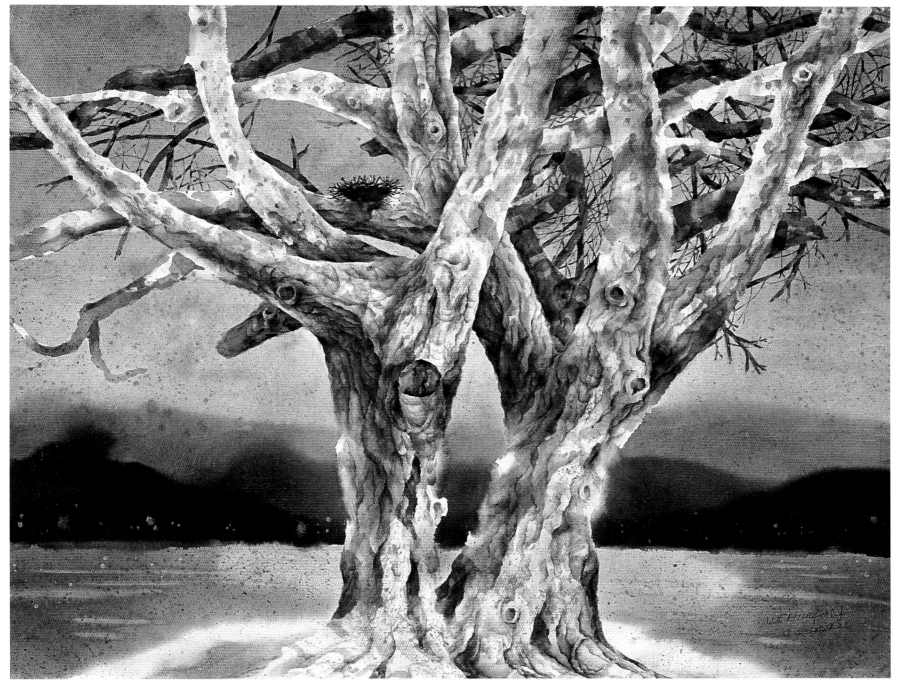

韦俊平　晨曦　80cm × 100cm
Wei Junping　*First sun rays in the morning*　80cm × 100cm

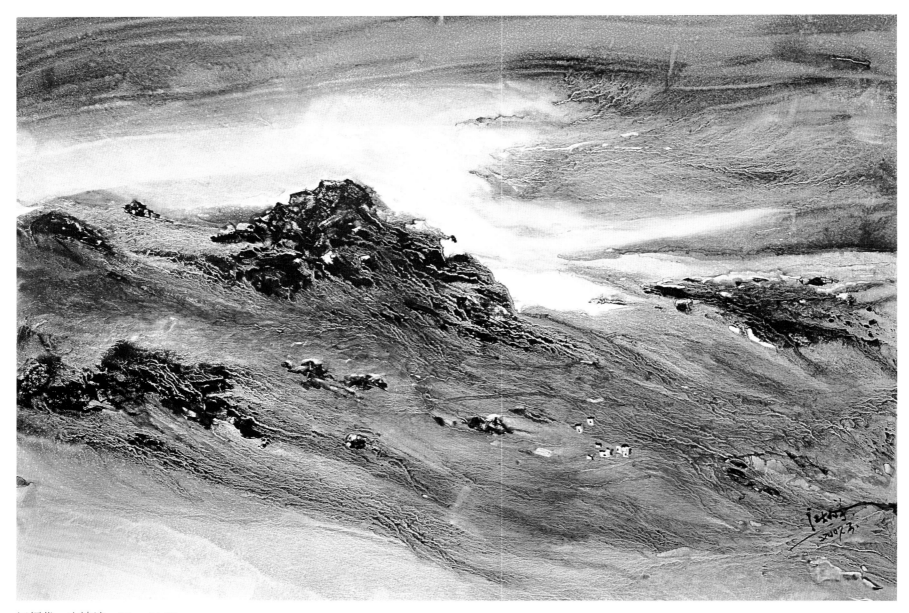

江炳华　山坡地　55cm × 80cm
Jiang Binghua　*Hilly ground*　55cm × 80cm

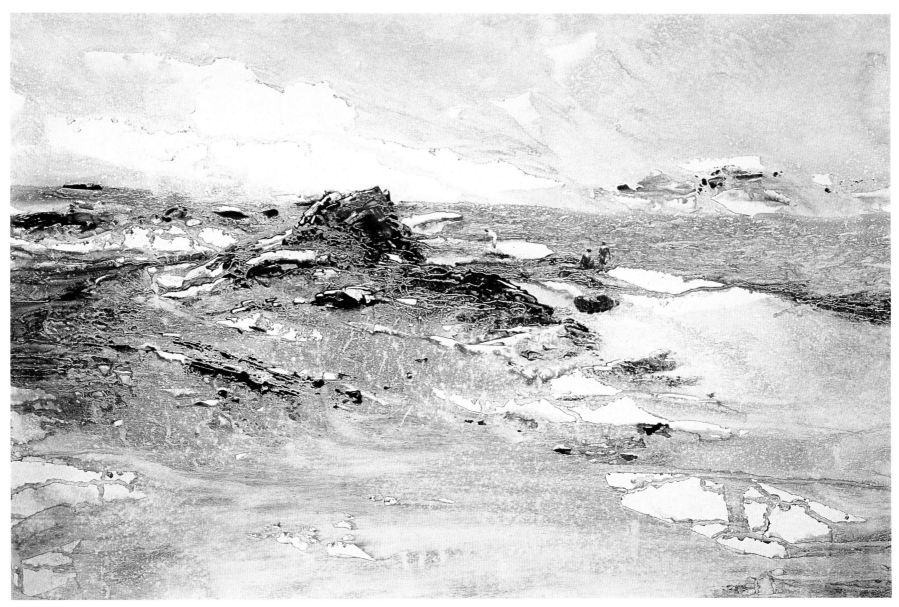

江炳华　北部湾漫步　55cm × 80cm
Jiang Binghua　*Wandering in Beibu Gulf*　55cm × 80cm

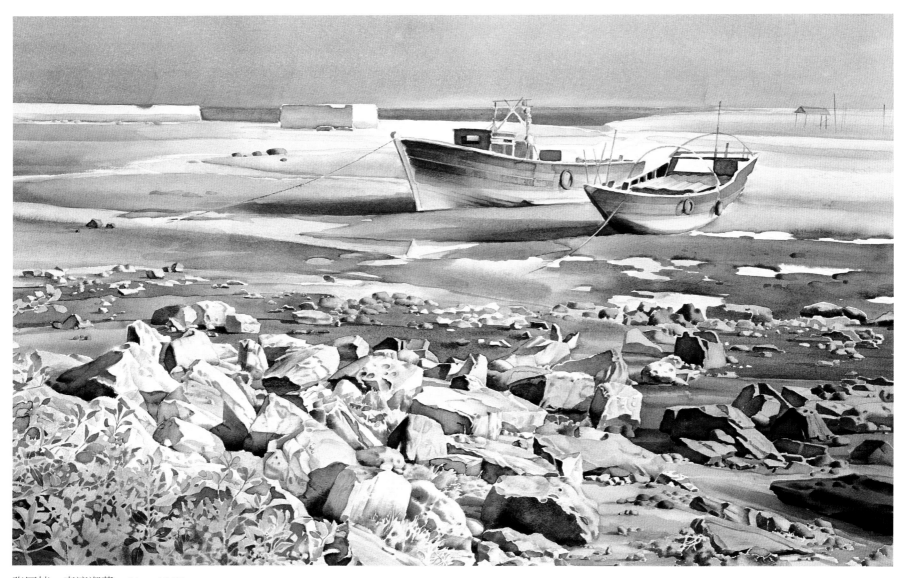

张国楠　南湾潮落　54cm × 79cm
Zhang Guonan　*Falling tide in Nan Bay*　54cm × 79cm

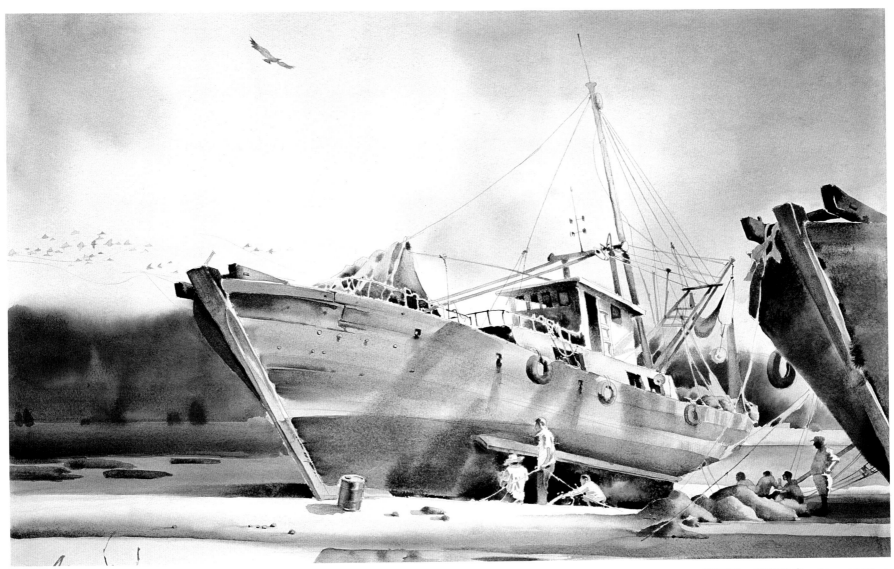

张国楠　整装待发　54cm × 79cm
Zhang Guonan　*Ready to set off*　54cm × 79cm

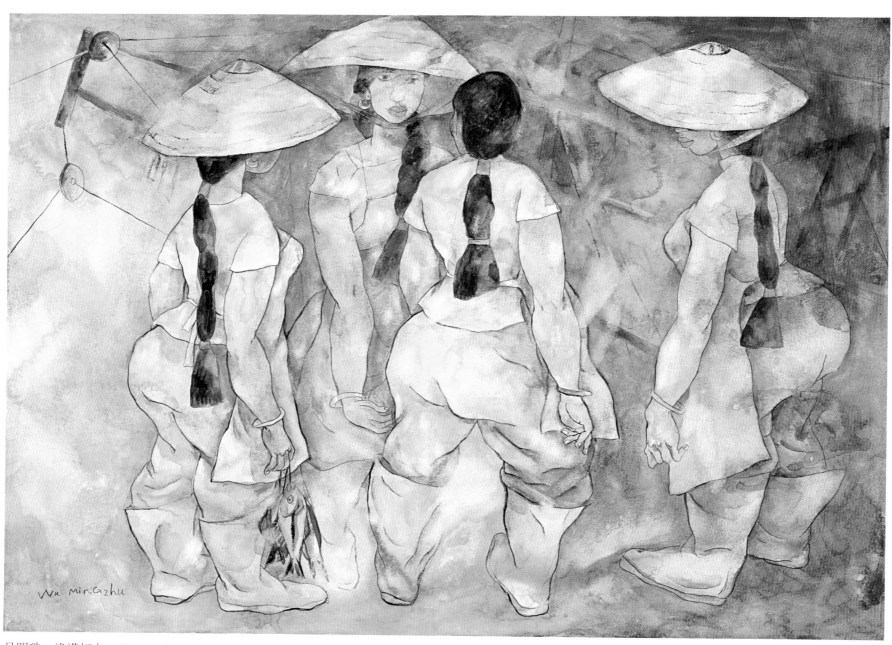

吴明珠　渔港妇女　77cm × 106cm
Wu Mingzhu　*Women of fishing port*　77cm × 106cm

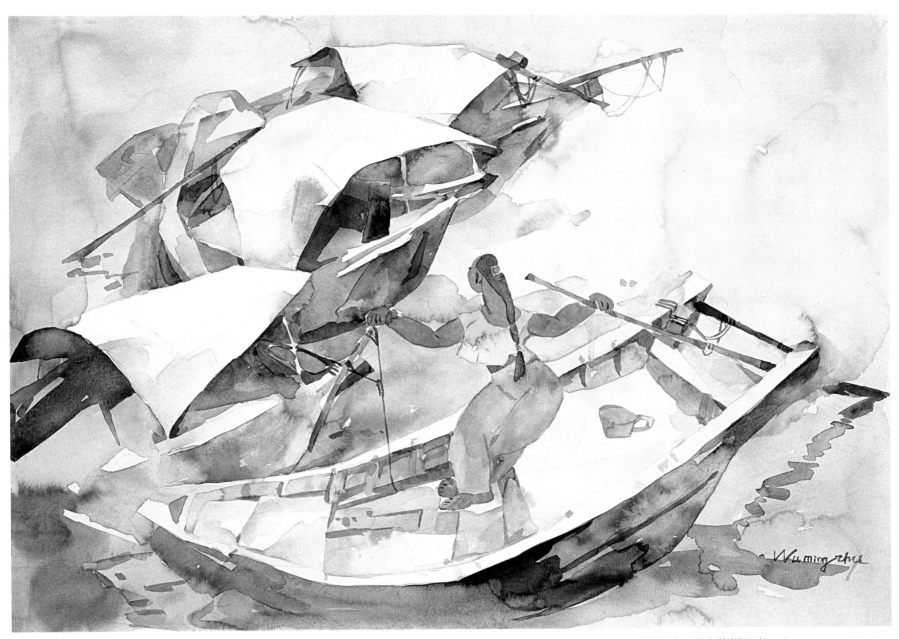

吴明珠　蛋家的摆渡女·之二　54cm × 79cm
Wu Mingzhu　*No.2 of ferry woman*　54cm × 79cm

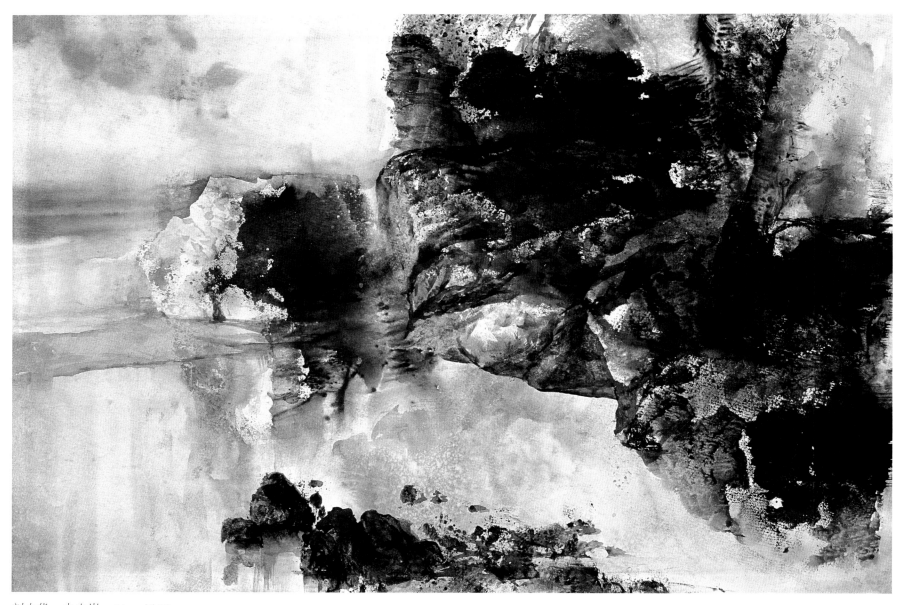

刘少华　火山岩　54cm × 79cm
Liu Shaohua　*Lava*　54cm × 79cm

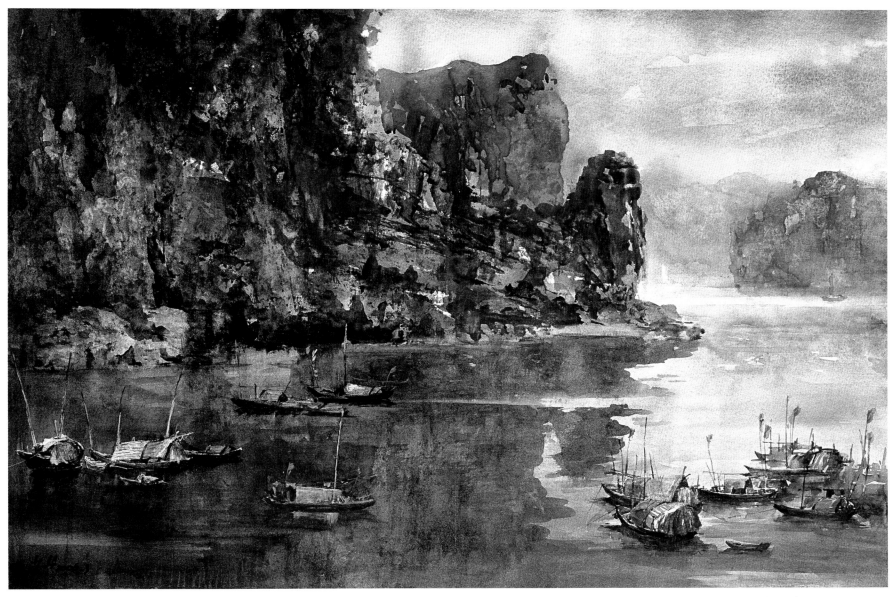

刘少华　泊　54cm × 79cm
Liu Shaohua　*The Berth*　54cm × 79cm

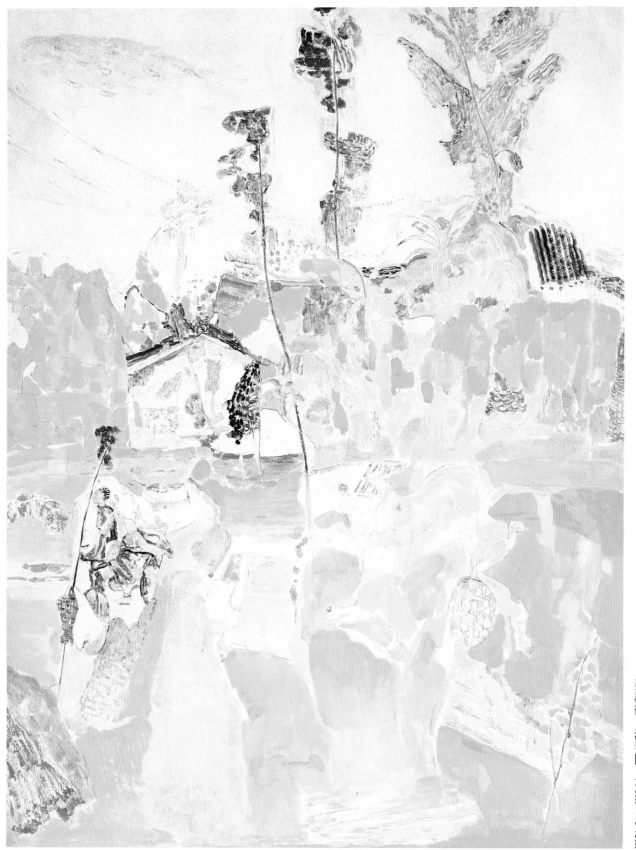

Cai Qunhui *Spring outing* 79cm × 54cm
蔡群徽 游春图 79cm × 54cm

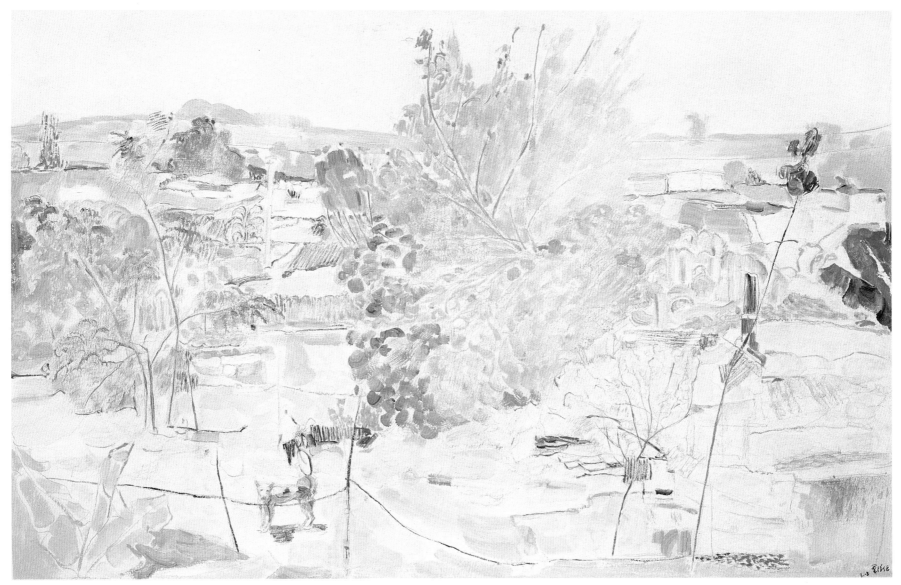

蔡群徽　九头庙秋色　79cm × 109cm
Cai Qunhui　*Jiutou Temple in autumn*　79cm × 109cm

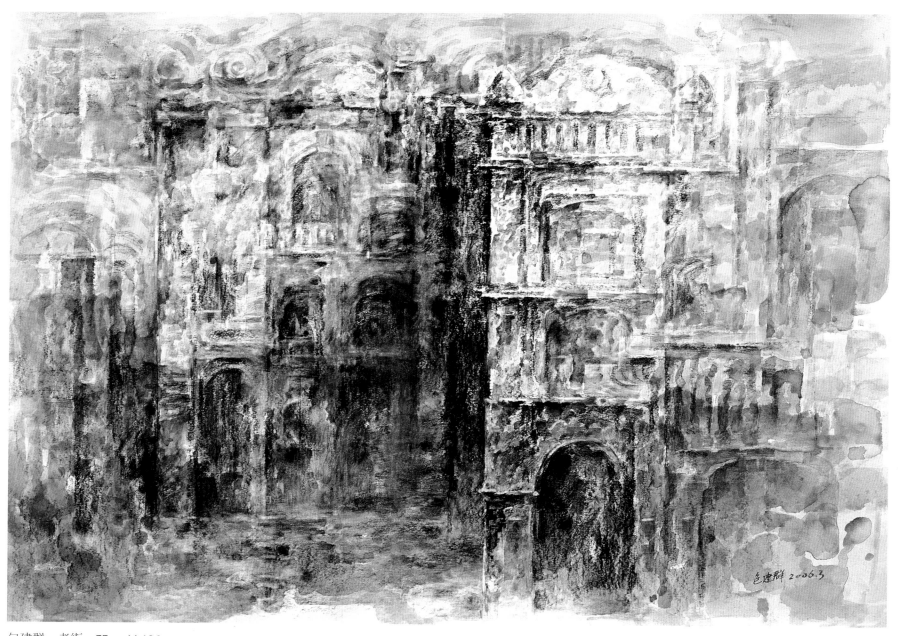

包建群 老街 77cm × 106cm
Bao Jianqun *Old street* 77cm × 106cm

144

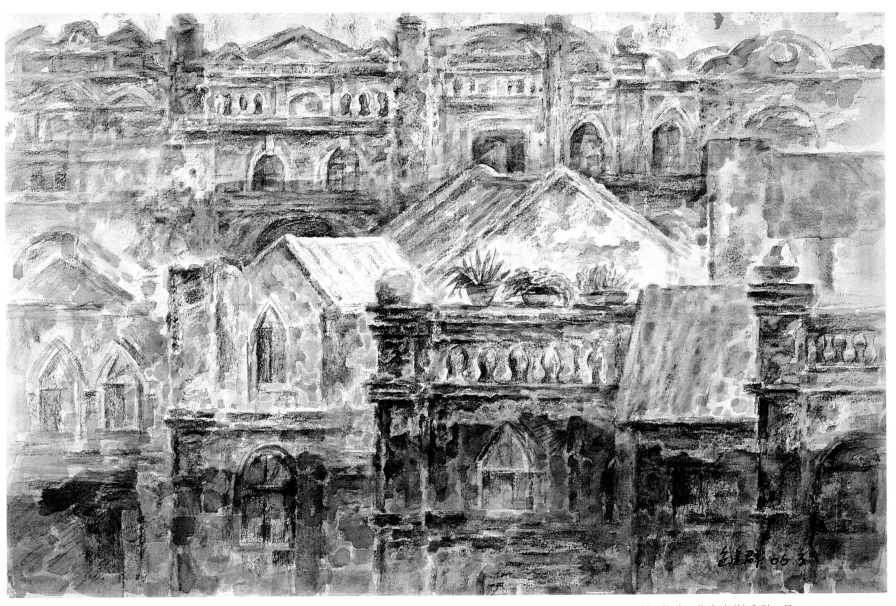

包建群　北海老街系列6号　77cm×106cm
Bao Jianqun　*No.6 of Beihai old street series*　77cm×106cm

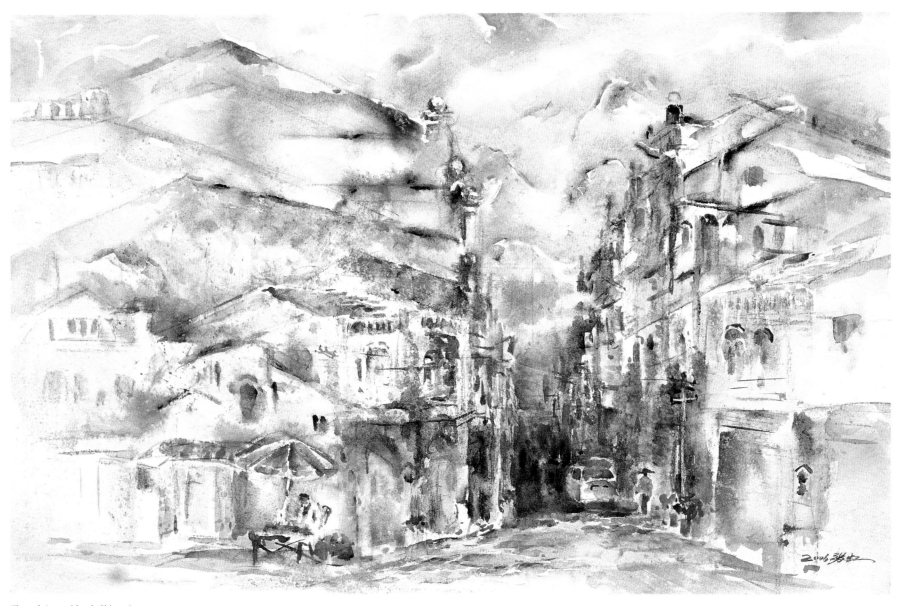

张 虹 百年老街·之一 54cm × 79cm
Zhang Hong *No.1 of a centennial street* 54cm × 79cm

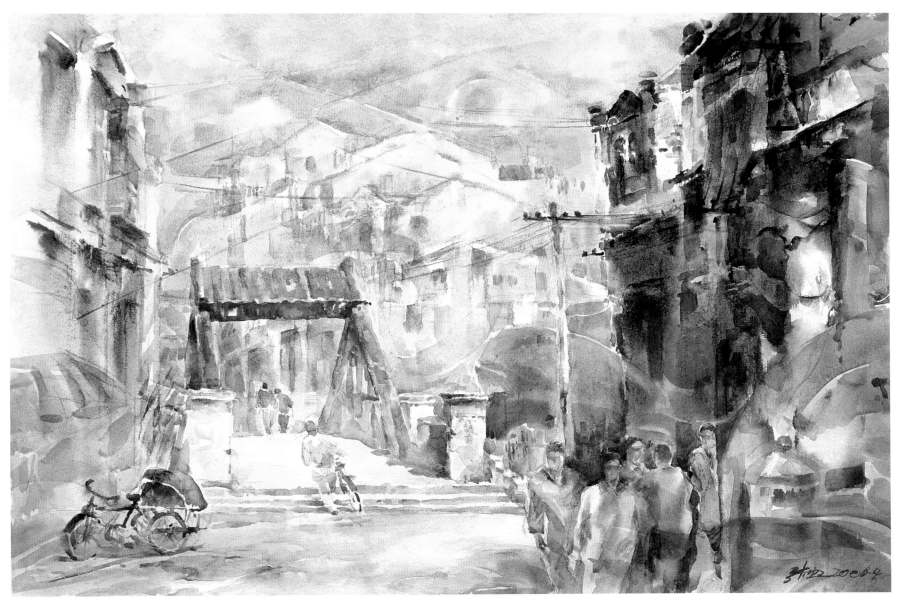

张　虹　百年老街·之二　54cm × 79cm
Zhang Hong　*No.2 of a centennial street*　54cm × 79cm

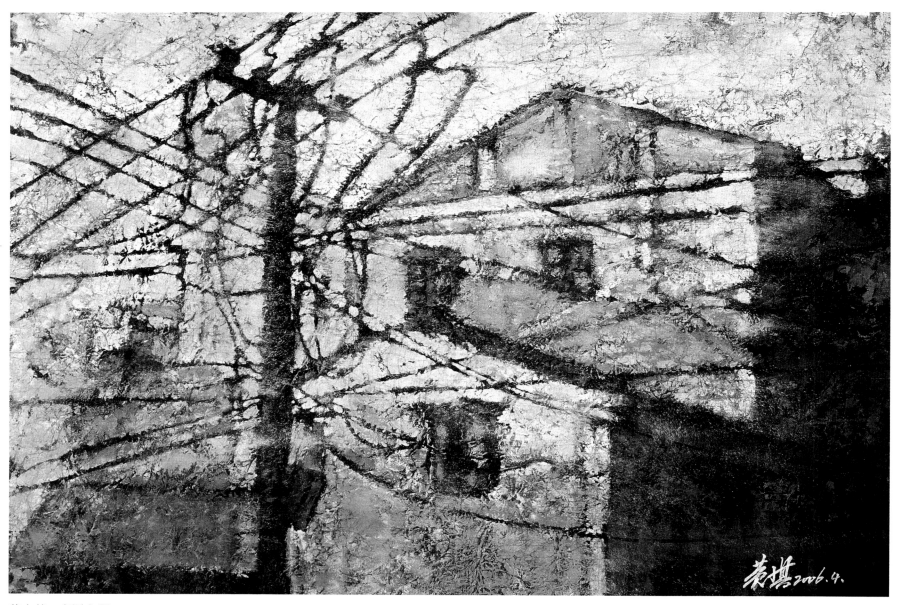

黄小其　老屋夕照　54cm × 79cm
Huang Xiaoqi　*Evening glow on old house*　54cm × 79cm

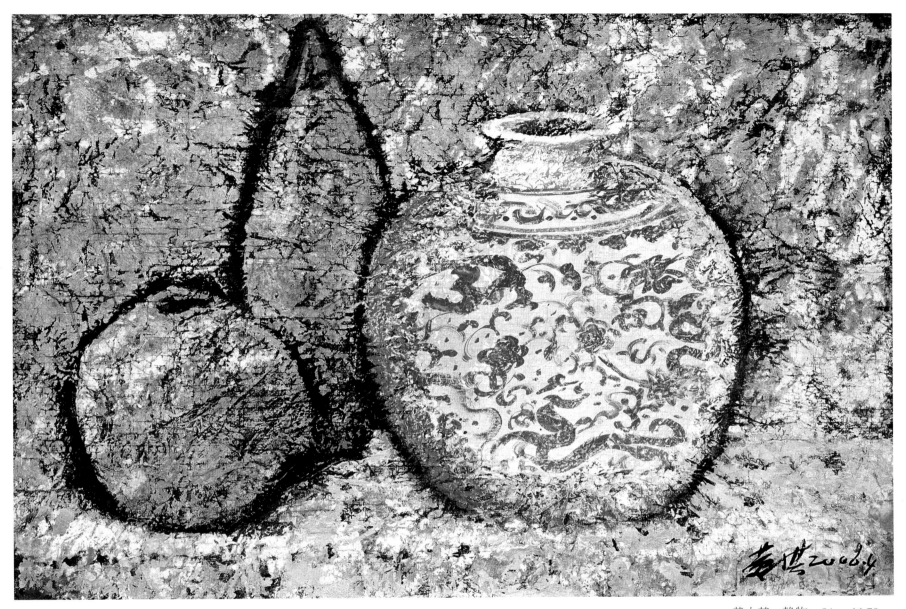

黄小其　静物　54cm × 79cm
Huang Xiaoqi　*Still-life*　54cm × 79cm

周红娣　风花雪月　54cm × 79cm
Zhou Hongdi　*Romance with wind, flowers, snow and moon*　54cm × 79cm

周红娣　春蕾　54cm × 79cm
Zhou Hongdi　*Spring buds*　54cm × 79cm

贺立言　乘风破浪　54cm × 79cm
He Liyan　*Sailing through wind and waves*　54cm × 79cm

贺立言　漓江　54cm × 79cm
He Liyan　*Lijiang River*　54cm × 79cm

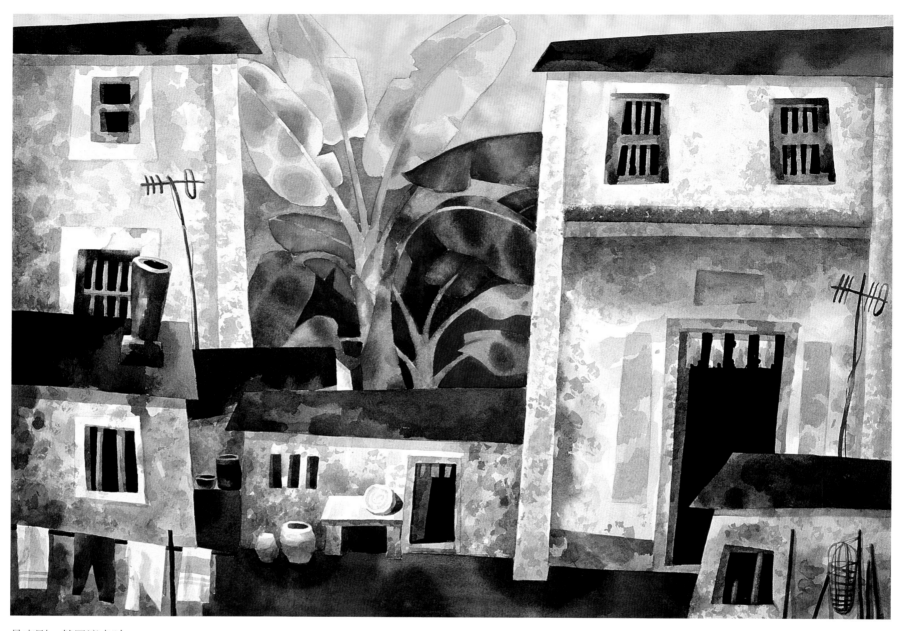

吴志刚　梦回滴水时　54cm × 79cm
Wu Zhigang　*Dream back to rainy season*　54cm × 79cm

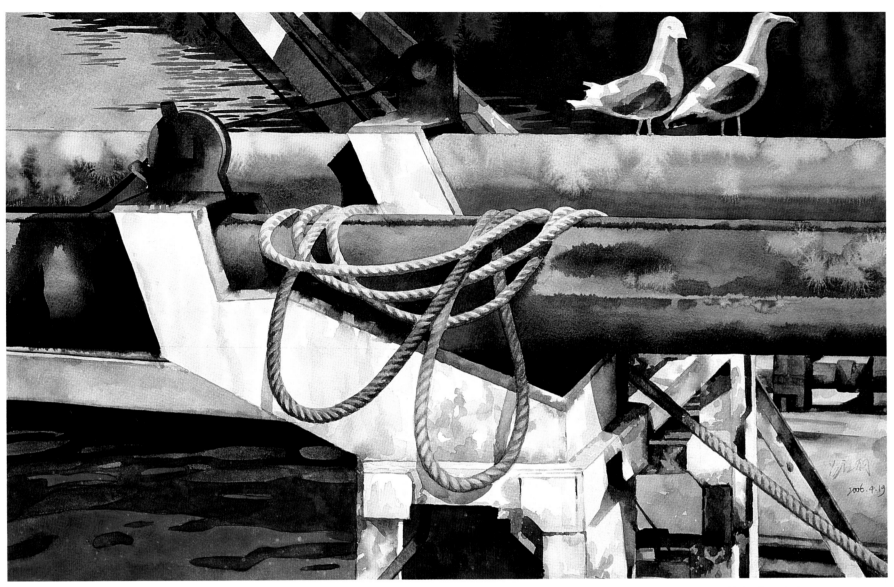

吴志刚 对语 54cm × 79cm
Wu Zhigang *Whisper* 54cm × 79cm

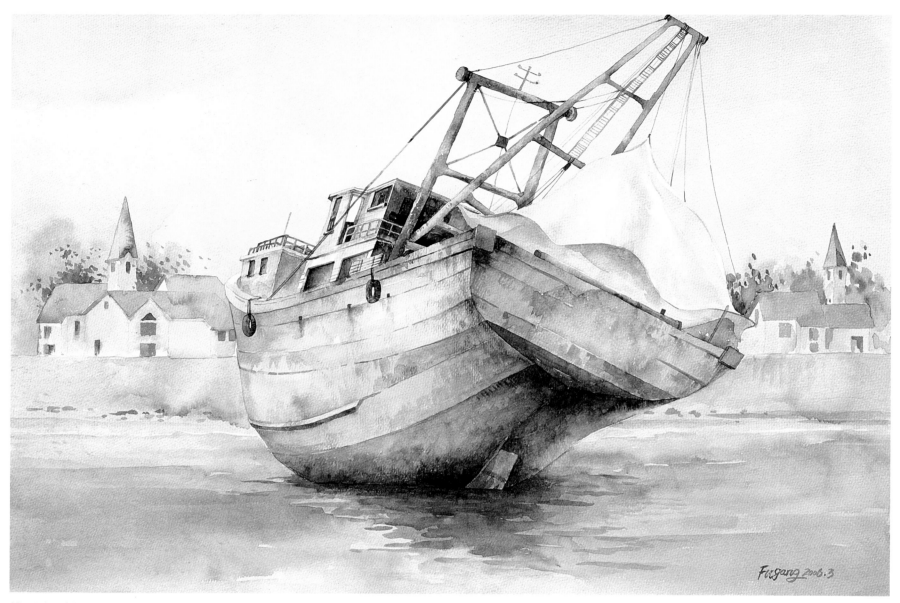

傅 刚 凉风 54cm × 79cm
Fu Gang *Cool breeze* 54cm × 79cm

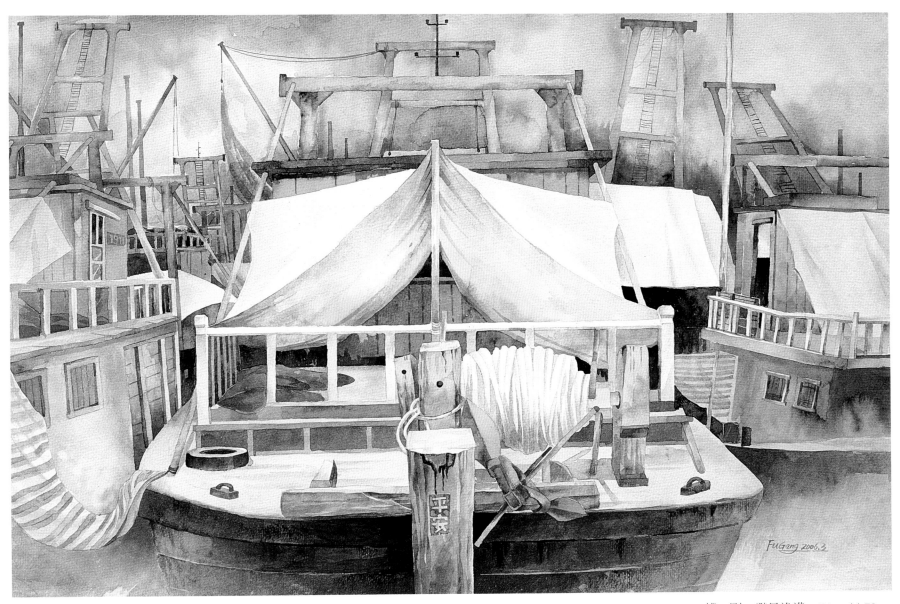

傅　刚　避风渔港　54cm × 79cm
Fu Gang　*Harbor shelter*　54cm × 79cm

画家简历

Brief Introductions of Artists

阳太阳

1909年生，广西桂林人。1931年毕业于上海艺专，在上海与庞薰琴、倪贻德等人创办"决澜社"，提倡新绘画。1935年入日本大学研究各国绘书艺术并积极创作。其油画作品入选世界性大型美展"日本二科美展"，与马蒂斯、罗丹、戈雅、勃拉克等大师的作品同场展出，并同时印入画册，被誉为"中华之夸"。

1949年后，历任广州美术学院院长、广西艺术学院院长、广西书画院院长、桂林中国书画院院长、中国美协理事、广西美协名誉主席、广西政协副主席等职。60年代初提出"漓江画派"文化主张，是漓江画派开拓者及代表人物。

Mr. Yang Taiyang, born in Guilin, Guangxi in 1909; graduated from Shanghai Fine Arts College in 1931; established "Julan Association" with Pang Xunqin, Ni Yide in Shanghai. In 1935, he entered Japan University. He participated in Japan's Second Major Art Exhibition, and his works were displayed and published along with works of Matisse, Rodin, Goray, and Boroque and received the title of "Pride of China".

After 1949, he became President of Guangzhou Academy of Fine Arts, Guangxi Arts Institute, Guangxi Academy of Painting and Calligraphy, and Guilin Academy of Chinese Traditional Painting; Director of China Artists Association, Honorary President of Guangxi Artists Association; He proposed Lijiang Painting School in the early 60s of last century and is an important founder member and distinguished representative figure of Lijiang Painting School in China.

黄格胜

1950年生于广西、壮族。1980年考取广西艺术学院研究生，师从著名画家黄独峰。1982年毕业留校，1998年任广西艺术学院院长。现为全国政协常委，十届全国政协代表，中国文联委员，中国美协理事，致公党中央常委，致公党广西区委会主委，广西政协常委，教育部高等院校艺术教育指导委员会副主任，广西区政府学位委员会委员，广西文联副主席。国家级优秀专家并享受国务院特殊津贴。

Mr. Huang Gesheng, born in Guangxi in 1950; Zhuang ethnic group; He gained an admission to the graduate school of Guangxi Arts Institute in 1980 and studied with famous artist Huang Dufeng; began teaching after graduation in 1982 and promoted to President of Guangxi Arts Institute in 1998; member of CPPCC Standing Committee, member of 10th CPPCC, member of China Arts and Literature Union, Director of China Artists Association, Executive Director of China Zhi Gong Party, Director of Guangxi China Zhi Gong Party, member of Guangxi CPPCC Standing Committee, Deputy Director of Steering Committee of Art Education under Ministry of Education, Vice Chairman of Guangxi Arts and Literature Union, State Council-subsidized excellent expert.

刘绍昆

1946年5月生于北京。阳太阳先生的研究生，中国美术家协会理事，中国油画学会常务理事，广西美术家协会主席，享受"突出贡献专家"津贴。

Mr. Liu Shaokun, born in Beijing in May 1946; graduated from Graduated Program under Mr. Yang Taiyang's supervision; Director of China Artists Association, Executive Director of China Oil Painting Academy, Chairman of Guangxi Artists Association, State-subsidized expert for excellent contribution.

雷　波

1965年生。毕业于广西艺术学院，结业于中央美术学院第八届研修班和中央美术学院首届高级研究班。现为国家一级美术师、中国美术家协会理事、中国油画学会副秘书长、广西美术家协会常务副主席。

Mr. Lei Bo, born in 1965; graduate of Guangxi Arts Institute; completed the 8th Training Course and 1st Senior Seminar of China Central Academy of Fine Arts; National First-class artist, Director of China Artists Association, Deputy Secretary of China Oil Painting Academy, Executive Vice Chairman of Guangxi Artists Association.

唐玉玲

广西全州人。1987年毕业于广西艺术学院美术师范系。先后于1992年和1997年到中央美术学院中国画系进修两年。现为中国美术家协会理事、广西美术家协会副主席、漓江画派促进会常务理事。

Ms. Tang Yuling was born in Quanzhou, Guangxi. She graduated from the Department of Fine Art Education of Guangxi Arts Institute in 1987. She went to the Central Academy of Fine Arts for her further study twice, in 1992 and 1997. She is now a director of China Artists Association, the vice president of Guangxi Artists Association, and a standing director of Promoting Committee of Lijiang Painting School.

雷务武

1953年6月生于广西南宁，1982年1月毕业于广西艺术学院美术系版画专业，4年本科，获文学学士学位。现为广西艺术学院教授、广西艺术学院美术学院院长、中国美术家协会会员、广西美术家协会副主席。1994年被广西壮族自治区政府评为广西"有突出贡献科技人员"称号，1998年被广西文联评为"德艺双馨"文艺家称号。

Mr. Lei Wuwu, born in Nanning, Guangxi in June 1953; graduated from Dept of Fine Arts of Guangxi Arts Institute in Jan. 1982 (undergraduate program), major: Printmaking, degree received: B.A.; awarded as Ethics and Talent Artist by Guangxi Arts and Literature Union in 1998 and Scientist of Outstanding Contribution by Guangxi Government in 1994; Professor of Guangxi Arts Institute, Dean of College of Fine Arts of Guangxi Arts Institute, member of China Artists Association, Vice Chairman of Guangxi Artists Association.

余永健

1957年生，福建漳州市人。1986年毕业于广西艺术学院美术系并留校任教。现为广西艺术学院桂林中国画学院院长、副教授、硕士生导师、中国美术家协会会员、广西美术家协会副主席。

Mr. Yu Yongjian, born in Zhangzhou, Fujian in 1957; began teaching in Guangxi Arts Institute since graduation in 1986; Dean, Associate Professor and master advisor of Guilin Chinese Painting Academy, member of China Artists Association, Vice Chairman of Guangxi Artists Association.

柒万里

生于广西南宁，苗族。毕业于广西艺术学院美术系，1979年师从岭南派及海派大师黄独峰教授。现任广西艺术学院设计学院院长、教授、硕士研究生导师，兼任新岭南书画研究院院长、广西美术家协会副主席、广西民族书画院副院长、秘书长、广西广告协会理事、广西普通高校艺术类招生考试专家委员会委员。

Mr. Qi Wanli, born in Nanning, Guangxi, Miao ethnic group; graduated from Dept of Fine Arts of Guangxi Arts Institute, studied painting under supervision of Prof. Huang Dufeng, a well-known Lingnan and Shanghai style painter; Dean, Professor and master advisor of Design College of Guangxi Arts Institute, Vice Chairman and Secretary General of Guangxi Artists Association, Director of Guangxi Advertisement Association, member of Expert Committee in Art Major Recruitment of Guangxi Higher Education.

蔡道东

1943年出生。曾担任中国水彩画大展评委和中国综合性国家美展省级评委，曾任北海市文化局局长和文联主席职务。现为中国美术家协会会员、广西美术家协会副主席和水彩画艺委会主任、国家一级美术师、教授。

Mr. Cai Daodong, born in 1943; former judge of national and provincial watercolor competitions and arts exhibitions, former Director of Beihai Bureau of Culture and Chairman of Beihai Art and Literature Union; member of China Artists Association, Vice Chairman of Guangxi Artists Association and Director of Guangxi Watercolor Artists Committee, national first-class artist, professor.

戴延兴

1950年1月出生于广西桂林。毕业于广西师范大学艺术系，进修结业于广州美术学院中国画系。现为桂林美术馆馆长、广西美术家协会副主席、桂林市文联副主席、桂林市美术家协会副主席、中国美术家协会会员。

Mr. Dai Yanxing, born in Guilin, Guangxi in Jan. 1950; graduate of Dept. of Fine Arts of Guangxi Normal University, received training course in Chinese Painting Dept. of Guangzhou Academy of Fine Arts; Director of Art Gallery of Guilin, Vice Chairman of Guangxi Artists Association, Vice Chairman of Guilin Art and Literature Union, Vice Chairman of Guilin Artists Association, member of China Artists Association.

张复兴

1946年生，天津人，祖籍山西。现为中国艺术研究院美术创作院创作研究员、一级美术师、广西美协常务理事、广西艺术学院名誉教授、桂林画院院长、中国美术家协会会员、广西自治区政协委员。

Mr. Zhang Fuxing, born in Tianjin in 1946, family origin: Shanxi; researcher of Arts Creation College of China Arts Academy, National First-class artist, Executive Director of Guangxi Artists Association, Honorary Professor of Guangxi Arts Institute, President of Guilin Painting Institute, member of China Artists Association, member of Guangxi CPPCC.

谢 森

1953年出生于广西。1976年毕业于广西艺术学院，留校任教至今。1979年进修于广州美术学院，1987年参加中央美术学院法国宾卡斯教授油画材料科技法班。现为广西艺术学院教授、硕士生导师、中国美协会员、广西美协常务理事、广西油画学会副会长。

Mr. Xie Sen, born in Guangxi in 1953; teaching in Guangxi Arts Institute since 1976 after graduation from same institute; completed training course in Guangzhou Academy of Fine Arts in 1979 and training on oil painting stuff and technique by Professor Pincas of France in China Central Academy of Fine Arts in 1987 respectively; Professor and master advisor of Guangxi Arts Institute, member of China Artists Association, Executive Director of Guangxi Artists Association, Vice President of Guangxi Oil Painting Academy.

黄 菁

1956年8月生于广西柳州。1982年毕业于广西艺术学院美术系油画专业，同年留校任教。1986年结业于中央美术学院油画系第二届油画研修班。现为广西艺术学院美术学院教授、中国美术家协会会员、中国油画学会广西分会副主任、广西美术家协会常务理事。

Mr. Huang Jing, born in Liuzhou, Guangxi in Aug. 1956; began teaching in Dept of Fine Arts of Guangxi Arts Institute after graduation in 1982, major: Oil Painting; completed 2nd Training Course in Oil Painting of China Central Academy of Fine Arts in 1986; Professor of Dept of Fine Arts of Guangxi Arts Institute, member of China Artists Association, Deputy Director of Guangxi China Oil Painters Association, Executive Director of Guangxi Artists Association.

郑军里

1957年生于广西南宁。毕业于广西艺术学院美术系中国画专业，曾在文化部中国画研究院人物画研究班深造。现为全国政协常委、中国美协会员、广西艺术学院中国画教授、硕士研究生导师。

Mr. Zheng Junli, born in Nanning, Guangxi in 1957; graduate of Chinese Painting Dept. of Fine Arts of Guangxi Arts Institute and Figure Painting Graduate Program of Traditional Chinese Painting Academy under the Ministry of Culture, member of the Standing Committee of CPPCC, member of China Artists Association, Professor and master advisor in Chinese Painting of Guangxi Arts Institute.

谢 麟

1957年生于广西容县，贺州信都人，祖籍广东德庆。1987年毕业于广西艺术学院美术系油画专业。1991年中国艺术研究院美术研究所首届全国美术干部理论研修班结业。1997年至1999年在中央美术学院第10届研修班学习。现为中国美术家协会会员，广西美术家协会秘书长。

Mr. Xie Lin, born in Rongxian County, Guangxi in 1957, native of Xindu, Hezhou, family origin: Deqing, Guangdong; graduated from Dept of Fine Arts of Guangxi Arts Institute in 1987, major: Oil Painting; completed First Artist Theory Training Course of Institute of Fine Arts of China Art Academy in 1991 and participated in the 10th Training Course of China Central Academy of Fine Arts from 1997 to 1999; member of China Artists Association, Secretary General of Guangxi Artists Association.

阳 山

1951年12月生，广西桂林人。中国当代艺术大师、著名画家、艺术教育家阳太阳教授之三子。1977年毕业于广西艺术学院美术系。现任广西艺术学院中国画学院副院长、副教授、硕士研究生导师、山水画教研室主任、中国美术家协会会员、广西美术家协会理事、广西书画院院士、广西政协委员、广西海外联谊会理事。

Mr. Yang Shan, born in Guilin, Guangxi in Dec. 1951; third son of Professor Yang Taiyang, China's contemporary master, famous painter and educator; graduated from Dept of Fine Arts of Guangxi Arts Institute in 1977; Vice Dean, Associate Professor and master advisor of Traditional Chinese Painting Academy and Director of Landscape Painting Office of Guangxi Arts Institute, member of China Artists Association, Director of Guangxi Artists Association, Academician of Guangxi Painting and Calligraphy Academy, Guangxi CPPCC member, Director of Guangxi Overseas Friendship Association.

伍小东

1960年生，广西桂林市人。1986年毕业于广西艺术学院美术系中国画专业，获学士学位。现为广西艺术学院桂林中国画学院副院长、副教授、硕士生导师。广西美术家协会常务理事，中国艺术研究院第二期中国画名家班学员。

Mr. Wu Xiaodong, born in Guilin, Guangxi in 1960; graduated from Dept of Fine Arts of Guangxi Arts Institute in 1986, major: Traditional Chinese Painting, degree received: B.A., completed 2nd Training Course in Traditional Chinese Painting of China Art Academy; Vice President, Associate Professor and master advisor of Guilin Chinese Painting and Calligraphy Academy of Guangxi Arts Institute, Executive Diretor of Guangxi Artists Association.

阳 光

1954年生，桂林人。毕业于广西师范大学美术系。现为桂林书画院副院长，桂林美术馆副馆长，国家一级美术师，中国美协会员，桂林市政协常委，广西人大代表。

Mr. Yang Guang, born in Guilin in 1954; graduate of Dept of Fine Arts of Guangxi Normal University; Vice President of Guilin Painting and Calligraphy Academy, Vice Director of Guilin Art Gallery, National First-class Artist, member of China Artists Association, Member of Guilin CPPCC, Guangxi NPC member.

姚震西

1966年生，广西合浦人。1988年毕业于广西艺术学院。现为广西美术出版社副总编、副编审、中国美术家协会会员、广西美术家协会理事、漓江画派促进会理事。

Mr. Yao Zhenxi was born in Hepu, Guangxi in 1966. Graduating from Guangxi Arts Institute in 1988, he is currently a vice editor-in-chief of the Guangxi Fine Art Publishing House in addiction to a member of the China Artists Association, a director of Guangxi Artists Association as well as a director of Promoting Committee of Lijiang Painting School.

刘南一

1956年生于广州市。1981年毕业于广西艺术学院，1992年结业于北京首都师范大学美术系研修班。现为广西艺术学院美术学院副院长、副教授、美术学硕士研究生导师、中国美术家协会会员、广西美术家协会常务理事。

Mr. Liu Nanyi, born in Guangzhou in 1956; graduated from Guangxi Arts Institute in 1981, completed training course of Dept of Fine Arts of Beijing Normal University in 1992; Vice Dean, Associate Professor and master advisor of Dept of Fine Arts of Guangxi Arts Institute, member of China Artists Association, Executive Director of Guangxi Artists Association.

黄超成

广西艺术学院教授，中国美术家协会会员，广西美术家协会常务理事，广西大地水彩画会副会长。

Mr. Huang Chaocheng, Professor of Guangxi Arts Institute, member of China Artists Association, Executive Director of Guangxi Artists Association, Vice Chairman of Guangxi Dadi Watercolor Painting and Art Association.

梁 耀

1959年11月生。中国美术家协会会员、广西致公画院副院长、广西艺术学院教授、广西书画院副院长。

Mr. Liang Yao, born in Nov. 1959; member of China Artists Association, Vice Dean of Guangxi Zhi Gong Painting Institute and Guangxi Painting and Calligraphic Academy, Professor of Guangxi Arts Institute.

黄宗湖

1954年生，广西玉林人。毕业于江南大学、日本爱知艺术大学研究生院，硕士。现为广西美术出版社总编辑，漓江画派促进会常务理事、"南方花鸟画"主要画家，广西人民代表大会华侨外事委员会委员，广西艺术学院和广西师范学院客座教授，广西书籍装帧艺术委员会副主任，第六届全国书籍装帧作品展评委，《中国书籍装帧年鉴》编委。

Mr. Huang Zonghu was born in 1954. His undergraduate study was in Jiangnan University and got his MA degree in Aichi Arts University in Japan. He is the editor-in-chief of Guangxi Fine Arts Publishing House, a standing director of Promoting Committee of Lijiang Painting School, an artist for Southern Flower-and-bird Painting, a member of Oversea Chinese Affairs Committee of NPC in Guangxi, a guest professor of both Guangxi Arts Institute and Guangxi Teachers Education College, the vice director of Guangxi Book Design Committee, a judge in the Sixth National Exhibition of Book Design, and an editor of *Book Design Annual in China*.

白晓军

1959年生，广西桂林人。1986年于广西艺术学院中国画研究生班毕业。现为广西师大美术系副教授、硕士研究生导师，第十届全国人民代表大会代表，桂林市政协副主席，中国美术家协会会员，广西美术家协会理事，桂林市美术家协会副主席，桂林中国画院副院长。

Mr. Bai Xiaojun was born in 1959. He finished his graduate courses of Chinese painting in Guangxi Arts Institute in 1986. And now, he teaches as an associate professor in the Department of Fine Art in Guangxi Teachers University as well as a director of graduate students. He was a representative of 10th NPC and vice chairman of PPC in Guilin. He is also a member of China Artists Association, a director of Guangxi Artists Association, the managing director of Promoting Committee of Lijiang Painting School, the vice president of Guilin Artists Association, the vice president of Guilin Academy of Chinese Painting.

刘 新

广西艺术学院美术学院副教授、美术史教研室主任，广西美术家协会理论委员会主任，中国美术家协会会员。从事美术史、批评、绘画等专业工作。

Mr. Liu Xin, Association Professor of Academy of Fine Arts and Director of History of Fine Arts Office of Guangxi Arts Institute, Director of Theory Committee of Guangxi Artists Association, member of China Artists Association; research fields: history of fine arts, critics and painting.

陈中华

合浦南珠人，研究生。1982年毕业于广西艺术学院美术系绘画专业。现为民建中央文化委员会委员、广西区政协委员、中国美术家协会会员、广西美术家协会理事。曾任广西民族学院艺术学院院长，现任广西民族大学中国—东盟研究中心副主任。

Mr. Chen Zhonghua, born in Nanzhu, Hepu; graduated from Dept of Fine Arts of Guangxi Arts Institute in 1982, major: Painting, highest education received: graduate program; member of Central Cultural Committee of China Democratic National Construction Association, Guangxi CPPC and Guangxi Artists Association, Director of Guangxi Artists Association, former Dean of College of Arts of Guangxi University for Nationalities, Deputy Director of China-ASEAN Studies Center of Guangxi University for Nationalities.

徐贵忠

1962年生于黑龙江省齐齐哈尔市。1988年毕业于中国美术学院油画系、1994年结业于中央美术学院油画系研修班、2003年国家公派俄罗斯访问学者。曾任教于广西师范大学艺术系，现任教于广西艺术学院美术学院。

Mr. Xu Guizhong, born in Qiqiha'er, Heilongjiang in 1962; graduated from Dept of Oil Painting of China Academy of Fine Arts in 1988 and completed training course in oil painting of China Central Academy of Fine Arts in 1994; state sponsored visiting scholar to Russia in 2003; previous teacher at Dept of Arts of Guangxi Normal University, now teaching at Dept of Fine Arts of Guangxi Arts Institute.

李福岩

1962年生于吉林。1987年毕业于西北师范大学美术系油画专业，获学士学位。1996年毕业于中央美术学院第八届油画研修班。现为广西艺术学院美术学院副教授、硕士研究生导师、油画系主任。

Mr. Li Fuyan, born in Jilin in 1962; graduated from Dept of Fine Arts of Northwest Normal University in 1987, major: Oil Painting, degree received: B.A.; completed the 8th Oil Painting Training Course of China Central Academy of Fine Arts in 1996; Associate Professor of Dept of Fine Arts of Guangxi Arts Institute, master advisor, Dean of Oil Painting Dept.

曾邕生

1951年生，广西南宁市人，京族。现为中国美术家协会会员、广西南宁市美协主席、广西美协常务理事、广西美术创作院长。

Mr. Zeng Yongsheng, born in Nanning, Guangxi in 1951; Jing ethnic group; member of China Artists Association, Chairman of Guangxi Nanning Artists Association, Executive Director of Guangxi Artists Association, Dean of Guangxi Academy of Art Creation.

杨 诚

1963年出生于广西南宁。1988年毕业于广西艺术学院美术系油画专业。现为广西美术家协会会员，中国美术家协会会员，广西美术出版社副编审。

Mr. Yang Cheng, born in Nanning, Guangxi in 1963; graduated from Dept of Fine Arts of Guangxi Arts Institute, major: Oil Painting; member of China Artists Association and Guangxi Artists Association, Associate Senior Editor of Guangxi Art Publishing House.

陈再乾

1952年5月生于广西容县。现为中国花鸟画硕士研究生导师，中国美术家协会会员，广西美术家协会理事，国家人事部中国人才研究会书画人才专业委员会委员。

Mr. Chen Zaiqian, born in Rongxian County, Guangxi in May 1952; master advisor of Chinese flower-and-bird painting, member of China Artists Association, Director of Guangxi Artists Association, member of Calligraphic Painting Committee of Chinese Talents Society of Ministry of Personnel.

王庆军

毕业于广西艺术学院美术系，进修于中国美协国画人物高研班与山水高研班。现为广西美协创作中心副主任，广西美协理事，《美术界》杂志编委，中国美术家协会会员。

Mr. Wang Qingjun, graduate of Dept of Fine Arts of Guangxi Arts Institute, completed training courses in traditional Chinese painting, figure painting and landscaping painting for senior artists by China Artists Association; Deputy Director of Creative Center and Director of Guangxi Artists Association, Editor of The World of Fine Arts, member of China Artists Association.

徐家珏

毕业于广州美术学院中国画系，现为中国美术家协会会员，桂林市美术家协会秘书长，广西书画院院士，桂林画院秘书长，国家高级美术师。

Mr. Xu Jiajue, graduate of Dept of Traditional Chinese Painting of Guangzhou Academy of Fine Arts; member of China Artists Association, Secretary General of Guilin Artists Association, Academician of Guangxi Painting and Calligraphy Academy, Secretary General of Guilin Painting and Calligraphy Academy, senior artist.

李灵机

1950年生，广东顺德人。现为中国美术家协会会员，广西美术家协会理事，梧州市美术家协会主席，国家二级美术师。

Mr. Li Lingji, born in Shunde, Guangdong; member of China Artists Association, Director of Guangxi Artists Association, Chairman of Wuzhou Artists Association, national second-class artists.

陈毅刚

1968年出生于广西钦州，1990年毕业于广西艺术学院美术系，1999年毕业于中央美术学院油画系研修班。现为广西桂林师范高等专科学校美术系副教授、副主任，中国美术家协会会员，中国油画家学会会员，广西美术家协会会员，广西油画学会会员。

Mr. Chen Yigang, born in Qinzhou, Guangxi in 1968; graduated from Dept. of Fine Arts of Guangxi Arts Institute in 1990, completed training in Dept. of Oil Painting of China Central Academy of Fine Arts in 1999; Associate Professor and Vice Dean of Dept. of Fine Arts of Guangxi Guilin Teachers College, member of China Artists Association, China Oil Painters Association, Guangxi Artists Association and Guangxi Oil Painters Association.

肖畅恒

1984年毕业于广西艺术学院。现为中国美术家协会会员，广西水彩画艺委会副秘书长，北海市文联副主席，北海市美协常务副主席，北海画院院长。

Mr. Xiao Changheng, graduated from Guangxi Arts Institute in 1984; member of China Artists Association, Secretary General of Guangxi Watercolor Painting and Arts Committee, Vice Chairman of Beihai Art and Literature Union, Executive Director of Beihai Artists Association, Director of Beihai Painting Academy.

吴烈民

1942年生，桂林市龙胜各族自治县人。毕业于广西艺术学院美术系，结业于中央美术学院。中国美术家协会会员。历任广西美术家协会理事、广西政协委员、漓江出版社副编审、装帧室主任。

Mr. Wu Liemin, born in Longsheng Minorities Autonomous County, Guilin in 1942; graduate of Dept of Fine Arts of Guangxi Arts Institute and China Central Academy of Fine Arts; member of China Artists Association, Director of Guangxi Artists Association, member of Guangxi CPPCC, Associate Senior Editor and Director of Design Studio of Lijiang Publishing House.

黄少鹏

1968年生于广西钦州。1991年毕业于广西艺术学院美术系油画专业，同年在广西群众艺术馆工作，1993年居北京"圆明园画家村"，1996年至今在广西艺术学院任教。

Mr. Huang Shaopeng, born in Qinzhou, Guangxi in 1968; began work at Guangxi Mass Art Center after graduated from Dept of Fine Arts of Guangxi Arts Institute (major: Oil Painting) in 1991; moved to live in Artists Village of Imperial Palace in Beijing in 1993; teaching in Guangxi Arts Institute since 1996.

傅俊山

安徽省亳州市人，毕业于鲁迅美术学院版画系。现为中国美术家协会会员，中国版画家协会会员，广西版画艺委会副主任兼秘书长，广西大地水彩画会理事，广西艺术学院美术学院副教授、版画第二工作室主任、硕士生导师。

Mr. Fu Junshan, native of Bozhou, Anhui Province; graduate of Dept of Printmaking of Luxun Art Academy; member of China Artists Association and China Printmaking Artists Association, Vice Dean and Secretary General of Guangxi Printmaking Arts Society, Director of Guangxi Dadi Watercolor Painting Academy; Associate Professor of Dept of Fine Arts of Guangxi Arts Institute, Director of the 2nd Printmaking Studio, master advisor.

曾翠玲

1991年毕业于广西艺术学院美术系，现为广西美术家协会理事。任教于广西青年干部学院。

Ms. Zeng Cuiling, graduated from Dept of Fine Arts of Guangxi Arts Institute in 1991, member of Guangxi Artists Association, teacher of Guangxi Youth Cadres Academy.

王可大

1953年生，北京市人。1982年毕业于哈尔滨师范大学美术学院油画专业，获学士学位。现任广西师范大学美术学院副教授，中国美术家协会会员，广西美协常务理事，桂林画院院士。

Mr. Wang Keda, born in Beijing in 1953; graduated from Dept of Fine Arts of Harbin Normal University in 1982, major: Oil Painting, degree received: B.A.; Associate Professor of College of Fine Arts of Guangxi Normal University, member of China Artists Association and Guangxi Artists Association, Executive Diretor of Guangxi Artists Association, Academician of Guilin Painting and Calligraphy Studio.

江炳华

广西柳州市人。职业画家，中国美术家协会会员。

Mr. Jiang Binghua, native of Liuzhou, Guangxi; freelance painter, member of China Artists Association.

杨永葳

1955年生，桂林市人。1982年毕业于广西艺术学院美术系，获学士学位。现为广西师范大学副教授，中国美术家协会会员。

Mr. Yang Yongwei, born in Guilin in 1955; graduated from Dept of Fine Arts of Guangxi Arts Institute in 1982, degree received: B.A.; Associate Professor of Guangxi Normal University, member of China Artists Association.

韦 军

1962年出生，广西武鸣人。1991年毕业于广西艺术学院美术系本科油画专业。现就职于广西艺术研究院，现为中国美术家协会会员，广西美术家协会理事。

Mr. Wei Jun, born in Wuming, Guangxi in 1962; graduate of Dept of Fine Arts of Guangxi Arts Institute (undergraduate program, major: Oil Painting); employee of Guangxi Institute of Arts, member of China Artists Association, Director of Guangxi Artists Association.

肖舜之

1956年生，广西桂林人。1984年毕业于广西艺术学院，获学士学位。1991年结业于中国美术学院中国画系。1990年至1992年参加广州美术学院中国画研究生专业课程进修班。现为广西师范大学美术学院教授、硕士研究生导师、中国美术家协会会员，广西美术家协会理事，漓江画派促进会常务理事。

Mr. Xiao Shunzhi was born in Guilin in 1956. He graduated from Guangxi Arts Institute in 1984 and awarded the Bachelor Degree. In 1991, he finished his graduate courses in Chinese Painting Department of China Academy of Fine Art. From 1990 to 1992, he attended the Graduating Courses in Guangzhou Academy of Fine Arts. Now he is a professor of Dept of Fine Arts of Guangxi Normal University and a director of graduates, a member of the China Artists Association, a managing director of Guangxi Artists Association, and the managing director of Promoting Committee of Lijiang Painting School.

蒋友舜

1949年出生于广西玉林市、毕业于广西艺术学院。现为柳州画院院长、副研究馆员，广西美协水彩画艺委会学术委员，广西艺术学院客座副教授，广西大地水彩画会理事。

Mr. Jiang Youshun, born in Yulin, Guangxi in 1949; Director of Liuzhou Painting Academy, Associate Research Librarian, member of Watercolor Arts Committee of Guangxi Artists Association, visiting associate professor of Guangxi Arts Institute, Director of Guangxi Dadi Watercolor Arts Association.

韦俊平

1966年出生。现为中国美术家协会会员，广西大地水彩画会秘书长（擅水彩画和中国画），广西艺术学院办公室主任。

Mr. Wei Junping, born in 1966; member of Guangxi Artists Association, Secretary General of Guangxi Dadi Watercolor Arts Association, Office Director of Guangxi Arts Institute; good at watercolor painting and traditional Chinese painting.

姚浩刚

1995年毕业于广西艺术学院美术系版画专业，同年留校任教至今。中国美术家协会会员。

Mr. Yao Haogang, born in 1995; teacher of Dept of Printmaking of Guangxi Arts Institute since graduation; member of China Artists Association.

李 翔

1974年生于广西柳州，壮族。1997年毕业于广州美术学院版画系铜版画专业，2004年毕业于中央美术学院版画系同等学力研究生班。现为广西艺术学院美术学院讲师。

Mr. Li Xiang, born in Liuzhou, Guangxi in 1974, Zhuang ethnic group; graduated from Dept of Printmaking of Guangzhou Academy of Fine Arts in 1997, major: copperplate Printmaking; graduated from Dept of Printmaking of China Central Academy of Fine Arts, graduate program in 2004; Lecturer of Dept of Fine Arts of Guangxi Arts Institute.

庞海燕

1995年毕业于广西艺术学院美术系版画专业，2004年结业于中央美术学院版画系同等学力研究生班。现任教于广西艺术学院。

Ms. Pang Haiyan, graduated from Dept of Fine Arts of Guangxi Arts Institute in 1995, major: Printmaking; completed Graduate Program of Printmaking of China Central Academy of Fine Arts in 2004; teacher of Guangxi Arts Institute.

罗思德

1969年生于广西德保县。广西艺术学院92级版画本科毕业，毕业后留校任教，中央美术学院97级助教进修班结业。现为广西艺术学院版画教研室主任，广西新岭南书画院高级画师。

Mr. Luo Side, born in Debao County, Guangxi in 1969; teacher of Dept of Printmaking of Guangxi Arts Institute (Grade 1992, undergraduate program) since graduation; completed Special Training Course for Teaching Assistants of Grade 1997 of China Central Academy of Fine Arts; Director of Office of Printmaking of Guangxi Arts Institute, Senior Painter of Guangxi Xinlingnan Painting and Calligraphy Academy.

蔡群徽

1996年毕业于广西艺术学院美术系油画专业。现为中国美术家协会会员，北海市美术家协会副主席，北海市美术家协会油画艺术委员会主任，北海市艺术学校副校长。

Mr. Cai Qunhui, graduated from Dept. of Fine Arts of Guangxi Arts Institute in 1996, major: Oil Painting; member of China Artists Association, Vice Chairman of Beihai Artists Association, Director of Oil Painting & Arts Committee of Beihai Artists Association, Vice President of Beihai Arts School.

熊 丁

1976年8月出生，壮族。2001年毕业于广西艺术学院，2005年考取广西艺术学院中国山水画硕士研究生，师从著名画家阳山教授。现为中国美术家协会会员。

Mr. Xiong Ding, born on Aug. 1, 1976; Zhuang ethnic group; graduated from Guangxi Arts Institute in 2001; admitted to study traditional Chinese painting of the graduate program of Guangxi Arts Institute in 2005 under the supervision of the well-known Prof. Yang Shan.

覃 勇

1968年生于广西，毕业于广西艺术学院。作品多次入选全国、自治区展览。

Mr. Qin Yong, born in Guangxi in 1968, graduate of Guangxi Arts Institute; Mr. Qin's works have been shown in various national and provincial exhibitions.

吴明珠

1982年毕业于广西艺术学院中国画系，文学学士。现为中国美术家协会会员，广西美协理事，北海市美学协会副主席，国家高级美术师。

Ms. Wu Mingzhu, graduated from Dept of Traditional Chinese Painting of Guangxi Arts Institute in 1982, B.A.; member of China Artists Association, Director of Guangxi Artists Association, Vice Chairman of Beihai Artists Association, national senior artist.

张国楠

1942年生于越南，毕业于广西艺术学院。中国美术家协会会员，高级工艺美术师。

Mr. Zhang Guonan, born in Vietnam in 1942; graduate of Guangxi Arts Institute; member of China Artists Association, senior artist.

周红娣

1960年出生于北京。广西美术家协会会员，北海画院水彩画家。

Ms. Zhou Hongdi, born in Beijing in 1960; member of Guangxi Artists Association, watercolor artist of Beihai Painting Academy.

贺立言

自由职业，长期从事平面设计及室内设计工作，水彩画家。

Mr. He Liyan, freelance water colorist with long-time experiences in graphic design and interior design.

包建群

1958年生，广西北海人。1984年毕业于广西艺术学院，获学士学位。现为广西北海市第五中学高级教师，北海画院特聘画师，中国美术家协会会员。

Mr. Bao Jianqun, born in Beihai, Guangxi in 1958; graduated from Guangxi Arts Institute in 1984, degree received: B.A.; senior teacher of Beihai No. 5 Middle School of Guangxi, guest painter of Beihai Studio, member of China Artists Association.

唐朝庆

1962年出生于桂林。1988年毕业于广西艺术学院美术系油画专业，获学士学位。广西美术家协会会员，现受聘于广西艺术学院任教。

Mr. Tang Chaoqing, born in Guilin in 1962; graduated from Dept of Fine Arts of Guangxi Arts Institute in 1988, major: Oil Painting, degree received: B.A.; member of Guangxi Artists Association, teacher of Guangxi Arts Institute.

吴以彩

1979年出生于广西玉林。2003年毕业于广西艺术学院美术系，2006年毕业于广西艺术学院油画专业研究生班，获硕士学位。现为广西美术家协会会员。

Ms. Wu Yicai, born in Yulin, Guangxi in 1979; graduated from Dept of Fine Arts of Guangxi Arts Institute in 2003, graduated from Dept of Fine Arts of Guangxi Arts Institute in 2006, major: Oil Painting, degree received: M.A.; member of Guangxi Artists Association.

潘丽萍

1979年生于广西钦州市。1996年考入广西艺术学院美术附中，1999年升入广西艺术学院美术系，就读版画专业，2003年获学士学位，同年考入广西艺术学院美术学院美术学版画方向研究生班，2006年获硕士学位。现任教于广西艺术学院美术学院，为中国美术家协会会员。

Ms. Pan Liping, born in Qinzhou, Guangxi in 1979; entered Affiliated School of Fine Arts of Guangxi Arts Institute and Dept of Fine Arts of Guangxi Arts Institute (major: Printmaking) in 1996 and 1999 respectively and Dept of Fine Arts of Guangxi Arts Institute (graduate engraving program) in 2003 after graduation and receipt of B.A. in 2003; teaching at Academy of Fine Arts of Guangxi Arts Institute, member of China Artists Assocation.

傅　刚

北海人。1986年毕业于上海市工艺美术学校绘画专业，后就读于广西艺术学院美术师范系。现就职于广西北海市群众艺术馆。现为广西美术家协会会员、北海市美术家协会秘书长、国家三级美术师。

Mr. Fu Gang, born in Beihai; graduated from Shanghai Arts Crafts College in 1986, major: Painting; graduate of Teachers' Department of Fine Arts of Guangxi Arts Institute; member of Guangxi Beihai Mass Art Center and Guangxi Artists Association, Secretary General of Beihai Artists Association, National Third Class Artist.

韦广寿

1966年生于广西环江，壮族。1990年毕业于广西艺术学院美术系。现为桂林画院专职画师，桂林美术馆学术部主任，（北京）民族画院特聘画家，中国美术家协会会员，中国少数民族美术促进会会员。

Mr. Wei Guangshou, born in Huanjiang, Guangxi in 1966; Zhuang ethnic group; graduated from Dept of Fine Arts of Guangxi Arts Institute in 1990; painter of Guilin Painting Academy, Director of Academic Dept of Guilin Art Gallery, Chair Painter of Beijing National Painting Academy, member of China Artists Association and China Committee for the Promotion of Minority Art.

张力绘

1990年毕业于广西艺术学院美术系第二油画工作室，获学士学位。现为广西美协理事、柳州市美协常务副主席、秘书长、美术学校美术师、讲师。

Mr. Zhang Lihui, graduated from 2nd Oil Painting Studio of Dept of Fine Arts of Guangxi Arts Institute in 1990, B.A.; Director of Guangxi Artists Association, Executive Vice Chairman and Secretary General of Liuzhou Artists Association, artist and lecture of Liuzhou Academy of Fine Arts.

梁　冰

1976年出生，壮族。1998年毕业于广西师范大学美术系，获学士学位，同年在广西师范学院工作。2001年考取广西艺术学院美术学院油画艺术创作方面硕士研究生，2004年获硕士学位。毕业至今，任教于广西师范学院艺术系，为美术教研室主任、讲师。

Ms. Liang Bing, born in 1976; Zhuang ethnic group; graduated from Dept of Fine Arts of Guangxi Normal University in 1998, degree received: B.A.; started teaching at Guangxi Teachers' College in the same year; admitted to Academy of Fine Arts of Guangxi Arts Institute as a graduate student of the Artistic Creation Program of Oil Painting in 2001 and received her M.A. in 2004 when graduated; Director and Lecture of Office of Fine Arts of Arts Dept of Guangxi Teachers' College since 2004.

黄　河

1967年10月生、广西崇左人。广西美术家协会会员，1991年毕业于广西艺术学院美术系本科油画专业。

Mr. Huang He, born in Chongzuo, Guangxi in Oct. 1967; graduated from Dept of Fine Arts of Guangxi Arts Institute (undergraduate program), major: Oil Painting; member of Guangxi Artists Association.

邓乐民

1965年10月生于广西崇左市。1993年毕业于广西艺术学院，获文学学士学位。现为广西美术家协会会员。

Mr. Deng Lemin, born in Chongzuo, Guangxi in Oct. 1965; graduate from Guangxi Arts Institute in 1993, degree received: B.A.; member of Guangxi Artists Association.

黄小其

1958年10月出生，广西北海人。1985年毕业于广西艺术学院美术系装潢专业。现为广西美术家协会会员，广西十佳资深室内建筑师，北海市美术家协会副主席。

Mr. Huang Xiaoqi, born in Beihai, Guangxi in Oct. 1958; graduated from Dept of Fine Arts of Guangxi Arts Institute in 1985, major: Decoration; member of Guangxi Artists Association, one of the top ten interior master architects in Guangxi, Vice Chairman of Beihai Artists Association.

吴志刚

1957年2月出生，广西北海市人。1984年毕业于广西艺术学院师范系，现任职于北海市群众艺术馆。现为国家二级美术师，北海市美术家协会副主席，北海市美术家协会版画艺委会主任。

Mr. Wu Zhigang, born in Beihai, Guangxi on Feb. 21, 1957; graduated from Teachers' Department of Guangxi Arts Institute in 1984; National Second Class Artist of Beihai Mass Art Center, Vice Chairman of Beihai Artists Association, Director of Printmaking Art Committee of Beihai Artists Association.

刘少华

毕业于广西艺术学院美术系。曾任北海市美协副主席、秘书长，北海画院秘书长，广西大地水彩画会理事，广西美协水彩画艺委会副秘书长。现为广西美术家协会会员，北海画院专职画师。

Mr. Liu Shaohua, graduate of Dept of Fine Arts of Guangxi Arts Institute, member of Guangxi Artists Association, painter of Beihai Painting Academy, former Vice Chairman and Secretary General of Beihai Artists Association, Secretary General of Beihai Painting Academy, Director of Guangxi Dadi Watercolor Artists Association, Deputy Secretary of Watercolor Artists Committee of Guangxi Artists Association.

张　虹

1960年9月出生于北海。现为北海市群众艺术馆副馆长，广西美术家协会会员，国家二级美术师，北海市美术家协会副主席，北海市广告协会副会长，中国建筑学会室内设计学会会员。

Mr. Zhang Hong, born in Beihai in Sept. 1960; Deputy Director of Beihai Mass Art Center, member of Guangxi Artists Association, National Second Class Artist, Vice Chairman of Beihai Artists Association, Deputy Director of Beihai Advertising Association, member of National Interior Decoration Association of Architectural Society of China.